The Mystery of Marquis d'

Frontispiece (overleaf):
Amand Edouard Ambroise Marie Lowis
Etienne Phillipe d'Sant Andre Tornay,
Marquis d'Oisy (1881–1959).

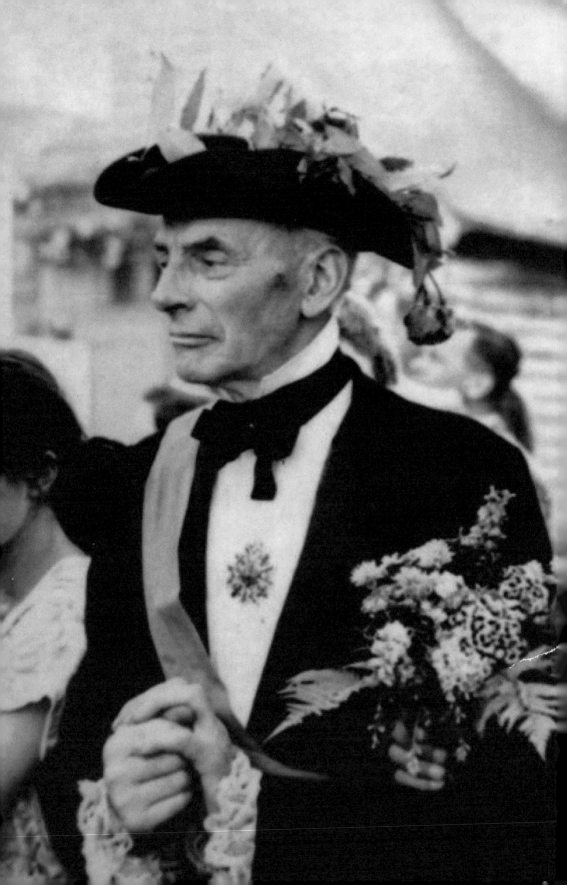

THE MYSTERY OF MARQUIS D'OISY

JULIAN W. S. LITTEN

with a foreword by
Sir Roy Strong

SHAUN TYAS
DONINGTON
2015

Published in 2015 by
SHAUN TYAS
1 High Street
Donington
Lincolnshire
PE11 4TA
in association with
The Society of the Faith
Faith House, 7 Tufton Street, London
SW1P 3QB

ISBN
978-1-907730-49-8

Typeset and designed from the texts of the author
by Shaun Tyas

Printed and bound in Great Britain by
Henry Ling Ltd., the Dorset Press, Dorchester

CONTENTS

The diagram shows the Shield of the Trinity: Father — is not — Son, both connected to God in the centre (Father is God, Son is God, Spirit is God), with Father — is not — Spirit and Son — is not — Spirit.

THE SOCIETY OF
THE FAITH

Faith House, 7 Tufton Street, London
SW1P 3QB
Registered in England as a
Limited Company number 214216
Registered with the Charity Commission
number 232821

The Society of the Faith was founded in 1905 by the Revd Canon J. A. Douglas, sometime Vicar of St Luke's Camberwell, and his brother, the Revd C. E. Douglas.

The Douglas brothers were firmly committed to a catholic understanding of the Church of England. They founded the Society to be 'an Association of Christians in communion with the See of Canterbury for mutual assistance in the work of Christ's Church and for the furtherance of such charitable undertakings as may from time to time be decided upon, more especially for the popularisation of Catholic faith.'

The Douglas brothers were also concerned with ecumenical relations, fostering Anglican-Orthodox contacts and founding the Nikaean Club to assist the Archbishop of Canterbury with ecumenical networking.

The Society's first work was the printing of Sunday School stamps, which proved immensely popular. This success inspired the foundation of Faith Press, which published many books both scholarly and popular, as well as church music. In 1916 the Society founded Faith Craft to produce high quality vestments and church furnishings. Their biggest single commission involved the refurbishment of St Mary-le-Bow in London after the Second World War.

The Douglas brothers lived on into the 1950s, but times and tastes were starting to change. Faith Press and Faith Craft both ceased operating around 1970, but the Society still pursues its original objectives: promoting high standards in publishing, church furnishing and theological education. Recent co-publications with the Canterbury Press include Michael Yelton's *Anglican Papalism* (2005), Paula Gooder's *The Meaning is in the Waiting* (2008), John Gunstone's *Lift High the Cross: Anglo-Catholics and the Congress Movement* (2010), and Margery Roberts' *Church Linen, Vestments and Textiles* (2015). In 2013, in association with Church House Publishing, the Society brought out Robert Reiss's book *The Testing of Vocation: 100 years of ministry selection in the Church of England*. A volume on the work of Faith Craft, *All Manner of Workmanship*, is currently in preparation with Spire Books, Ltd.

Since 1935 the Society has held the lease of Faith House, 7 Tufton Street, Westminster. Faith House is currently home to the church furnishers Watts & Company, The National Churches Trust, Sion College and Open Europe.

DEDICATION

This short work is dedicated to the memory of

Ambrose Thomas
1881–1959

who would have liked to be remembered as

Amand Eduoard Ambroise Marie Lowis Etienne
Philippe d'Saint Andre Tournay, Marquis d'Oisy

Lady Warwick used to say he came not from any foreign land but from the East End of London.
Basil Dean, 1970

He had a family tree. But, of course, I wasn't interested in that then. But it's gone. It's history gone. There's still a shroud of mystery about him, isn't there? All the time. The whole time.
Reginald Payne, 2010

FOREWORD

I recall a series of books on England which shared the title of 'Highways and Byways'. The life of the man celebrated in this book, who styled himself the Marquis d'Oisy, definitely belongs in the latter category. I can totally understand the author's fascination with this elusive off-beat character. It's the accumulation of question marks hanging over him which is so tantalising. Who was he? Where did he come from? He seemingly sprang from nowhere, claiming to be of French aristocratic descent via Brazil. Even his date of birth is uncertain. We catch glimpses of him attempting to become a monk. Suddenly, he vanishes, and there are lost years from 1901 to 1915. Somewhere along the line, he learned the art and technique of decorative painting, and also a great deal about historic costume. By 1917 he's holed up in North West Essex, styling himself a Marquis, and embarked on designing and staging a long series of historical pageants until 1936, when the imminence of the Second World War killed them off. Described as tall, dressed in sandals and shorts and invested with an 'atrocious Cockney accent', he reeled from one bankruptcy to the next. He turned his hand to painting furniture for Maples, doing up churches and designing ladies' dresses – one of those artistic hangers-on to whoever lived in the 'great house' – in his case Daisy, Countess of Warwick. This is a character who could have walked straight out of one of E. F. Benson's Mapp and Lucia novels. What more can I say, other than to urge the reader to read on?

ROY STRONG

INTRODUCTION

It was in the summer of 1964 that I first visited Thaxted church. At that time, as a lad of sixteen, I was still discovering the disciplines of church art and architecture and learning about, and trying to differentiate between, such things as Early English and Perpendicular. Overall, the simplicity of the fixtures and fittings at Thaxted had, even then, a profound effect on me, and to this day I regard the interior of Thaxted as the yard-stick of ecclesiastical elegance. On that first visit I was surprised to see that the wooden eagle lectern had been painted in pastel colours, albeit somewhat distressed by then, but what delighted me most were the coronas in the Lady Chapel and two garishly-painted cupboards, which I erroneously took to be examples of canal-boat art. It was not for another ten years that I was to discover that all of these items had been decorated by an artist with the unusual name of the Marquis d'Oisy. And, as with most people of an enquiring mind, promised myself that one day I might do some further research on Marquis,[1] if only to trace other examples of his work.

That dim and distant promise was reactivated in June 2010. Whilst idling through Peter Anson, *Bishops at Large* (London: Faber & Faber, 1964), I came across the following on p. 272:

> A year or so later [1901], having adopted the religious name of Columba Mary, he [the Rev'd Henry Bernard Ventham] tried to form an Old Catholic Benedictine community. Dom Columba Mary's first novice was a young lapsed Roman Catholic named Ambrose Thomas who had been dismissed from the novitiate at Erdington Abbey, near Birmingham. Ventham and Thomas furnished a monastic chapel, but there was no money to pay the bills sent in. A writ was served, whereupon Thomas sought sanctuary with the Anglican Benedictine Brothers on Caldey Island, and Ventham lay low. Br Aelred Carlyle paid the debts, and advised Thomas to get reconciled with the Church of Rome. He sailed away from Caldey Island on a ketch, bound for Bideford and Buckfast Abbey.

A footnote to that paragraph related the following:

> Having failed to become a catholic or an Old Catholic monk, Thomas ended his days as an Anglican layman. He became a familiar figure at Thaxted, Essex where he called himself the Marquis d'Oisey, claiming that he belonged to an ancient and noble family from Flanders. He designed ladies' costumes and painted furniture in an extravagant baroque manner, and took a keen interest in folk-dancing as well as most of the religious and social activities sponsored by the vicar, the Rev'd Conrad Noel, grandson

[1] d'Oisy was more familiarly known in the Thaxted environs as 'Marquis', consequently that is how he will be referred to throughout this publication.

of the Earl of Gainsborough, well known for his support of Communism and services of an advanced 'English Use' type.

This reminded me of my earlier promise. The hunt was on and for the next four years the Marquis began to share my life. That which follows is the result of those researches and the story of a quite remarkable and individual man.

Acknowledgements

The compilation of a biography of someone who has done their best to gloss over, if not entirely expunge, their first twenty-five years, is a difficult task. To some extent it was easier in the first quarter of the twentieth century, when there was still much illiteracy in the shires, the remains of subservience to the aristocracy and a complete lack of such efficient means of electronic information-retrieval as the international network, to have foiled attempts to have the details of one's formative years substantiated. That would not be the case today.

Fortunately, there are a number of individuals – particularly those in their late seventies and early eighties – who, having spent their entire lives in the environs of Thaxted, retain memories of the Marquis d'Oisy and one in particular, Reginald ('Reg') Payne of Hatfield Broad Oak who, in his teenage years, had worked for Marquis (see his reminiscenses in Appendix 1.5). To these I am indebted, not only for their time but also for their willingness in providing a multitude of the jig-saw pieces which, once interlocked, provided the overall picture of the man. However, one vitally important piece is still missing, which will become evident as the reader progresses through the following pages.

My greatest thanks go to Peter King of Thaxted, for it was he who rekindled my interest in d'Oisy and introduced me to Gordon Barker who, in turn, brought my quest to the attentions of Reg Payne and to Robert Smith of Pledgdon Green. Gordon also took me to see d'Oisy's grave in Great Dunmow churchyard and drove me to a number of buildings in the Pledgdon / Saffron Walden area containing works by, or relating to, Marquis. John Langham-Service of Thetford has been of inestimable assistance, checking and cross-checking even the most spurious of references. As ever, my encouragement in getting this information committed to paper is due to the Rev. Anthony Couchman, a fellow d'Oisy enthusiast. Finally, I am indebted to Sir Roy Strong for his kindness in providing the Foreword.

I am also grateful to the Rev. Aelred Baker OSB; Mike Bailie (Thaxted); Ken Baker (Thaxted); Heather Barker (Elsenham); Judy Bennett; Dr James Bettley; Professor Arthur Burns (University College London); Fr Shaun Church (Our Lady of the Holy Souls, Kensal New Town); Mrs Gillian Drew (Milton Keynes); Roland Fernsby (Ferneux Pelham); Mrs Elizabeth Gillett (Elsenham); Mike Goatcher (Thaxted); Mrs Rosalind Halliday (Pledgdon Green); Mrs Sylvia

INTRODUCTION AND ACKNOWLEDGEMENTS

Heath (Chiswick); Mr and Mrs Martin Heath (Chiswick); Mrs Zita Hill (Thaxted); George Hoy (Widdington); Anna Humphrey (St Mary's Cemetery, Kensal Green); Sybil King (Thaxted); Bruce Munro (Thaxted); Gordon Ridgewell (Hertford, who researched the pages of the *Herts & Essex Observer*); Alan Robinson (St Edmund's College, Ware); Heather Salvidge, Mrs Jean Springham and Michael Yelton (Cambridge) for their assistance in compiling this memoir.

Julian Litten,
King's Lynn
February 2015

PART 1

THE EARLY YEARS: 1881–1902

Attempts to discover the real name and parentage of Marquis have not been easy as all that there is to go on are Anson's comments in *Bishops at Large* and a letter penned by him in 1962 to Dom Michael Hanbury. That Thomas was at Caldey in 1901 is substantiated by the Census return for that year, in which it is stated that

> Caldy [*sic*] Priory. Ambrose Thomas. Single. Aged 20. Benedictine Monk.
> Living on own Means. Born Bath, Somerset.

According to Reg Payne, Marquis said that he was born on 21st June 1880 in Rio de Janeiro and, at his bankruptcy hearing in 1921, Marquis told the court that he was brought to England from Brazil in 1886. Later in the 1920s he told Gordon Barker's father that it was in 1888 that he came to England from Rio escorted by his mother, he having by then inherited his title from his grandmother, adding that his father was a viscount and his mother a countess. To contradict this, Marquis' obituary in the *Herts & Essex Observer*,[1] based on information provided by his friend Bernard Keel, stated that he had come to England from France in 1892. It is quite possible that if he had come from Brazil at such an early age that he truly did not know the exact date or town of his birth. Between 1790 and 1800 there was an exodus of French aristocracy to Brazil as a result of the French Revolution only to be reversed in 1889 when King Pedro of Brazil went into exile, though some had been returning since 1886.

However, the fact that in 1901 Ambrose Thomas gave Bath as his place of birth led to a search of the 1891 census returns for that city to see what might be revealed, but no 'Ambrose Thomas' came to light. Curiously, Bath did appear in Marquis' reminiscences to Reg Payne, who once related to him[2] a story when, as a child, "he was in Bath and this house 'with the river running outside,' he [Marquis] said, 'and they were so cruel to me. Forbade me to go with them. And I can hear them laughing and happy in the boat as they sailed by. It's stuck with me all those years.'" This was a great mistake on Marquis' part, and probably the only time in his later life that he unwittingly erred from his charade, in relating a childhood event from his Bath days.

It was in 1899, when he was nineteen, that he joined the Benedictine Community at Erdington, Birmingham. His time there, though, was short-lived and he was dismissed in 1900. Not even the tolerant Dom Bede Camm, the

[1] *Herts & Essex Observer*, 18 December 1959, 1.
[2] This would have been in about 1944 when Reg Payne (b. 1928) was working for Marquis.

Novice Master at Erdington Abbey, could tame him. The nature of the misdemeanour has not been exposed; perhaps Bro Ambrose was intolerant of discipline – not a wise stricture for a romantic and a dreamer – or that he found the meagre monastic fare unsuitable to his liking, or the daily structure of prayer placed too many demands on his free spirit.

In 1906 Dom Bede Camm wrote a sentimental novel entitled *The Voyage of The Pax*.[3] Camm described it in his preface as "first written to be read aloud to some lads who, under my care, were preparing themselves for the monastic life in our Abbey ... but, after lying in a drawer for a good many years, has been brought to light again." That it was based on the novices themselves is explained within the dedication, "to the memory of one of those for whom it was written ... who is himself portrayed, though he was very far from suspecting it." This was Lewis Joseph Arnold (1886–1904), who had probably joined the community two or three years after Ambrose Thomas had been dismissed from it. Be that as it may, Dom Bede Camm would certainly have known, and taught, Ambrose Thomas. Whilst it is not recorded why Thomas was dismissed there is a character in the novel called Eutyches who refused to join the crew of *The Pax*, preferring instead the pleasure boat, *Gloria Mundi*. The *Gloria Mundi* eventually foundered, with loss of all hands. Could Eutyches, the only one of the brethren in *The Voyage of The Pax* to have erred and strayed from the way, be an allusion to Ambrose Thomas?

For Thomas, where to go next was the question. Not wanting to return home and admit failure he looked around for an alternative religious community to take him. If we are to trust Peter Anson, and there is no reason why one should not, he became associated with Henry Bernard Ventham, who was at that time in Liverpool endeavouring to establish an Old Catholic Benedictine Mission with Fr Richard O'Halloran. But can this be the case for, many years later, Marquis said to Reg Payne that in 1900 he started up a business as an artistic designer of houses and furniture using a legacy of £600, or was this romanticism on Marquis' part?

Fr O'Halloran is an intriguing individual. Having been put in charge of the Roman Catholic Mission at Mattock Lane, Ealing, founded by Cardinal Vaughan in 1895, he was informed in 1900 that the Mission was to be handed over to the Benedictines of Downside. This was due to O'Halloran having formed an association with a renegade Anglican priest, Arnold Harris Mathew, *de jure* 4th Earl of Llandaff, who was trying to establish an Old Catholic Church in England. O'Halloran refused to vacate the premises, but since the title deeds of the Mission were held by Cardinal Vaughan he had no alternative than to leave. It was then that he formed an association with Henry Ventham who was

[3] Dom Bede Camm, *The Voyage of the Pax: An Allegory* (London: Burns & Oates, 1906).

at that time going under the name of Fr Columba Mary having been recently ordained into the Old Catholic Church in England by Bishop Joseph René Vilatte, a lapsed Catholic of the Latin Rite and First Primate of the Old Catholic Church of America.[4]

In the archives at Prinknash Abbey is a letter penned in July 1962 by the monk/artist/architectural historian Peter Anson to Dom Michael Hanbury OSB [d.1990] of Prinknash Abbey. Writing about the Rev'd Henry Bernard Ventham, Anson said:

> I have also discovered that H B Ventham ... was one of the oblates who used to meet at Malling [Abbey, Kent]. Sometime during the 1890s he spent a short time as a novice at Llanthony. Ventham was associated indirectly with the handful of monks on Caldey in the summer of 1901, when he was trying to form an Old Catholic Benedictine community, sponsored by Fr O'Halloran, the excommunicated priest at Ealing, who defied Cardinal Vaughan, and refused to leave his church when the Downside Benedictines were put in charge of the mission at Ealing. The experiment went bankrupt, and Ventham's novice, Br Ambrose [Thomas], fled to Caldey, where Aelred [Carlyle] advised him to get reconciled with Rome, put him on to a ketch bound for Bideford, when he made his way to Buckfast.[5]

Precisely why Ambrose Thomas selected Ealing as a refuge from Erdington needs some explanation. It may well be that his knowledge of Fr Columba Mary (Fr Henry Bernard Ventham) dated back to his childhood days at Bath for Anson, in *Bishops at Large*, states how Ventham was "plausible enough to combine the roles of an Anglican lay-reader in the Diocese of Bath and Wells with that of a Roman Catholic layman in other parts of England."[6]

A community comprising two religious could not be a "community" *per se*, and it was thus that Ambrose Thomas became Ventham's first novice. As it was to turn out, Thomas was the community's only novice as the venture only lasted until January 1901 for, when the bills relating to the chapel furnishings could not be paid, a writ was served, whereupon Ambrose Thomas sought sanctuary with the Anglican Benedictine Brothers on Caldey Island and both O'Halloran and Ventham laid low.[7] Br Aelred Carlyle, the Superior of Caldey (he was not yet an

4 As with most *vagante* bishops, Vilatte had a string of self-imposed titles:Mar Timotheos, Archbishop-Metropolitan of the Old Catholic Church of America, Doctor Christiantissimus, First Primate of the American Catholic church, etc etc.

5 Letter in the archives at Prinknash Abbey. I am grateful to the Archivist, Rev'd Aelred Baker OSB, for bringing this to my attention.

6 Peter Anson, *Bishops at Large* (London: Faber & Faber, 1964), 271–2.

7 The 1901 census records that Bernard Henry Bernard Ventham was at the Priory of St Paul, Barry, South Wales. An unusual choice, and one wonders if he told the prior that he was not single but had, in 1895, married a woman old enough to be his mother ?

abbot) agreed to pay the bills and release Thomas of the debt. Thomas must have been greatly relieved, but it was not the last time that he was to be burdened by debt and creditors.

Life at Caldey, which could hardly be described as comfortable, did not appeal to Ambrose Thomas. It had been in October 1900 that the Rev'd W Done Bushell, the owner of Caldey Island, wrote to Br Aelred Carlyle offering the Brothers the old rooms and church of the ancient Priory on the Island. The small band of men arrived on 10th January 1901 but their occupation of the rooms put at their disposal was only contingent on Fr Bushell not requiring them for his own use, and in Holy Week they had to move into the partially-restored Gatehouse, which contained two rooms above and one below, Br Aelred occupying the room which had belonged formerly to the Prior of olden days, which was in the same state in which it had been left nearly four centuries before. During August and September, when the whole house was required by Done Bushell, the Brothers were reduced to a tent encampment in the pine woods. One Brother recorded in his diary how

> we experienced for the second time the joy of Camp life in storm. Rain began to fall about 10.30, and continued all night very heavily. All our beds were wet in the morning, but the morning dawned clear and fine, and we were not much the worse for our rough night. Our Monastic Camp consists of three second-hand bell tents. The larder is a disused fowl-house, improvising with shelves for the occasion. The Refectory is outside the tents, under the trees, very nice in fine weather, with plenty of our fowls for company; the Kitchen also is outside, all the cooking has to be done on a navvy's coal-box, which is alright on a fine day, but cannot be expected to burn in the rain.[8]

Is it any wonder, therefore, that Ambrose Thomas decided that life on Caldey was not for him?

When the 1901 census was taken Thomas had been at Caldey for almost three months. The statement, "Living on own Means" falls in line with the Brothers' *Requirements for Postulants*, which stated that "They must be free from engagements of debt or marriage, and are expected to defray the expenses of their noviciate."[9] Consequently, it was vital that Thomas needed to rid himself of the debt to fulfil the *Requirements*. Doubtless Carlyle thought of him as a suitable postulant and so bailed him out; indeed, he might also have found to means to have allowed Thomas to "defray the expenses of their noviciate".

[8] W. R. Shepherd, *The Benedictines of Caldey Island* (Caldey: Caldey Abbey, 1907), 29.
[9] Ibid., 108.

According to Peter Anson, Aelred Carlyle advised Ambrose Thomas to get reconciled with the Church of Rome. He sailed away from Caldey on a ketch, bound for Bideford and Buckfast Abbey, but never arrived at Buckfast. In the space of eighteen months he had experimented with three religious orders, all of which had failed him or, rather, had disappointed him. He was ready for a change. Whether he had planned what he was going to do during the last few days at Caldey, or whether the thought came to him as he crossed from Caldey to Bideford, we shall not know. Suffice to say that Ambrose Thomas decided to give up the call of the cloister and to seek his solace elsewhere.

PART 2

MAN TO MARQUIS: 1902–1920

Precisely what happened when Ambrose Thomas landed at Bideford remains a mystery. He certainly did not go on to Buckfast as there is nothing in their records relating to his arrival or any sojourn made there by a man calling himself Bro Ambrose or Ambrose Thomas. It is, of course, possible that he went to Barry, South Wales where Bernard Ventham was sojourning at the Priory of St Paul, but bearing in mind the debacle at Ealing that left Thomas carrying the can of debt, this seems unlikely.

Whether or not it was true, Marquis told Reg Payne that when was twenty-one (1901) he was working as a navvy on the tunnel extension of the tube line from Kentish Town to Camden Town,[1] but when he was offered a job as a banjo-man[2] in 1902 he decided to leave. Could it have been that, in working as a navvy, he was taking Carlyle's advice to get some experience of the world? According to the archives of Transport for London, the Charing Cross, Euston and Hampstead Railway (CCE&HR) opened in 1907 and belonged to the Underground Electric Railway Company of London. It ran from Charing Cross tube station – know for many years as Strand – via Euston and Camden Town to Golders Green and Highgate, now known as Archway. It was presumably on this section of the Northern Line that Ambrose Thomas worked. However, the Transport for London Historical Archives and Records Custody Service yielded no information of an Ambrose Thomas in their staff records' database.[3] It may be, of course, that Ambrose Thomas was working for a sub-contractor rather than for London Transport *per se*.

Precisely what Ambrose Thomas was doing during the thirteen years between leaving the life of a navvy and taking up ecclesiastical design remains to be discovered, for the next time that we hear of him is in 1915 when, according to Michael Yelton,

> The Marquis de Tournay d'Oisy, representing Louis Grossé, carried out some work to the high altar [at St Saviour, Hoxton] including a sacred heart motif on the figure of Christ, and added some curtaining, originally on a temporary basis for Corpus Christi Day.[4]

[1] This was corroborated by identical information given by Marquis to John Hunter and to Jack Haigh.

[2] In charge of the large riddles – known as 'banjos' – through which the spoil was sifted to rescue the stones and pebbles for hardcore.

[3] Letter of 21st September 2010 from Tamara Thornhill, Senior Archivist.

[4] M. Yelton, *Martin Travers 1886–1948: an Appreciation* (London: Unicorn Press, 2003), 90.

This information was repeated by Yelton in 2005:

> In 1915 alterations were made, originally on a temporary basis for the Corpus Christi Day celebrations that year, by the exotically named Marquis de Tournay d'Oisy, representing the vestment makers Louis Grossé. He added a Sacred Heart motif on the figure of Christ, and some curtaining around the altar.[5]

Where, for example, did he acquire his skill as a painter, how did he get to know the many actors and actresses who were to be an important influence in his later life and what drew him to the ecclesiastical furnishing firm of Loius Grossé? It has been suggested that he may have attached himself to a firm producing theatrical and cinema scenery, though which company this was and what positions he occupied within it between his stated employ in 1902/03 and his association with Grossé remains to be established. But, of greater importance, in which year did he adopt the name of Marquis d'Oisy?

Be that as it may, joining Grossé must have been like a dream come true for Ambrose Thomas. If he was not going to adopt the religious life then the world of ecclesiastical fixtures and fittings was the next best thing. Here he would be in daily contact with the Roman Catholic clergy and be able to use the skills he had acquired for decorating churches and to learn how vestments were designed and made. Whilst the cutting and making-up of vestments would not have come within his remit he would have been able to see such things being done in Grossé's workshops, which was to become useful to him in later years when he was not only designing but also making the costumes for the Pledgdon Pageants.

It was in 1917 that Ambrose Thomas moved to north-west Essex, arriving with the name Amand Eduoard Ambroise Marie Lowis Etienne Philippe d'Saint Andre Tournay, Marquis d'Oisy, or 'Louis' to his friends. Reg Payne relates that Marquis told him that he took Pledgdon Green Cottage and Palegates Farm, Broxted in 1917. In actuality, it was the other way round, with Marquis first living at Palegates Farm[6] prior to moving to Pledgdon Green Cottage in the same year. The Cottage was one of a number of properties owned by the silent screen actress Irene Rooke (1878–1958),[7] and it was probably the attraction of her saying to Marquis that he could have it rent free for life which persuaded him to give up Palegates Farm and take up residence at Pledgdon Green.

Irene Rooke's first husband was a bit-part actor called Francis Greppo. They had drifted apart by 1906 and it is quite possible that Irene, the more successful of the two, had purchased the cottage at Pledgdon Green for her

[5] M. Yelton, *Anglican Papalism: an illustrated history, 1905–1960* (London: Canterbury Press, 2005), 155.

[6] This would have been a rental.

[7] Her full name was Irene Bessie Ingaretha Rooke.

estranged husband's use. That he subsequently went under the stage-name of Francis Greville - Greville being the surname of the Warwicks of nearby Little Easton - adds weight to this supposition. By 1917 the Greppos had severed their relationship and Francis had joined the army[8] which led to Irene offering the cottage to Marquis. Irene Rooke subsequently married the actor Henry Arthur Lunt, who went under the stage name of Milton Rosmer. She retired from the profession in c.1938 and died at Chesham, Buckinghamshire on 14th June 1958.

It has not been recorded how or when Marquis met Irene Rooke. He was a handsome slender man, over six feet tall, though as he was homosexual[9] there was never a physical relationship between the two of them. It might have been nothing more than that Rooke liked Marquis and wanted to help him. Whether or not Marquis left Grossé's employ at this time has not been established, but in 1917 England was in the midst of a major war and commissions for ecclesiastical fixtures and fittings would have been at low ebb. From what one can gather about Marquis it would seem unlikely that he would have deliberately severed connections with any possible sources of income and, bearing in mind that he executed a screen at Our Lady of the Holy Souls, Kensal New Town in 1921, it seems likely that he maintained some sort of connection with Grossé. Settling at Pledgdon was a brave move on Marquis'part but, with his contacts in the film and stage world, and relying on his artistic talents, he probably felt sufficiently confident to set himself up in business as a free-lance artist.

But to set one's self up in business one needed to have money or a financial backer. Unfortunately, none of Marquis' papers have survived, consequently his source of foundation funding remains a mystery unless, of course, Irene Rooke had undertaken to support him until he became established. From what can be gleaned from Marquis' subsequent conversations with Reg Payne and Gordon Barker, he had a reasonably regular outlet for his furniture with Liberty's, Maples and Heal's of London and with Robert Sayle & Co. of Cambridge[10] so it would seem more likely that he secured a bank loan on the strength of his work rather than borrowing from friends. This is corroborated by the statement he made at his bankruptcy hearing on 25th January 1921 when Marquis informed the court that he attributed part of his failure to interest on borrowed money.

Marquis' arrival at Pledgdon, a sleepy village within the environs of Bishop's Stortford, led to much speculation as to whether or not this tall,

[8] Francis Greppo died in the Great War in September 1918.
[9] So said Lady Warwick's son-in-law, Basil Dean.
[10] A department store in St Andrew's Street, Cambridge. It opened in 1840, sold to Gordon Selfridge in 1934 and thence to John Leis in 1940, retaining the name Robert Sayle & Co. until redeveloped 2004–2007, re-opening as John Lewis.

mysterious gentleman, who rode a large black bicycle and wore a long black cape and fedora, might not be a spy. It was said that children were in fear of him and frequently secreted themselves in the hedgerows and often shouted after him "Bolshevik!" when he rode by.[11] But this was a rather unfair judgement, as Marquis was a personable individual and, to all accounts, got on well with the adults and children of the village. But then anyone who arrived in a village in the middle of war-time, especially one who dressed in an exotic manner and possessed an even more exotic foreign name, was bound to draw attention to himself.

Precisely why Marquis chose north-west Essex in which to settle has never been resolved. Peter Anson infers that Marquis' move to Pledgdon was due to his acquaintanceship with the Rev'd Conrad Noel, who had been presented to the living of Thaxted by Lady Warwick in 1910. This may well be the case, and Marquis might have got to know Noel during the first decade of the twentieth century when the latter was curate to the Rev'd Percy Dearmer at St Mary's, Primrose Hill.[12] However, it seems more plausible that Marquis' knowledge of Noel was due to George Bennett Chambers (1881–1969), who was Noel's curate between 1910 and 1912. Chambers had been at Caldey exactly at the same time as Ambrose Thomas and appears in the 1901 census as:

> George B Chambers. Single. 20. Benedictine monk. Born Ealing

One can only assume that Thomas and Chambers had formed a friendship whilst at Caldey. Could it be that Marquis learnt about Conrad Noel from Chambers, and had accompanied Chambers when he attended Noel's weeknight lectures at St Mary's, Charing Cross Road in the autumn of 1906? When Chambers' period as Noel's curate came to an end in 1912 he took a curacy at Woburn, Buckinghamshire but was back in Thaxted in 1913, giving up his summer holiday to help out when Conrad Noel was taken ill from diabetes. In 1915 he moved to St Mary's, Barrow, Staffordshire as curate to the Rev'd Stephen Liberty, also a friend of Conrad Noel's, and joined the Church Socialist League in the same year. By August 1919 Chambers had left Barrow to be a curate at St Clement's, Notting Hill, but by then Marquis was already resident at Pledgdon.[13]

[11] The Foster sisters of Pledgdon Green remembered how they and their peers would shout after Marquis as he rode by.

[12] Noel had been presented to the living of Thaxted in 1910 by its patron, Frances, Lady Warwick.

[13] R. Groves, *Conrad Noel and the Thaxted Movement* (New York: Augustus Kelley, 1968), 272. Chambers did not get a parish of his own until 1927, when he became vicar of Carbrooke, Norfolk. He was one of the two priests who assisted Jack Putterill at Conrad Noel's funeral mass in July 1942.

PART TWO

The cottage at Pledgdon was a small, two-storey, sixteenth-century timber-framed building with lath and plaster, set in a large garden with eight[14] acres of land and situated on the edge of the village green where Marquis kept, over the years, a succession of tethered Jersey cows and goats.[15] The cottage had a balcony on the first floor[16] and it was here that Marquis would sleep, whatever the weather, with his dogs at his side. Reg Payne recalled that Marquis had a succession of greyhounds, all bitches, with names such as Nellie, Sally and Jenny. In the 1940s he had a whippet called Alice, and also

> a rogue of a dog, a so-called Alsatian pedigree, who wasn't, and ate anything, even old Ever-Ready razor-blades.[17]

That he slept in the open has given rise to suggestions that Marquis might have had some form of lung-infection, but he was never hospitalised for the same and neither was lung disease the cause of his death. It may simply be that it was all part of his eccentricity, though he was not a Pantheist.

During his early years at Pledgdon he formed a friendship with Frances, Lady Warwick at nearby Easton Lodge. Lady Warwick was a shrewd individual, convinced that d'Oisy was not an aristocrat, saying to her son-in-law, Basil Dean,

> that he came not from any foreign land but from the East End of London.[18]

and yet she was kind to him, giving him the occasional commissions for painted furniture, and trusted him sufficiently to have him look after her dogs and Easton Lodge when she was not there, subsequently allowing him use of the gardens at the Lodge to stage his pageants.

One of the many private commissions that Marquis received for his painted furniture during these early days came from the actor Charles Ashton (b. 1884) for his house at Loughton, Essex. Ashton had appeared in the silent film *Pillars of Society* with Irene Rooke in 1920 and it may have been she who recommended him to Marquis.[19]

[14] Some said that it was of five acres, others that it was eight, but when it was put on the market in January 2014 for £865,000 it was said to be of 10½ acres.

[15] Never any more than one of each species at a time; he seemed to have abandoned this husbandry in the late 1940s.

[16] According to Gordon Barker this balcony was specially constructed in 1917 for Marquis' use.

[17] Information from Reg Payne.

[18] Basil Dean, *Seven Ages: an Autobiography. Vol. 1: 1888–1927* (London: Hutchinson, 1970), 263.

[19] Information from Heather Savidge. Ashton moved to Arkesden, Essex in 1954 where the item was seen by Kyran Casteel, Ashton's guardian.

Work was not coming in quite as quickly as Marquis would have desired and tragedy was struck towards the end of 1920 when a receiving order was filed at the High Courts of Justice on 21st December:

> d'OISY, Marquis. Amand Edouard Ambroise Marie Louis Ettienne Phillippe de-Saint-André de Tounnay (described in the Receiving Order as the Marquis Louis de Tounnay d'Oisy), 3, Queen's Road Studios, St John's Wood, London N.W., GENTLEMAN" in the matter of bankruptcy.[20]

The address given – 3, Queen's Road Studios, St John's Wood – had been taken by Marquis in 1920, and he remained its registered householder until 1925. It must have been quite a financial strain running both Pledgdon Green Cottage and the studio in St John's Wood and it would appear from the High Court petition that he had indeed somewhat over-stretched himself.

[20] *London Gazette*, 28 January, 1921.

PART 3

THE PLEASANT YEARS: 1921–1930

Marquis appeared in court on 25th January 1921 to answer the charge of bankruptcy, owing £1,524 against assets of £118. The transcript records how

> The applicant, who had assets of £118 and debts of £1,524 is a Brazilian subject, held a French title of nobility without any territorial possessions. He was brought to this country as a child in 1886 and, in 1900, with £600 representing legacies, he began business as an artistic designer of houses and furniture. In 1917 he took Pledgdon Green Cottage for the purpose of demonstrating his works to people who required their properties restored and, in the same year, he took a farm at Broxted, Essex. The failure was attributed to losses in connection with the Essex farm and Pledgdon Green Cottage, to interest on borrowed money, and the slump in the trade which caused a decline in his designing business.

After further investigations into his financial affairs he reappeared at court on 17th March 1921, this time before Registrar Hope, to answer to Mr E. Parker, Assistant Official Registrar, his debts had risen to £1,575 against improved assets of £576.

It was beginning to look as though his business venture was about to fold, but his former employer, Louis Grossé, came to the rescue and in the summer of 1921 secured him a job at Our Lady of the Holy Souls, Bosworth Road, Kensal New Town, W10 to design and paint an inner porch at the west end of the nave in memory of Fr Joseph J. Greene (d. 1913), first rector of Kensal, and his successor, Fr Arnold Baker (d. 1918). It was a timely commission, allowing for some of his debts to be redeemed. A short *divertissement* on August Bank Holiday Monday 1921 took Marquis to Thaxted church, where he attended the wedding of his Caldey friend, the Rev'd George Chambers, to Aline Robinson.

Obviously the Kensal New Town work could not be undertaken from Pledgdon, so Marquis went back to his studio above the garage at 3 Queen's Road Studios in St John's Wood[1] and it was here, in September 1921, that a correspondent from the *Daily Chronicle* came to see him. The interview between Marquis and the reporter subsequently appeared in the Perth, Australia newspaper, *The Daily News*:

> **Marquis becomes a Dressmaker. Cuts dresses and does embroidery himself.**
> In a studio over a garage in St John's Wood is the workshop of a French nobleman, who has lately taken to dressmaking. The highly decorative

[1] The correct postal address was 3 Queen's Grove Studios.

rooms belong to the Marquis de Tournay d'Oisy, who showed a 'Daily Chronicle' representative some of the dresses and furniture which he has designed and painted.

For some time the marquis has devoted his attention to ecclesiastical vestments and church furnishings, but is now specialising in painted furniture and in cloaks and dresses. 'A woman's dress should express her personality,' the marquis said, 'For that reason I like to talk to a client for a little while before I discuss the dress she wants. Chatting informally on all sorts of subjects, I get an impression of her character, and can better design the dress which will express it. If a house gown is wanted I like to visit my client's home, for the frock in which a woman receives her dinner guests should not be expressive only of the wearer's personality, but be in tune with her house.'

Cloaks and dinner gowns in velvet, with decoration in paint, are a speciality of this French dressmaker. 'A flannel jumper sounds incongruous until one explains that the flannel is simply the background for the decorations in bright wool. I don't suggest that such a jumper is suitable for Bond-street,' said the marquis, 'but it might be worn in the country or on the river. It will wear for ever; indeed, most of my cloaks and gowns are of such a character that they can never be unfashionable. They can be worn two or three times, put away for months, and brought out again.' The marquis cuts out every dress, and does all the embroidery and paint-work, leaving only the actual stitchery to an assistant.

His furniture is as original as the clothes he makes. A painted grand piano occupied a large corner of the studio. Its keys are green and gold, instead of black and white, and the framework is rosewood, hidden under a variety of colours. 'Painted floors are very much in demand,' added the marquis, 'It costs less to paint a floor in a good colour with a centre design than to cover it with linoleum and hearthrug.'[2]

What the reporter from the *Daily Chronicle* did not know was that d'Oisy was still troubled by debt. On 23rd September 1921 the London Gazette announced that, in the matter of the Marquis Louis de Tournay d'Oisy, the last day for creditors to submit proofs of debts owed by him was to be 11th October 1921. That indicates that by then he had been adjudicated bankrupt.

Meanwhile, he was progressing with the west screen at Our Lady of the Holy Souls. The six upper panels on the east side of the double doors depicted the Last Judgement, the lower panels with arabesques, similar to the quality of decoration reserved for his furniture. On the main framework, to the south, was a panel depicting a mitred saint and, on the north, one showing Our Lady of the Holy Souls. On the central cross bar of the doors was the dedicatory inscription:

[2] *Daily News*, Perth (Australia), 23 September 1921. It was not unusual for colonial papers, when short of local news, to rely on pieces from English newspapers.

ORATE PRO PATRIBUS GREENE ET BARKER, O.S.C. MCMXXI
QUORUM IN MEMORIAM HOC VESTIBULUM INSTRUCTUM
EST.[3]

The work was completed in time for the planned Solemn Blessing and Opening
at 8.00pm on Friday 11th November 1921, for which a special Order of Service
was printed. Of course, Marquis was present. It began with the blessing of the
porch to Mendelssohn's motet, *Beati Mortui*, followed by a sermon from the
Rev. Philip Fletcher. The hymn *Ave, maris stella*, was then sung and, after
Benediction and the *Magnificat*, came Fr Baker's favourite hymn, *Who can paint
that lovely city?* During the singing of *Ave, maria stella* a collection was taken:

> It is earnestly hoped that all will give generously, so that the whole sum
> required for the payment of the Porch may be completed.

Doubtless Marquis agreed with the sentiment. More so, he managed to have an
advertisement included on the back of the Order of Service:

> The New Porch has been designed and painted by the Marquis de Saint
> André de Tournay d'Oisy, of 3 Queen's Road Studios, St John's Wood,
> N.W.8.

Unfortunately, the decoration on the screen fell victim to a re-ordering
programme in the 1960s in response to the call for simpler interior decoration,
promulgated by the Vatican Council in 1962, and was covered over with a thick
brown wood stain. Attempts to remove some of this in 2010 met with success
and it is to be hoped that sufficient funds will be forthcoming to complete the
restoration of this rare and highly colourful example of d'Oisy's work.

In the winter of 1921 Marquis was producing designs for the costumes to
be used in the play *Lady Larcombe's Lapse* by Mrs Jessie Porter.[4] It was a
somewhat wasted effort as the play only ran for one night, opening and closing
at the Kingsway Theatre, London on 5th February 1922. Starring Irene Rooke
as Lady Larcombe, produced by her husband Milton Rosner and with costumes
designed by 'Marquis de Tourney D'Oisy', *The Times* described the plot thus

> Lady Larcombe's lapse was to visit a nightclub, which has the eventual
> effect of her son renouncing his libertine ways.[5]

The reason for the play's short run was not explained.

[3] Pray for Fathers Greene and Baker – 1921 – to whose memory this vestibule is
erected.

[4] J. P. Wearing, *The London Stage 1920–1929: a Calendar of Productions, Performers
and Personnel*, 2nd edn (Plymouth: Rowman & Littlefield, 2014), 147.

[5] *Times*, 6th February 1922.

Most of 1922 was taken up with fulfilling orders for Liberty's, Maple's and Heal's in London and Sayle's of Cambridge. Buying second-hand furniture from Sid Carr of Bishop's Stortford, Hertfordshire, whom he considered to be a pleasant and generous man who did not overcharge, and using hinges and hand-made nails from Mortimer of Dunmow, Essex he would repair and paint blanket-chests, chests of drawers, corner cupboards, dressing-tables, wardrobes, dressing-table mirrors, wall-mirrors, stools, beds and tea-caddies, using the London & Stanstead Furniture Company to transport the finished works to London or Cambridge about every three or four weeks. In return, the carriers would also bring down items of new furniture for painting. It was a busy time and so he employed local men to assist him in the work. He also had a small local output in Dunmow, Saffron Walden and Thaxted, selling to friends and private clients, and was regularly going to St John's Wood to paint works there.

In the interim, Marquis was spending what time he could spare in creating the costumes and scenery for his *Pageant of Fashion* which was to be held at the Holland Park Rink, Kensington on 12th October 1922, travelling up and down from Pledgdon to his studio at St John's Wood as often as work would permit. How he secured this contract has not been recorded, but the principal feature of the event was *The Temple of Fashion* and a pageant showing *The Dawn of Fashion* with its passage through various countries. It seems unlikely that anyone from the Pledgdon Green area took part for there are no local reminiscences of the event, and it may be that he was relying on his London friends from the theatrical fraternity. Whatever the case, Marquis would have been delighted with the facilities presented at the Holland Park Rink for it was here that Strand Electrics[6] has just installed a Sunray Compartment Batten, a revolution in theatrical lighting using filters instead of colour-dipped lamps, which was to become the backbone of all future Strand installations.

It must have been on a high note that Marquis returned to Essex after the performance, dreaming of expansive future productions whilst on the train home, planning this, that and the other extravaganza for, if nothing else, Marquis was a great dreamer.

Marquis' theatre work was also in demand. During the winter of 1922 he was working in collaboration with Reville Ltd and Paul Caret designing the costumes for the play *Trespasses* by Edward Percy[7] which had its first performance at the Theatre Royal, Brighton on 5th March 1923 before transferring to the Ambassadors, London for seven performances between 16th

[6] Established in 1914 by Arthur Earnshawe (Duke of York's Theatre) and Phillip Sheridan (Strand Theatre). In 1918 they were joined by Moss Mansell, manufacturer of arc resistances and dimmers.

[7] Though his full name was Edward Percy Smith.

and 21st April. Its short run was probably due to its rather boring plot, described by *The Times*[8] as

> involving a middle-aged man married to a young woman who seeks a lover of her own age.

The theatre programme credits him as 'Marquis de Tourney D'Oisy'.[9]

On 24th June 1923 Marquis wrote to Conrad Noel, enclosing a typescript [now lost] outlining an idea that he had for the Chantry and almshouses at the west end of the churchyard at Thaxted:

> Guest house and pilgrims hostel at west side with refectory. Windows show life of old guilds of Thaxted, wall painted green and gold as if curtains.

As for the church building itself, he was proposing:

> Reredos with figures of saints and in all chapels. Cupboard with scene of life of Our Lady in L[ady] C[hapel], painted saints in chapel of St Anne. Priests say masses at all the altars, guilds in place.

It was in June or July of 1923 that Marquis, in association with John Hyman and Christabel Russ, had been asked to design the costumes for Edward Percy's new play *Ancient Lights* which was to have it pre-London performance at the Playhouse, Cardiff on 17th September before transferring to the Everyman Theatre, London for a run of seventeen performances between 1st and 17th October. The part of Stella Langridge was played by his dear friend Irene Rooke and the production was, again, produced by Milton Rosman. Interestingly the play-bill had Marquis down as 'Marquis D'Oisy' rather than 'Marquis de Tourney D'Oisy'.[10] Unfortunately, *The Times*[11] was not particularly enamoured of the plot, describing it as

> Shallow, and relied on stereotypical characters.

On 4th October, whilst Marquis was in London enjoying the performances of *Ancient Lights*, he received a reply from Conrad Noel to his letter of 24th June:

> Thanks for the typescript on St John the Baptist; not my vision, but helpful. Only shilling fund run by Mrs Holst[12] can pay for kind of work you envisage. Vestment cupboard a priority. Need an estimate. Could also paint existing cupboard in sacristy. As for rest, don't want to raise hopes too high. Don't really want portraits of saints, modern artists can do

8 *The Times*, 17th April 1923.
9 Wearing, *The London Stage 1920–1929*, 223.
10 Wearing, *The London Stage 1920–1929*, 250.
11 *The Times*, 7th October 1923.
12 At that time Gustav Holst, his wife and daughter Imogen were resident at Thaxted.

Ignatius Loyola that is the kind of neurotic writer who is now accounted a saint, but God forbid that his statue should ever find a niche in Thaxted.[13]

To some extent Marquis was probably not too despondent with the reply. It had, though, reminded him of an earlier request from Noel for him to decorate the vestment press and the sacristy cupboard, which he probably did during the winter of 1923–24. The delay had been occasioned by more theatre work, this time collaborating with Joosten Phienka on costumes for the play *What the Public Wants* by Arnold Bennett, another production starring Irene Rooke, in the role of Emily Vernon, and Milton Rosmer, as Sir Charles Worgan. It opened at the Everyman, London on 19th October 1923 and had nineteen performances between then and 3rd November.[14]

By the mid-1920s it was apparent to those who had business dealings with him that Marquis was frequently short of cash. Gordon Barker recalled an incident when his grandfather patched the thatch roof of the Pledgdon Green cottage; the money did eventually materialise, though it took Marquis some time to pay. Not everyone was willing to wait for their cash as evidenced by the following short article in the *Chelmsford Chronicle* on 15th February 1924:

MARQUIS at COURT
Curious County Court Case
Story of a house at Henham
On Friday at Dunmow County Court Charles Dare, builder, of Great Bardfield, sued John Barclay, gentleman, Pledgdon Green, Henham for £59 16s 4d for materials supplied and work done to a cottage at Pledgdon Green, where Mr Barclay lived with the Marquis de Tourney D'Oisy. The work was ordered by the Marquis, who it is understood was an undischarged bankrupt.

1925 was one of the highlight years in Marquis' life when Lady Warwick suggested to her son-in-law, the film producer and stage director Basil Dean (1887–1978),[15] that he could do no worse than solicit Marquis' assistance in the restoration and repairs to Little Easton Manor, Essex. This began a twelve year association, as the work itself could only be done in phases as and when monies were forthcoming. Basil Dean described this association quite minutely in two of his publications:

13 Correspondence in the Conrad Noel Archive at Hull History Centre. I am grateful to Prof Arthur Burns for bringing this to my attention.
14 Wearing, *The London Stage 1920–1929*, 253. Reviewed: *Times*, 22nd October 1923, 10.
15 Basil Dean had married, as his second wife, Lady Mercy Greville, the daughter of Frances Maynard, Lady Warwick.

PART THREE

We decided to make our home, Nancie and I, at Little Easton Manor, in Essex. I had purchased the house from the Maynard Estate on condition that the money was used to augment the younger daughter's portion, to which Nancie was entitled on marriage, and that the whole sum be placed in trust for her and her children.

Restoring an ancient manor house that has lain neglected, or put to misuse, for centuries, is a most expensive hobby . . . I thought at first the work would be completed in at most twelve months, but I was to spend twelve years on the task, aided and abetted by my artist friends, during which time the old house exerted more and more of its happy influence over me.

Fortunately, there lived not far away a certain Marquis D'Oisy, who was said to be descended from one of the oldest French families, some said that of Cardinal Richelieu. Although he had never been to France, could not speak a word of French,[16] and had an atrocious Cockney accent, he was, by tacit consent, known throughout the district as 'the Marquis', yet I never heard him lay claim to any title. Lady Warwick used to say he came not from any foreign land but from the East End of London. He was a strange creature altogether, very tall and thin, emaciated almost, with a squeaky voice and a chin beard: an obvious homo- sexual. He lived with a Scottish henchman called John in a tumbledown cottage so primitive that one had to bend almost double to get through the door. Lady Warwick once murmured mischievously to me: 'If you ever go to lunch with the Marquis he'll give you nasturtium leaves and violets to eat.' Nevertheless, she had done her best to help him and now suggested I should employ him to supervise the restoration of the manor.

The Marquis was well acquainted with both fact and legend regarding the house. As he led me round the property on a sort of treasure hunt, his long nose twitched with excitement, like huntsmen after a fox, I caught something of his zest for restoration. He began by tracing the lines of the great hall and the 'fire', its red brick chimney-stack still standing, smothered in ivy at one end. He also showed me the entrance to an underground passage to the church, long since blocked up, which enabled hunted men to seek sanctuary in the church. To test his story I asked the gardener one day to dig down below the flowers and the winter-planted vegetables. There, sure enough, were the brick footings extending the length and breadth of the garden, just as the Marquis had said.

The inside of the house, what remained of it, had been ravaged by Victorian adaptation to menial use ... The Marquis was not a whit disturbed by all the mess, poking his long shepherd's crook through rotting plaster and tearing away accumulations of Victorian wallpaper to show me where original oak beams might be found. And there they were. In two small rooms we found beneath the deal boards the original oak floors, fastened with the original hand-cut nails, and still valiantly resisting the depravity of dry rot.

[16] If Marquis had come from Brazil when he was six or seven years old, he would have forgotten almost all of his Portuguese within a very short time.

After two days of discovery it was decided to begin work at once. There lived in the village of Little Easton an excellent local builder, who understood how to handle oak with respect and when not to meddle with age. He knew, too, about that distinctive Essex craft known as 'pargetting', a method of ornamenting exterior plaster with all manner of attractive design, according to the whim of the craftsman. So the Marquis, combining his antiquarian zeal with natural good taste, made plans and drew sketches that would have made a qualified architect shudder but which Mr Pickford, after scratching his head with the brim of his bowler hat, pocketed with the obvious intention of relying upon commonsense and local tradition. So prices were fixed – to be many times exceeded, needless to say – while Nancie and I watched and waited and finally went off to America, confident that all would be well.[17]

Basil Dean published further reminiscences of Marquis in 1973:

On the opposite side of the county there dwelt that enigmatic figure, the Marquis d'Oisy, so known to us all, although none would swear the title was true inheritance – pathetic if it were so, ridiculous if false; artist-antiquarian, vegetarian, and decorator-extraordinary of cottage replacements of period furniture to Lady Warwick. We owed to him much of our knowledge of the manor's history, all of our discovery of its foundations, and enthusiastic guidance along the path to its restoration. A passionate student of peasant ways – a folk-artist, you might say – he spent much of his time organising medieval pageantry in remote villages, blandly ignoring the desperate poverty in which he lived. One of his plays was called *Henham Hall*. It presented a colourful picture of rural England in the fifteenth century, and aroused much local interest because of the numbers of men and women, boys and girls of the surrounding villages involved in the performance. Among the incidents was the award of the Dunmow Flitch, done after the ancient manner. The applicants had to kneel before the Prior of Dunmow and take an oath before 'the Canons and people' that they had never quarrelled during the past year. The modern version of the ceremony, in which candidates are cross-examined in the presence of a judge and jury, is without historical foundation.

It was not long before the Marquis d'Oisy brought his village players over from Henham to present a series of medieval tableaux to the sound of pipe and tabor, conducted by a well-known expert in that type of music.[18] I gather it was an hilariously self-conscious entertainment that delighted the village audience, especially when they saw the Marquis's white muslin draperies changing colour, blue to red to amber, by the simple use of coloured gelatine held in front of some flickering electric globes. The battery-operated lighting plant at the Manor was objecting

[17] Basil Dean, *Seven Ages: an Autobiography. Vol. I: 1888–1927* (London: Hutchinson, 1973), 262–5.

[18] This was on 16th July 1927. The "well known expert in that type of music" was Kenworthy Schofield.

strenuously to this overtime working. Such naïve enjoyment was a measure of the remoteness of those Essex villages, even in the late twenties.[19]

From the earlier of the two accounts we learn more about Marquis than from any other publication: that he was probably not that which he said he was, that he could neither speak nor read French, that he was tall and thin and a vegetarian[20] and shared the cottage at Pledgdon with a Scottish friend called John. That he could neither read nor speak French is not to be wondered at for had he been born in Brazil his native tongue would have been Portuguese. Marquis' Scottish friend was John Anderson Barclay (d. 1955) who subsequently ran The White House pub at Quendon, Essex (near Saffron Walden) which he later converted into an illicit private night club frequented by a number of individuals known to Marquis, one of whom was Basil Dean's wife, Mercy Greville, who once had occasion had to hide beneath the club's kitchen sink during a police raid. Although Basil Dean believed Barclay to be Marquis' 'henchman', and Reg Payne thought him to be the manservant, he was in fact Marquis' cutter and they probably met at Louis Grossé's. Be that as it may, Barclay had left Pledgdon for Quendon by the end of the 1920s.

Marquis' first Pledgdon Green Pageant took place on Saturday 10th July 1926 in the gardens of Pledgdon Green Cottage with Imogen Holst conducting the orchestra, as recorded in 2007 by Rosamund Strode:

> Another of Imogen's pre-RCM[21] activities was to provide the music for a pageant held near Thaxted in July [1926]. The goal of this fund-raising effort was to build what became Cecil Sharp House, headquarters for the EFDS[22], on the north side of Regents Park. The preliminary announcement for the event reads as follows:
>
> A message from the Marquis D'Oisy: A festival will be held under the auspices of the English Folk Dance Society at Pledgdon Green on Saturday, July 10th, at 3.30 pm., wet or fine. In the event of very bad weather we hope to adjourn to a neighbouring barn.[23] An old fourteenth century monk [Mr A. A. Thomson] has written a chronicle of St Thomas of Canterbury – the borders of his MS he has beautifully illuminated with miniatures of the principal scenes of the story, using that wealth of pure colour so dear to the mediaeval illuminator. It is these miniatures that have come to life in our play. Folk dances led by Miss Morris will be shown in mediaeval dress. The Letchworth Morris team, in traditional costume will dance to the pipe and tabor played by Mr K. Schofield. Miss Imogen Holst is

[19] Basil Dean, *Seven Ages: an Autobiography. Vol. II: 1927–1972* (London: Hutchinson, 1973), 20 and 27.
[20] Though Reg Payne doubted this.
[21] Royal College of Music.
[22] English Folk Dance Society.
[23] This would have been the barn at Pledgdon Hall Farm.

arranging and conducting the old music which accompanies the play. After tea we will return to the twentieth century and have a folk-dance party from 6.30 to 10 pm., to which all dancers are invited.[24]

The Marquis D'Oisy was a somewhat ambivalent, flamboyant character, known for painting plain furniture with Italianate decoration and with a flair for staging events and pageants such as this one. He was to disappear off the Essex scene rather suddenly and apparently without explanation a few years later[25]. Joan Morris and Kenworthy Schofield were to be married just two weeks after this event; all the Holsts went to the wedding in Bishop's Stortford church, and Gustav Holst played the organ.[26]

That the performance was well received was made plain by a contemporary newspaper account of the proceedings:

<div align="center">

HENHAM
English Folk Dancing Society,
Essex Branch.
PLEDGDON GREEN (HENHAM) FESTIVAL

</div>

On Saturday a large gathering attended this festival, which was held in the grounds of the Marquis d'Oisy's house. The main feature was a Miracle Play entitled "The Passion of Master Saint Thomas", a series of tableaux illustrating the life and martyrdom of Thomas à Becket. The tableaux were presented on a small stage with doors, representing a cathedral, while the lawn in front was used for the other portions of the play, processions, dances, etc. English folk dances formed part of two of the scenes, and the Letchworth Morris Dancers[27] gave a display. The Thaxted Choir provided the music. The Book of the Play was written by Mr A. A. Thompson, who also acted as the aged Chronicler during the play. The costumes were designed by the Marquis d'Oisy, and Mr R. A. Glazenbrook was stage manager. During the interval a short speech was given by the Producer, who stated that the object of the Festival was to raise funds for the memorial to Cecil Sharp, the composer who had done so much to rediscover the old English folk dance tunes, and to lead the way to the revival of country dancing. Mrs A. Muir made a charming Saracen Princess, the Marquis d'Oisy sustained the part of Becket with grace and dignity. Mr T. Bidwell delighted the audience with two humorous interludes as the Verger, and G. E. Bradshaw, three months (Becket as a baby), rose nobly to what must have been a novel occasion, and in an

[24] There is a copy of this notice in a scrapbook in the Britten-Pears Foundation Archive, Imogen Holst Section, HO/2/6/1/18.

[25] There is no substantiation for this comment.

[26] Rosamund Strode, 'Part I: 1907–1931' in Christopher Crogan (ed.), *Imogen Holst: a Life in Music*, Aldeburgh Studies in Music 7 (Woodbridge: Boydell Press, 2007), 32–3.

[27] The Squire of the Letchworth Morris Men was the textile designer Alec Hunter, who was eventually to move to Thaxted with his wife, Margaret, and son, John, in 1936.

unrehearsed performance gained the affection and applause of all.[28]

It was kind of Imogen Holst to have given of her time, both to the rehearsals and the performances, and equally generous of the Letchworth Morris team to have taken part. From the surviving photographs of the event the costumes and the scenery were quite impressive and one has little doubt that Marquis and John Barclay threw their all into their production, working late into the night on the treadle sewing-machines at Pledgdon Green Cottage and at Rough Apple Cottage on Pledgdon Green. Doubtless the actors, musicians and dancers all had a great time and a goodly sum was raised for Cecil Sharp House. The Marquis undoubtedly enjoyed himself as Thomas à Becket, but the most interesting snippet of information in the newspaper report relates to A. A. Thompson who was not only appearing as The Aged Chronicler but was also the author of the script.

Arthur Alexander Thompson (1894–1968) was a well-known cricket commentator and the author of numerous books on cricket, who was originally with Kodak but by the mid-1920s was working as a drama critic and a columnist for *Radio Times*. At the time of his first meeting with Marquis he lived at Henham but in the 1930s moved to White Cottage, Broxted. Almost without exception the scripts for Marquis' pageants were written by A. A. Thompson. Some might think that to have been a somewhat lowly task for such a well-known author, but Thompson was a generous and pleasant man who no doubt enjoyed providing the scripts – which, for him, would be easy to pen – and probably warmed to the idea that he was giving pleasure to those at Henham and Pledgdon Green who found great enjoyment performing in the pageants.

The Little Easton production of the pageant 'Henham Hall' – including the episode of the Dunmow Flitch lampooned by Basil Dean – took place a year later on Saturday 16th July 1927. The report in the *Herts and Essex Observer* on the following Saturday was not particularly long, but it does shed light on the number of players involved and, of greater importance, their names. The day itself was overcast, which would have somewhat interfered with the electrics and dampen the spirits of Lady Warwick and her house-party, as well as those of the local Member of Parliament and her nearby neighbour and tenant, the author H. G. Wells. Doubtless these were the luminaries of the audience, itself comprised of residents of Dunmow, Henham, Great Easton, Little Easton, Pledgdon Green and Thaxted.

Henham Hall: A Folk Play

Inclement weather failed to damp the enthusiasm of the audience which witnessed the second annual Pledgdon Green Festival on Saturday. Henham Hall, a folk play written by A. A. Thomson [sic] and produced by

[28] *Herts & Essex Observer*, 17th July 1926, 8.

the marquis d'Oisy, presented a gaily-coloured picture of rural England in the fifteenth century, blending a romantic love story. Interwoven with the story were a number of historical incidents, including the giving of the Dunmow Flitch according to the original ceremony, and Edward IV's honeymoon with Elizabeth Woodville, at Little Easton Manor.

The story, told by a wandering minstrel, portrayed the love of Elizabeth Fitzwalter for a blue-eyed stranger, the disguised Earl of Oxford. A medieval atmosphere was conveyed in the setting which, shaded by tall elms, represented the turrets and embattlements of Henham Hall, together with the ancient Cock Inn, scene of much broad comedy. The great Henham Fair scene, enacted with light-hearted spontaneity by nearly a hundred villagers, showed Merrie England brought to life again, while the Letchworth Morris-dancers, accompanied by Dr Kenworthy Schofield, one of the few living exponents of the pipe and tabor, added to the spirit of robust jollity. The last scene, depicting the Royal Revels at Dumnow, was a riot of gorgeous colour.

Cast: A Minstrel, A. A. Thompson; Dowager Lady Fitzwalter, Jean Muir; Elizabeth, Maid of Henham Hall, Beatrice Thomson; Lord of the Broom, R. C. Budge; Blue-eyed Stranger, Harold Peacock; Host of the Cock, T. Bidwell; Hostess, H. Bradshaw; Tapster's Boy, E. Benterman; Wise Woman of Widdington, Violet Budge; Queen Elizabeth (Woodville), Joyce Ward; King Edward IV, Marquis d'Oisy; Cardinal Bourchier, J. Bacon. Ladies and gentleman of Court: The Duchess of York, the King's Mother, A. Garner; Jacqueline de Luxembourg, Dowager Duchess of Bedford, the Queen's mother, E. Daniel; the Dukes of Clarence and Gloucester, the King's brothers, H. Buds, J. Orr; Dame Margaret, the King's sister, Patricia Orr; Isabel Plantagenet, Countess of Essex, Muriel Wilson; Henry Bouchier, Earl of Essex, A. H. Garner; the Bearer of the Sword of State, R. Drysdale-Smith; Maids in attendance of the Lady Elizabeth, Marjorie Baker, Mary Baker; Court Ladies and Gentlemen, Elizabeth Gold, Madge Gold, Hilda Mees, Mary Willis, Donald Gold; Train Bearers, W. Ward, N. Ward, W. Baker, J. Pogrum, F. Palmer, S. Harman, T. Bidwell, U Budge.

Morris Dancers: Alec Hunter, Charles Williams, Harry Doherty, Ernest Hales, Montague Young, Stanley Truscott. Pipe and Tabor: Kenworthy Scholfield.

Country Dancers: Joyce Schofield, Margaret Hunter, E. Turner, G. Turner, L. Garner, E. Renterman, F. Renterman, H. Lay, C. Sunderland, E. Balaam, P. Clarke, F. Clarke, L. Wright, F. Catt, A. Stubbs, Denis Hayden-Coffin, J. Barclay, L. Snow, H. Lindsell, L. Pechy, A. Barnes, L. Triggs.

Fiddlers: Thomas Rayson and Walter Close.

Villagers: H. Blake, V. Wickens, L. Wicjkens, M. Marshall, E. Johnson, M. Bidwell, M. King, H. Bradshaw, L. Camp, E. Neville, E. Dixon, V. Heard, M. Snow, D. Clayden, M. Sommerfield, Leslie Camp, J. King, Gwendoline Bradshaw.

Prior of Dunmow, V. Daniel; Parson of Henham, C. Parsons; Retainers, E. H. Clarke, H. Blake, F. Livings, E. Livings; Seneschal, W Silvester;

Trumpeter, J. Grimshaw.

The orchestra was conducted by Mr L. Dupère, F.R.C.O.

Among those present were the Dowager Countess of Warwick, Lady Carlyle, Mr H. G. Wells,[29] Mr Basil and Lady Mercy Dean, and Mr W. Foot Mitchell, M.P.[30]

To some extent it was a little unfair of Basil Dean to have been so dismissive of Marquis' attempts. Yes, it probably was a rather rustic and amateur performance, but those taking part entered into the general fun of things. With a cast of over one hundred and fifty players, Marquis had obviously pulled out as many stops as his organic personality could lay hands on. In addition to Dr Kenworthy Schofield, who was not only a highly accomplished musician but arguably one of the finest jig dancers in England, he again persuaded Alec Hunter to bring along most of the Letchworth Morris Men. Furthermore their wives, Joyce Schofield and Margaret Hunter, appeared as country dancers. Marquis appeared in the guise of Edward IV, his friend John Barclay was one of the country dancers and A. A. Thompson appeared as The Minstrel. It must have been a very jolly day, with Marquis in his element, even though the electrics put great strain on the battery-operated lighting system at Little Easton Manor.

Between these two pageants Marquis was continuing with his painted furniture commissions as well as completing the work for Thaxted church. He also found time in 1927 to submit an illustrated article for the *Ideal Home*; under the title 'Reconstruction' it was a description of the restoration of Little Easton Manor. Doubtless it pleased Basil Dean, for he makes no scathing comment on it in his autobiography. This was soon followed by another article for *Ideal Home*, on the subject of wall-hangings.[31] Wall hangings apart, and buoyed by the success eight months earlier of the Second Henham Pageant, Marquis was planning an even grander extravaganza for 1928, again to raise funds for Cecil Sharp House, but this time at the Parry Theatre at the Royal College of Music in London rather than at Pledgdon Green or Little Easton Hall.

One assumes that the rehearsals took place in the barn at Pledgdon Hall Farm, the venue where the 1926 Henham Pageant was scheduled to take place should the day prove inclement. Marquis and John Barclay would have been exceptionally busy during the winter months of 1927–28 making the costumes. And here one wonders how such an impoverished gentleman found the money for the luxuriant fabrics; could it have been that those who wished to be members of the Pledgdon Players had to pay a weekly sub, or was he able to use his connections at Grossé's for remnants and off-cuts? Probably it was a

[29] H. G. Wells rented a cottage, Easton Glebe, on the Easton estate between 1910 and 1928.

[30] *Herts & Essex Observer*, Saturday 23rd July 1927, 5.

[31] Marquis d'Oisy, 'Wall Hangings of Today' in *Ideal Home*, February 1928, 84.

combination of both.

It was on Saturday 19th May 1928 that the Marquis took the Pledgdon Players, together with a reporter from the *Herts & Essex Observer*, to London, presumably by motor coach:

The Pledgdon Green Players in London.

The Pledgdon Players, from Pledgdon Green, gave two performances in London last Saturday at the Parry Theatre, lent by the Royal College of Music. The performances were very well received by the London audience. The Pledgdon Green Play, 'Peascods', formed the introduction to the performance. The players were in rainbow coloured dresses of great brilliance and danced to music played on the green fiddle of the Peascods. Walter Close (Debden) was fiddler. Jean Muir (Berden), Marjory Birch (Wenden), Elaine Cranmer-Byng (Thaxted), Edward Livings, Frank Livings, Nellie Blake (Stony Common), Hubert Wilson (Widdington) and John Barclay (Pledgdon Green) were the dancers. Edwin Benterman (Manuden) the Hobbyhorse, George Brown (Stony Common) the Dame, John Bacon (Newport) the Fool, and Marquis d'Oisy (Pledgdon Green) the Peascod. The words of the play were written by A. A. Thompson (Henham).

The next item on the programme was 'Spanish Ladies', a folk dance and song. This scene and several that followed were so striking that they were applauded by the London audience on the rise of the curtain before any action took place. The setting represented a quayside in Spain, with a brilliant blue sky, gaily dressed Spanish ladies with fans and mantillas danced with British sailors while other ladies sat in the high balcony of a house at the side of the stage. The singer was Christopher Mayson.

Next a tableaux representing as a piece of cottage pottery the song 'A Framer's Son so Sweet', sung by Helen Kennedy-North. The pottery figures were charmingly portrayed by Nellie Blake and Walter Silvester (Stony Common). This was followed by the folk dance 'Epping Forest' and the song 'The Keeper', the dancers being Marjorie Birch, Jean Muir, Elsie Turner, John Barclay, Edward Livings and Leslie Snow. The singers were Christopher Mayson and Eliadha Hafield (Dunmow). Another piece of cottage pottery, 'The Bonny Lighter Boy' was given by the same performers as the 'Farmer's Son'. 'The Sailor from the Sea', sang by Elsie Avril and Christopher Mayson, followed by a dance called 'The Boatman', in which the singers were joined by other sailors and lasses, Mary Baker (Clavering), Elise Turner and Leslie Snow (Henham) and John Barclay (Pledgdon Green). This concluded the first half of the programme.

After a short interval the ballard 'Lady Malary' was sung by Helen Kennedy-North, in a dress of cloth of gold, whilst the sad story of Lady Malary was acted in four scenes of great beauty. Jean Muir was Lady Malary, attended by Patricia Orr (Henham) and Elaine Cranmer-Byng (Thaxted). Spencer Harman (Pledgdon Green) was the page boy. The Lord was played by The Marquis d'Oisy, with Herbert Blake (Stony Common) and Jack Orr (Henham) as Noblemen, while the following took part in the funeral procession of Lady Malary, which concludes the ballad: Frank

Livings, Edwin Benterman, Leslie Snow, George Brown, Walter Silvester, Walter Close and Hubert Wilson.

'Dabbling in Dew' was sung by Elsie Avril and Christopher Mayson, followed by the folk dance 'Parson's Farewell', in which Marjory Birch, Elaine Turner, Edward Livings and John Barclay took part. The costumes of rosy pink and bottle green looked particularly well against a background of deep amber.

'A Rosebud in June' was a pastoral song of haymakers, the charming singing of Eliadha Hafield being unaccompanied. Joan Sharp played the pipe for the dance 'Maid in the Moon' which followed, Nellie Blake, Frank Livings, Walter Silvester, Violet Wickens, Elaine Cranmer-Byng and Herbert Blake being the dancers.

'Jenny Pluck Pears', a dance with a particularly fine tune, was the next item. This was fantastic, the ladies being in costumes with huge panniers and enormous wigs, and the men in gay coloured coats, powder and patches. With floods of golden light in front of a grey velvet curtain the effect was most striking. This old-world dance was accompanied on the spinet by Averal de Jersey; the dancers were Mary Baker, Jean Muir, Elise Turner, Edward Livings, John Barclay and Herbert Wilson.

This was followed by 'Green Broom', sung by Helen Kennedy-North, the story of the song being acted in once scene. Jack Orr was a splendid Old Man. Frank Livings, as the son who lay in bed till noon, did some good acting. Patricia Orr made an attractive Lady in Bloom with Nellie Blake as the pretty maid. Marjory Birch, Violet Wickens, Elaine Cranmer-Byng, Walter Close, Leslie Snow, Hubert Wilson and Walter Silvester were the dancers for 'Broom the Bonny Bonny Broom'.

The concluding scene was the famous 'Bridgewater fair'. Gaily coloured stalls and booths were set up all round the stage and together with the costumes of the performers made a scene of the most intense and brilliant colour. Christopher Mayson and George Brown made a splendid character study of the part of Master John. The Carroty Kit of John Barclay was also notable. The whole company took part in this scene, which concluded with all the rollicking fun of an Old English Fair.

The performance was arranged and produced by the Marquis d'Oisy, the proceeds being for the Cecil Sharp Memorial fund.[32]

What with the rainbow coloured dresses, the cloth-of-gold [Grossé's?] gown worn by Helen Kennedy-North and the spectacle of Bridgewater Fair, the entire performance was gay in the extreme and without doubt the star of the show was Helen Kennedy-North. One has no doubt that d'Oisy was anxious that this particular show should go well; after all, it was a London audience that he was catering for. Be that as it may, he could not resist appearing in the show himself, taking the part of Peascod in the first act, of the Lord in the 'Story of Lady Malary' after the interval, and in the finale. Marquis' friend John Barclay

[32] *Herts & Essex Observer*, Saturday 26th May 1928, 4.

appeared in three of the scenes as well as the finale and yet again the script was provided by A. A. Thompson. One wonders if, during the excitement of the day, Marquis ever let slip that he was once associated with the theatre; if he did, it was not recorded. But with this particular pageant/revue he was certainly in his element.

Much gratitude has to be given to the reporter from the *Herts & Essex Observer*, for providing such a comprehensive list of the players and the villages from which they came. The majority hailed from Pledgdon Green with others from Berden, Clavering, Debden, Dunmow, Henham, Manuden, Newport, Stony Common, Thaxted, Wenden and Widdington.

In the 1927 pageant given at Little Easton Manor, Frank and Nellie Livings of Stoney Common appeared as retainers to the Prior of Dunmow. Frank worked at Rochford's Nursery at Stansted and had known Marquis for some time, occasionally acting as his chauffer when required. In the following year Frank, Nellie and their son Edward [Ted] appeared in the London production at the Parry Theatre as dancers, though Nellie was billed under her maiden name of Blake. Marquis got on well with the Livings', so much so that in the autumn of 1928 they holidayed together at Dymchurch, Kent between Sunday 30th September and Saturday 6th October. It was to be a cycling holiday, visiting local beauty spots and with a day trip to Boulogne. Precisely where in Dymchurch they lodged was not recorded, but it may be more than just a coincidence that in 1927 Irene Rooke had purchased 'Spindles', a clapboard cottage on the shingle beach at Dymchurch, and it is not improbable that she lent it to Marquis and his friends for the week.

Mrs Livings kept a small photo album of the holiday, in which she pasted a series of photographs of Marquis on furlough. On 30th September, the day of their arrival, Marquis is shown on the beach at Dungeness wearing a serge suit [with turn-ups to the trousers and French cuffs to the jacket], an opened-necked white shirt, a v-necked pullover and a pair of deck-shoes, the outfit which he was to wear on the successive six days, and in most of the images he is also shown wearing spectacles. On the following day, Monday 1st October, the Livings' and Marquis were in Boulogne, where Marquis, now wearing polished black shoes, was photographed sitting on a low parapet with the dome of the cathedral behind him; for all of Marquis' talk of his French ancestry, this day trip to Boulogne appears to have been the only time that he visited France.

There are three images for Wednesday 3rd October: Marquis, with his bicycle, *sans* jacket and wearing his black shoes, on the way to Lympne Castle, then a snapshot of him sitting in a rowing-boat by the bank of the canal below the castle and, thirdly, an evocative image of him outside the charnel at Hythe church, holding a skull in his hands. The visit to Rye on 4th October is recorded by two photographs of Marquis atop the tower of St Mary's church and that on

5th October to Hastings shows a contended d'Oisy asleep in a deck-chair on the pier. The last day of the holiday, Saturday 6th October, is recorded by five photographs of him on the beach at Dymchurch in various moods. For a man of forty-seven he looks extremely fit and boyish – puckish almost – and could easily have passed for being ten years younger. Most noticeable, though, when studying the photographs, is that he is wearing a ring on the wedding finger of his left hand. This was the reliquary ring which Marquis claimed contained a fragment of bone of a saint which, on his death in 1959, passed to Bernard Keel, who subsequently sold it when on hard times. Not to put too fine a point on it one doubts if Marquis paid all his own way on this holiday, but the Livings' were probably well aware of Marquis' financial position and, in any case, would have considered it a privilege to entertain a Marquis. d'Oisy would have been sufficiently gracious to have allowed them to have done so.

1929 saw Marquis submitting to the twentieth century when he agreed to have a telephone installed at Pledgdon Green Cottage, being given the number Stansted 56 and a listing as: Marquis d'Oisy, Pledgdon Green, Henham.[33] What a pity he had waited so long, as it could have been a very useful tool to help his business. It was also in 1929 that Lady Warwick brought out her autobiography, *Life's Ebb and Flow*, which contained the following amongst her reminiscences of local personalities

> Nearby, the tall Marquis d'Oisy, image of a remote ancestor, the great Cardinal Richelieu, paints and decorates his furniture and composes pageants.[34]

and yet how much more she could have said of him had she wished!

The telephone, though, would have proved very useful indeed to Marquis when planning the Third Henham Pageant for 1930, which was given in the garden of Pledgdon Green Cottage. This time the Pledgdon Players were to start with 'Peascods', as performed at the Parry Theatre, London two years earlier, and then a new work entitled 'King Robert of Sicily' in two acts in which Marquis played the part of Pope Urban. Yet again A. A. Thompson was the author; indeed, one wonders when he had time to write anything else other than scripts for Marquis, especially as he was also brought in to act the Hermit in 'King Robert' and the Fool in 'Peascods' rather than John Bacon who had been given the Fool part in 1928, but he had now been "promoted" to the part of the Archbishop in 'King Robert'. John Barclay made a brief appearances as a dancer

[33] This information appears on the *Henham History* page on the internet. The telephone was eventually cut off in the 1940s after which he used the telephone in the pub owned by Reg Payne's father.

[34] Frances, Countess of Warwick, *Life's Ebb and Flow* (New York: William Morrow & Co., 1929), 339.

in 'Peascods' and as Second Ambassador in 'King Robert'. Marquis appeared in his, by now, traditional role of Peascod in 'Peascods' and also chose to be Pope Urban in 'King Robert'. The Livings', father and son, appeared again as dancers in 'Peascods'.

A number of the altar-servers at Thaxted church were drafted in to perform in 'King Robert'. Typecast in their roles were Alan Caton as Sub-Deacon; Arthur Caton [weaver] as Crucifer; and Ernie Drane [parish clerk] as Thurifer. Then there was Cedric Arnold [organ builder] as a Country Dancer. The Letchworth Morris Men also performed, with Dr Kenworthy Schofield on pipe and tabour and, as one of the dancers, Morris Sunderland, who was later to become the Fool of the National Morris Ring. The music for the entire production was arranged and conducted by Jack Putterill, Conrad Noel's curate and eventual successor as vicar of Thaxted. All in all the Thaxted contingent was well represented. The Pageant was performed on Saturday 28th June and received the usual quality of write-up in the following week's edition of the *Herts & Essex Observer*:

PLEDGDON GREEN FESTIVAL
'KING ROBERT OF SICILY' PRESENTED

Produced by the marquis d'Oisy, the play 'King Robert of Sicily' – the story of which is taken from very old manuscripts in the British Museum – was given with great success at the fifth annual Pledgdon Green Festival recently.

This medieval story, full of interest and old-time atmosphere, was preceded by the usual Peldgdon Green play entitled 'Peascods' the characters and those taking part being: The fiddler, Thomas Hayson; the dancers, John Barclay, Edward Livings, Frank Livings, Herbert Blake, Hubert Wilson, Walter Silvester, Beatrice Thomson, Margaret Wood, Winnie Cook, Verney Cook, M Golding, Elaine Cranmer-Byng; the hobby-horse, Edwin Bentern; the dame, George Brown; the fool, A A Thomson; the Peasant, the Marquis d'Oisy.

'The Apron Play' was the title of the introduction to King Robert of Sicily. The whole production is a charming one and was skilfully acted. The scenes depicted, among others, the proud King Robert attending evensong. He falls asleep and an Angel enters and assumes the King's robes and state. Robert is left alone on the locked church and is eventually released by the verger, who takes him for a thief. The Angel-king gives a banquet at which there is an entertainment of singing and dancing. Robert comes claiming to be the king and the Angel-king makes him his fool and degrades him so that he eats with the hounds. There were the processions of the courts of Sicily and Allemayne as they pass on their journey to Rome. Amid scenes of high festival the Pope greets the Angel-king and the Emperor of Allemayne. In desperation Robert again rushes in, claiming kingship. His pretensions are laughed to scorn, and he reaches the lowest depths of despair. Eventually, having learnt the lesson of humility, Robert is restored to his throne. The proud lady who rejected her true lover

because of his humble birth, is also humbled and accepts her lover.

The singing and dancing, together with such efficient acting, made the performance delightful to witness, and while reflecting credit on those taking part, bore eloquent testimony to the careful work of the producer.

The characters on 'The Apron Play' were: The hermit, A. A. Thomson; the proud lady, Nancy Gardiner; the gentlewoman, Eliadha Hadfield; and the humble lover, Geoffrey Beaumont. In 'King Robert of Sicily': King Robert, Frank Livings; the Angel King, Edward Livings; the Emperor of Allemayne, C. Rayment; Pope Urban, Marquis d'Oisy; the Emperor's Ambassador, R. C. Budge; Second Ambassador, John Barclay; the Archbishop, John Bacon; the Verger, George Brown; the King's Chaplain, H. B. Bradshaw; the train bearer, Spencer Harman; cross bearer, Arthur Caton; Acolytes, Charles Lloyd and Val Eldrid; Thurifer, Ernest Drain (sic); Deacon, Albert Barker; Sub-Deacon, Alan Caton; Royal pages, Herbert Blake, Hubert Wilson, Walter Silvester, Edwin Benterman; Angels, Beatrice Thomson and Elaine Cranmer-Byng; Ladies of the court and townspeople, Joyce Ward, Elizabeth Gold, Barbara Gold, Violet Budge, Elsie Bacon, Lillian Chapman, Vera Shearing, Mabel Little, Florence Millbank; country dancers, A. Frost, E. Heard, P. J. Coleman, H. Strickland, C. Arnold, F. Saunders, M. Wood, M. Golding, W. Cook, V. Cook, M. Linthorn, E. Ross and M. Doran; Morris dancers, Ernest Hales, Jack Hannah, M. Sunderland, C. Williams, Jack Thompson and Bob Fernée; pipe and tabor, Dr Kenworthy Schofield, of Harpenden; fiddler, Thomas Rayson, Oxford.

The words of the play are by A. A. Thomson [sic] (the well known novelist, of Broxted). Music was arranged and conducted by the Rev Jack Putterill, assisted by the Thaxted choir and orchestra.[35] The choir sang madrigals exceptionally well, tone and balance being good. The Morris dances were by the Letchworth dancers and the country dances by the Essex County team.[36]

Whether or not Marquis made new costumes for every performance, or relied on those in the Pledgdon Players' wardrobe, is not known but it would seem highly unlikely that he and John Barclay fashioned new creations for every pageant. 'Peascods', for example, was a repeat of the previous year's London event and one assumes that the costumes were merely brought out from store. Be that as it may, a good time was had by all, but the cloud of recurring debt was soon to darken the scene and Marquis was to find himself back in the bankruptcy courts to answer to the original 1921 Order.

Financial troubles apart, the 1920s were Marquis' hey-day. His gardens at Pledgdon Green, which were kept in immaculate condition, were the scene of many summer parties, a number of which featured the Letchworth Morris Men and the Thaxted Morris Men. He also hosted luncheon parties for many

[35] Kate Butters was to recall that she was one of the players in the orchestra.
[36] *Herts & Essex Observer*, Saturday 5th July 1930, 3.

fashionable individuals, most of them being guests of Lady Warwick brought over from Little Easton.Manor. One of these guests was Ellen Terry (1841–1928), who was quite elderly at the time. These lunches put a financial strain on Marquis' pocket and it was not unusual for him to rely on the edible plants and flowers – nasturtiums and violets - in his garden to augment the fare. By all accounts, Marquis was a generous man and enjoyed entertaining, which makes it all the more frustrating that his Visitors Book for Pledgdon Green Cottage was lost following the dispersal of Bernard Keel's effects.

Marquis was quite often seen cycling to Little Easton Manor to have lunch or dinner with Lady Warwick. He once told Jack Haigh how, after one of these dinners, he and Lady Warwick went around the grounds of the manor viewing the deer when Lady Warwick turned to Marquis and said, "Oh Louis, isn't life *wonderful*!" After relaying the story he turned to Jack and said with a chuckle, "I don't know what she expected of *me*!"

PART 4

PAGEANTS TO POVERTY: 1931–1940

It was on 17th November 1931 that the *London Gazette* informed its readers that Marquis had been summoned to appear at the Bankruptcy Buildings in Carey Street, London on 9th December on matters relating to the charges made ten years earlier:

> D'OISY, Amand Edouard Ambroise Marie Louis Ettienne Phillippe de Sant Andre de Tounnay [*sic*], Marquis (described in the Receiving Order as the Marquis Louis de Tounnay d'Oisy), 3 Queen's Road Studios, St John's Wood, London NW. GENTLEMAN..
> Court: HIGH COURT OF JUSTICE.
> No. of Matter: 1,072 of 1920.
> Day fixed for Hearing – Dec 9 1931. 11a.m.
> Place: Bankruptcy Buildings, Carey Street, London WC2.

The published account of the case was similar to that issued in 1921, though he had given up the Queen's Road Studios address in 1925. The 1931 version read

> 1931. Application for an Order for Discharge from Bankruptcy. The Order was made on 25th January 1921. The applicant, who had assets of £118 and debts of £1,524 is a Brazilian subject, held a French title of nobility without any territorial possessions. He was brought to this country as a child in 1886 and, in 1900, with £600 representing legacies, he began business as an artistic designer of houses and furniture. In 1917 he took Pledgdon Green Cottage for the purpose of demonstrating his works to people who required their properties restored and, in the same year, he took a farm at Broxted, Essex. The failure was attributed to losses in connection with the Essex farm and Pledgdon Green Cottage, to interest on borrowed money, and the slump in the trade which caused a decline in his designing business.

Marquis was now in his fiftieth year and should, by that age, have been at the pinnacle of his career, not back in the bankruptcy courts. However, this time the court dealt with him more leniently and, to his relief, received a discharge from the 1921 order, suspended for two months from 12th December. This could have been due to the fact that he had been able to have redeemed some of the debts in the intervening ten years; Marquis was never wealthy, but he was an honourable man and doubtless more embarrassed by his debts than trying to avoid them. On 11th February 1932 the bankruptcy was cancelled.

The whole of the 1930s, and the run-up to the Second World War, contain relatively few recorded incidents in Marquis' life. By now he was an accepted figure on the Thaxted and Little Easton scene, lunching occasionally with the elderly Lady Warwick, taking afternoon tea with Conrad Noel, fulfilling the –

now diminishing – orders from the London and Cambridge department stores and being grateful for the individual commissions from those who lived in the locality as well and his remaining friends in the theatrical fraternity. More distressing, the early 1930s saw him on the bread-line and, unable to afford the maintenance of Pledgdon Green Cottage, it started to fall into disrepair; the garden, once so beautiful, was beginning to become a burden, requiring outside help to manage. Somehow he managed to keep his spirits up and even joined the Thaxted Morris Men for a short time, dancing with them at Earls Colne in 1932.[1]

In January 1931 the Thaxted Morris Men were invited to take part in the All-England Festival of the English Folk Dance Society at the Royal Albert Hall at which event they first saw the Abbots Bromley Horn Dance. It made a great impression on them and they were determined to create their own version of the Horn Dance for that year's Whitsun Morris Ring Meeting at Thaxted. However, it was not until June 1933 that the Thaxted Morris Men first performed the Horn Dance, with real antlers mounted on wooden heads carved by Leonard Drane, red tabards from d'Oisy and embroidered 'mitres' made by Alec Hunter. A depiction of this event was used as Alec Hunter's 1936 Christmas card.[2] d'Oisy's tabards lasted until 1950 for at the June 1951 Thaxted Morris Weekend new costumes, designed by Alec Hunter and made by Margaret Hunter, were first used and continue to be used to this day.

Amongst the private commissions coming it at this time – 1933 to 1934 – was one from a Roman Catholic lady[3] who lived close to the site of the first Leiston Abbey in Suffolk for a triptych depicting Our Lady of Leiston, now to be seen beside the west wall of the south transept of Leiston church. Each of the wings shows a kneeling Premonstratensian canon and three angels with musical instruments. On the centre panel is the Blessed Virgin enthroned, with a depiction of Leiston Abbey according to d'Oisy, and the sea in the distance with contemporary sailing ships and steam ships.[4] It is a truly beautiful example of d'Oisy's work, showing great attention to detail[5].

[1] Gordon Barker owns a photograph showing Marquis in his Morris outfit with the Thaxted Men at Earls Colne. The baldric outfits were in use until 1938.

[2] The watercolour design for this card is in the Couchman/Litten Collection, King's Lynn.

[3] Gordon Barker is of the opinion that this lady was Irene Rooke.

[4] Reg Payne's, who worked for Marquis in the 1940s, was of the opinion that Marquis owned some land at Minsmere, which is not too distant from Leiston. This has yet to be confirmed.

[5] Reg Payne is of the opinion that Marquis owned a piece of land at Minsmere, Suffolk, which is close by to Leiston.

Conrad Noel also came to the rescue, asking Marquis to decorate the Becket Chapel in Thaxted church, painting the niche containing the statue of St Thomas à Becket and the carved woodwork framing the tabernacle on the chapel's altar. He also commissioned two painted coronas for the Lady Chapel, a painted corona for the statue of Our Lady and similar cresting for the chancel High Altar.[6] These would have kept Marquis busy for a few months and to help keep the wolf from the door.

Marquis was a gregarious individual and delighted in sharing his knowledge of the history of costume and painting with whomever was willing to listen. During the week of 13th to 17th January 1936 he spoke to the Elsenham Women's Institute on the subject of 'Dress through the Ages'.[7] Indeed, he was frequently booked as a speaker by various ladies organisations in the area, who treated him with great deference, thrilled to have a marquis addressing them.

Throughout the first six months of 1936 Marquis was preparing for his largest – and what was to prove his last – pageant. It was to be his greatest extravaganza, involving some six hundred performers and school-children drawn in from Pledgdon Green, Thaxted, North-East Middlesex and Hertfordshire. A great undertaking indeed, so much so that it is to be regretted that it was only performed the once. Again it was being held to raise funds for charity, this time for the King George V Jubilee Trust and the Hertfordshire Branch of the English Folk Dance and Song Society. Entitled 'Seven Centuries of Dancing' the venue was to be the tree-bordered avenue in front of the iron gates at the south side of Hatfield House, with the audience seated in a horse-shoe arrangement so as to get a full view of the proceedings. 3.00pm on Saturday 6th July was the appointed time and date for the festivities to be staged.

The script, or commentary, had been written by the stalwart A. A. Thompson, who also acted as the Narrator. Imogen Holst had been drafted to conduct the nineteen-strong orchestra and Dr Kenworthy Schofield performed on his pipe and tabor for the Letchworth Morris Men. Yet again Marquis – whom else? – was responsible for the costumes, but this time he had prudently delegated some of the tasks of the day to a Wardrobe Mistress, Miss E Fram.

Certain individuals – such as the Marchioness of Salisbury, Lord and Lady Brocket and Sir Francis and Lady Fremantle – had taken tickets but were not, disappointingly, in the audience, though by purchase of tickets had given the event their tacit approval. Fortunately the President of the English Folk Dance

6 All of these items, except the High Altar cresting, remain [2015] in situ. The sections of the High Altar cresting was [1996] kept in a chest in the church but has since disappeared.

7 *Herts & Essex Observer*, Saturday 18th January 1936, 5.

Society [the Dowager Lady Ampthill], together with the wife of the Director of Cecil Sharp House [Mrs Douglas Kennedy] as well as Ralph Vaughan Williams were in attendance. Lady Warwick was not there but, at 75 years of age, had probably excused herself. Running through the list of characters, one would presume that Marquis took the part of King Charles II. The reporter from the *Herts & Essex Observer* was ecstatic in his review of the occasion:

A LIGHT-HEARTED PAGEANT.
Songs and Dances of the Past Performed at Hatfield.
600 FOLK DANCERS IN COLOURFUL SCENES

History has both its gloomy and its gay sides. History books tell of torture, wars and prison cells, but they also tell of a light-heartedness, a gaiety, a colourfulness of which, in the duller world of to-day, we can surely never tire of hearing.

Only the gay, lighthearted side of the past was recalled when the Herts Branch of the English Folk Dance and Song Society held their great pageant, 'Seven Centuries of Dancing', in the grounds of Hatfield house, on Saturday afternoon. All through the centuries people have danced and sung as well as fought and quarrelled, and it was their dancing and their singing, it was the people of old England in holiday mood and in bright costume, that the Pageant recalled.

In a gay tripping step which was taken through the centuries – folk dancing was shown as the pleasure of the people – folk dancing was revealed in its heyday, in its decline and in its happy revival at the present time.

No more appropriate setting could have been found for such a colourful and light-hearted pageant than Hatfield House, which was lent for the occasion by the Marquis and Marchioness of Salisbury, for between Hatfield House and the spirit of pageantry there has always been a happy connection.

The brilliant episodes of the Pageant, in which many figures well known in history, including the Cardinal de Luxembourg, Queen Elizabeth and Charles II, were brought back to life, must have been identical with scenes that have taken place there in days gone by.

A Sense of Continuity
It was in the tree-bordered avenue in front of the iron gates at the South side of Hatfield House that the Pageant was staged. In this beautiful setting the large crowds of onlookers were seated in a horseshoe formation – a good arrangement, as it enabled all to get an excellent view of the proceedings.

Not only the dancing, which took place directly in front of them, but also the characters for the next episode becoming visible in the distance and passing along in front of the walls of the house presented a delightful spectacle. There were no breaks between the different episodes and this served to bring about among those watching them a strong sense of the continuity of the past.

As many as 600 performers took part in the Pageant, and although the majority of them came from Hertfordshire, there were dancers from North-East Middlesex, Enfield, Greensleeves (London) and Thaxted among them. Outstanding features in the performances were the picturesque Elizabethan scenes which showed Queen Elizabeth in regal splendour visiting Hatfield, the home of her childhood, and a delightful glimpse into the Victorian era when many couples went whirling round the arena in a merry polka.

The costumes worn in each of the different episodes ere true to their period and were designed by the Marquis d'Oisy, the producer of the Pageant. The words were written and spoken by Mr A A Thomson and music was provided by an orchestra under the direction of Miss Imogen Holst. Dr Kenworthy Schofield and others played on the pipe and tabor.

Purely Symbolical

As the clock at Hatfield House struck three, the crowds assembled on the greensward saw a gay little procession winding its way along in front of the house and as it approached, two gilded heralds flung open the great iron gates to let it pass through. As an introduction to the Pageant, these gaily-clad folk performed in the centre of the arena a charming little play representative of the 14th century – 'The Pledgdon Green Play'. Purely symbolical and decorative, this represented in the person of the Grand Peascod the spirit of Folk Dancing, who, so we were told, lives only whilst the true spirit of mirth and gaiety, the Merrie England of olden times, is preserved.

As the dancers grew listless and bored on Saturday, we watched the Great Peascod wither on his stalk, and saw him revived only with great difficulty after the great Book of Joy had been consulted. The dancers, having learnt the terrible result of dullness, then proceeded with great vigour and a real spirit of joy pervaded the remainder of the performance, carrying all before it.

Then on to re-live history! The next episode carried us on to the fifteenth century, when we saw the Cardinal de Luxembourg in residence at his palace at Hatfield watching Morris men and greeting the folk upon a holiday. A wonderful sight was presented, as the Cardinal, followed by a stately retinue, was a dignified figure in robes of scarlet and white and the dresses of the holidaymakers seemed to be of every colour under the sun. Pleasure was greatly added to when a team of men in scarlet came running out to greet the cardinal and performed in front of him, to music played on a pipe and tabor, the intricate steps of some Morris dancers, their red handkerchiefs fluttering in the breeze as they did so.

The Elizabethan Era

Fifteenth century then gave way to sixteenth and back to Hatfield, the home of her childhood and of her retirement came red-headed Queen Elizabeth. She brought with her all the picturesque ness and graciousness of her era.

As she was borne into the arena on her sedan chair, the Queen was greeted by cheering and cries of welcome from a great company of her

subjects, both young and old. She graciously stayed to watch them and there were scenes of rare beauty as little children from the schools at Redbourn, Cromer-road, Barnet and St Audrey's, Jatfield, played a singing game and danced the 'Sellenger's Round' before her and all the company joined in the charming 'Newcastle'. The Queen appeared delighted when her favourite dance, the stately 'Dargabon', was performed and a party of madrigal singers stepped forward to play their part in her entertainment. The costumes in this episode, which were chiefly carried out in black and gold, were particularly effective.

Then as Queen Elizabeth and her subjects stepped to one side, Charles II and some of his ladies, including the witty Nell Gwynne, appeared out of the mists of time. For King Charles' pleasure was danced 'Hey Boys!' (which as Pepys tells us, was his favourite dance), the Rapper Sword dance (Barsdon) and a Morris dance.

The powdered and bewigged ladies and gentlemen of the eighteenth century came next upon the scene, the ladies arriving in their sedan chairs,[8] the gentlemen gallantly helping them to alight. The formal grace of their period was displayed in a characteristic dance, 'Oranges and Lemons', before they stepped back to join the merry throng from the earlier periods.

Side Whiskers

The next episode, entitled 'Side Whiskers', was one of the highlights of the Pageant and, to quote the programme, was intended to show that 'among the antimacassars and the aspidistras, even the Victorians had their light moments'. As the merry strains of 'See me dance the Polka' were struck up, a much-be-whiskered gentleman took the centre of the arena and sang the words. In a few minutes he was joined by his partner and they went whirling round in a merry polka, other ladies and gentlemen of their period followed suit.

Not until they were nearly exhausted was the curtain pulled down on the nineteenth century and up on the twentieth. 'Here we go Round', the episode which represented the present day, showed folk dancing holding its own again with dancers performing the 'Morpeth Rant', and Morris dancers given by a team of men.

A riot of dancing and colours was the final episode 'Whirligig', when ladies and gentleman of every period stepped forward and in one great company, danced their own dances on the greensward. The Circassian Circle, Peascods, Morris dances, the polka (danced to the strains of a barrel-organ) were included in this great medley of dances of every age.

So, on a riotously happy note the Pageant ended.

Accepted Invitations

Among those who accepted invitations to be present at the Pageant were the Rt Hon Margaret Bondfield, the Dowager Lady Ampthill (President of the English Folk Dance Society), Sir Augustus and Lady Daniel, Mr

8 The *Herts & Essex Observer* subsequently published a photograph depicting a Miss C. James as a court lady of the eighteenth century being carried in a sedan chair, its sides having been painted by Marquis.

Geoffrey Shaw, Mr A. H. Fox-Strangways, Dr Vaughan Williams, Sir Arthur and Lady Somerville, Dr and Mrs Kennedy Scott and Mrs Douglas Kennedy (wife of the Director of Cecil Sharp House).

Those who took tickets included the Marchioness of Salisbury, Mrs Furse (President of the Herts Branch of the Folk Dance Society), Lord and Lady Brocket, Col and Mrs Edgcumbe, Sir Francis and Lady Fremantle, Mr R. T. Kent, Mr and Mrs W. Graveson, Mrs Charrington, the Hon Mrs Fordham, Mr Arthur Du Cane, Miss Welsford, Mrs Jansen and Miss Pam.

The orchestra was composed of the following instrumentalists: Pianist, Mrs Sweeting; violins, Mr Ganiford, Miss Manly, Miss Butler, Mrs Ogden, Mrs Gregory, Miss French and Miss Goodman; viola, Miss Davies; 'cellos, Miss Forbes, Miss Burton and Mr Goodchild; bass, Miss D. Callard; flutes, Mrs Wilson and Mr V. Callard; clarinets, Mr Ridley and Mr Sturt; oboes, Dr Long and Mr Matthews. The madrigal singers were under the leadership of Dr Tom Goodey. Miss E. Fram was the Wardrobe Mistress, the Hon Secretary of the Pageant was Miss Ogden and the Hon Assistant Secretary, Miss L. M. Du Cane. The enquiry office was in the charge of Miss E. Busby (Hon Treasurer of the Branch).

Following the Pageant, there was a country dance party on the lawns, in which visitors were invited to join. The proceeds of the pageant are for the King George V Jubilee Trust and Hertfordshire Branch of the English Folk Dance and Song Society.[9]

The national situation at the end of the 1930s, with the threat of another major war brewing, put paid to the possibility of a pageant in 1937. These must have been worrying time for Marquis, not that he was concerned by the prospect of a temporary suspension of his annual festivities – though, of course, that would have been a great disappointment to him – rather than with a possible down-turn in commissions from the London stores. Fortunately, things were not as bad as he might have predicted.

The 1930s closed on a sad note with the death of Lady Warwick on 26th July 1938. Marquis had remained friends with her for more than twenty years, making visits to Little Easton Manor for lunch or dinner and looking after the house and the dogs when she was away. They must have made an odd couple, the elderly dowager and the tall young Marquis, and yet they found a friendship which satisfied them both. By the late 1930s she was far from being the gossip of her early days. After having married Francis Greville, Lord Brooke (later 5th Earl of Warwick) in 1881, she had a succession of lovers, including Albert Edward, Prince of Wales and the millionaire bachelor Joseph Laycock. She had a distinct habit of divulging to others when she was involved with a man of wealth and power which, among other indiscretions, earned her the nickname of 'The Babbling Brooke'.

[9] *Herts & Essex Observer*, 16th July 1936, 4.

Six weeks later Marquis' putative cousin, Prince Alfonso of Spain (b. 1907) died. His was a sad end. Having crashed his car into a telephone booth in America on 1st September 1938 he appeared to have suffered only minor injuries, but his haemophilia led to fatal internal bleeding and he died five days later on 6th September.[10]

The war effort took its toll on Marquis and in 1939 he had to surrender the eight acres associated with Pledgdon Green Cottage to a local farmer for the duration. Doubtless it would have pained him to see his much-loved meadows ploughed-up for potatoes and peas, but he would have been the first to have said that it was food that was needed to feed a hungry nation, not meadow flowers, even though he was partial to the occasional nasturtium and violet.

[10] M Dennison, *The Last Princess: the Devoted Life of Queen Victoria's Youngest Daughter* (London: Weidenfield & Nicolson, 2007).

PART 5

THE WARS YEARS AND ITS AFTERMATH: 1941–1950

The years 1941 to 1950 are well documented solely because of the reminiscences of individuals who knew Marquis towards the end of his life and at the beginning of theirs.

The first of these reminiscences comes from Reginald ('Reg') Payne (b. 1927) who worked for Marquis between 1942 and 1944. The second memoir emanates from Robert ('Bob') Smith (b. 1925) of Pledgdon Hall Farm who knew Marquis throughout the Second World War. The third is from Jack Haigh, who became acquainted with Marquis at the latter end of the Second World War, fourth are notes penned by John Hunter (1932–2005) in 1990 who met Marquis in 1945, and the last are the memoirs of Gordon Barker (b. 1933), who frequently chauffered Marquis after the Second World War and subsequently kept a weather-eye on his well-being. Kate Butters (1899–2003),[1] who had performed in the 1930 Pledgdon Players pageant 'King Robert of Sicily', compiled her notes on Marquis on 26th April 1986.

As Marquis aged, so too did his friends. Lady Warwick had died in 1938 and Conrad Noel in 1942, Marquis is mentioned as being amongst the mourners present at Noel's funeral, his name appearing after those of Lord and Lady Noel Buxton and the Hon Mrs Maynard Greville.[2] Thus saw the deaths of two individuals whom Marquis considered to have been his closest friends and, incidentally, who might well have known his true identity.

At about the time of Conrad Noel's funeral the fifteen-year old Reginald [Reg] Payne came to work for him. Reg had known Marquis all his life and his father, the local publican who also ran the village shop, had been responsible for signing his alien papers in 1917 and 1918. When he first started work Reg had a job in Stanstead at 5s. [25p.] a week, which he soon left when Marquis offered him the princely wage of £1. He recalled Marquis as being 6ft 5in tall, taking size 13 shoes, and "the most fairest[3] man I've ever met in my life." Reg rarely saw him angry, but there was one incident when gypsies established camp at the entrance to his garden and lit a fire for their evening stew. Marquis stormed out of the cottage, discharged the contents of the cooking pot onto the fire, loosened the horses and made the gypsies move on.

[1] Kate was a local girl, having been born at Elsenham, where her father was railway station master.

[2] *Saffron Walden Weekly News*, 31st July 1942, 9. It is to be regretted that Marquis does not appear in Conral Noel's *Autobiography*, a posthumous publication edited by Sidney Dark (London: J. M. Dent & Sons Ltd., 1945).

[3] i.e. lenient.

The work that Reg had to do was mainly sanding-down and preparing the furniture in Marquis' workshop[4] as well as assisting him with painting pub signs for Rayment's Brewery, the signs themselves having been made by the brewery's cooper, George Felton. There was also one occasion in 1942 or 1943 when Marquis and Reg went down to Drayton Beauchamp, Buckinghamshire for a few days to lay a patio at the home of the actress Ann Trevor (1899–1970)[5] and, whilst they were there, they motored over to Chesham to call on Irene Rooke and Milton Rosmer. There was also a trip when they went to London to decorate a new grand piano, Reg furiously sandpapering the varnish in readiness for Marquis' brush.

Reg recalled that Marquis was not totally vegetarian, happy to get a chicken whenever he could, but he was tee-total, did not smoke and never swore or used bad language. As for his day-to-day dress, Marquis would wear a heavy, thick linen shirt, a pair of shorts and sandals, but no socks. This was his daily outfit – unless he was going to see a client – spring, summer, autumn and winter. He was even seen out and about so attired during the heavy snows of 1947. More often than not addressed as "sir" by those who lived in the village, Reg managed to get away with calling him "Marq". Small-talk within the workshop was limited but Marquis would sometimes mention his past, telling Reg that his father was a viscount, his mother a countess and that he inherited his title from his grandmother. Marquis said that he had been born in Rio de Janeiro on 21st June 1880 and had been brought to England by his mother in 1888, settling at Bath. His father decided to travel over separately in 1896, but was lost at sea; it was then, according to Marquis, that he inherited his money. He also spoke of a time when he had an apartment in London but gave it away to his butler, though on another occasion he said that he had lived with his mother and household staff in a house adjacent to Regent's Park and that they had a carriage drawn by two horses, which would seem an unusual way to travel around London in the early days of the motor car.

The true character of Marquis came out when Reg talked about his own childhood:

> To me, he was always very charming. Very helpful. He was like a dad to me. My father was gassed in the First World War and he didn't seem interested in me a lot until the [Second World] War came along and he then sprung to life. He was 2nd Lieutenant in the Home Guard – ran that – village pub, village shop, everybody came to him for advice, except me. There was a distance between us. I didn't like to go to him, in case I got

[4] This was adjacent to the cottage at Pledgdon. In the early days Marquis employed two men and had a large workshop in the garden, but this was destroyed by fire in c.1940.

[5] Her real maiden name was Trilnick and she married a man called Garland.

snapped-up. So he [Marquis] would tell me, straight away. A sympathetic ear. The most endearing thing, I think.

It also appears that from the 1920s Marquis had a motor, usually an Austin, buying a new one every year and selling it just before the year was out so as to get a good return on it, but after a bad accident in 1947 – he was known to be a terrible driver – he got others to drive for him.[6] The last car that he had was a Morris 14, purchased in c.1943. It was serviced by Jack Haigh but by 1949/50 it had reached the end of its life and so was towed to Haigh's farm where it sat for many years before being sold to a scrap dealer for a few pounds. Having got rid of the Morris 14, Marquis used hired cars or his bicycle and, on the rare occasion, public transport.

It was during the war years that the commissions from the London stores began to fall off and Marquis was reduced to making fruit boxes for a farm at Barnston and to tarring and painting the barns at Pledgdon Hall Farm for Albert [Bert] Smith. Bert's son, Robert [Bob] recalled those days, saying how, in addition to painting some bedroom furniture for his mother, Marquis

> ... had this artistic air, which would give him the ability to do things. It was
> always strange to me that he came down to the farm in the War to paint
> the buildings, a man with his ability, so he went through a very rough time.

Marquis was indeed going through a rough time. The orders from the London stores had almost dried up and even for the small amount he was doing the transport of the furniture to London was, owing to petrol rationing, getting more difficult. Added to that, most of his friends in the theatrical profession were also feeling the pinch and in any case were at a time in their lives when they no longer needed anything new for their homes. But, if he stayed at Pledgdon, limited his travel, spent more time on his garden and kept to growing as much of his food as possible, then it would just be possible that he could eke out a living for the duration, taking up the occasional jobs, such as painting and tarring the Pledgdon Hall Farm barns, whenever they arose. As for his decorative furniture that was now being considered as passé, but he was now too old a dog to learn new tricks. Even the luncheon parties had petered out[7], and few came up from London to see him owing to the general restrictions on travel.

By all accounts the gardens at Pledgdon Green Cottage were quite spectacular, especially the rose garden and its pergola, a photograph of which

6 Amongst his various chauffeurs were Walter Andrews, Gilbert Bardle, Gordon Barker and George Hoy of Widdington. Gordon Barker's father, who first drove for Marquis, owned a garage and car hire service at Elsenham, Essex.

7 Guests invited to Pledgdon Green Cottage at this time were Florence Desmond and Dodie Smith, the latter living at Great Bardfield, Essex at the time.

was taken by Imogen Holst on 10th July 1926 and is now in the Britten Pears Foundation Archive at Aldeburgh.[8] In 1944 Marquis fenced off a small section of the garden in which to keep chickens and he also decided to create a Herb Garden, drafting in Reg Payne and Bernard [Bernie] Keel (1904–1973) to do the manual work. Keel – a non-smoker who lived at nearby Smith's Cottage, Smith Green, Takeley[9] – began his association with Marquis doing odd jobs around Pledgdon Green Cottage, but as Marquis' income began to diminish Keel took a took a job for three days a week gardening at Hill Pasture, Broxted for the artist Humphrey Waterfield (1908–1971).[10] Be that as it may, Keel was to end up as Marquis' stalwart friend and prop. Reg Payne recalled:

> The day we did the Herb Garden he [Marquis] has a plinth made to put a sun-dial on. I was working on the hedge and I said "Look out!" The wind came, took this massive structure, which was a dovecote, crashed it on the floor. It nearly killed him, it did. The Dunmow blacksmith[11] had made it. Inch and a half by about half-inch thick steel, and about a foot square. The centre pillar, it had all rotted. You should see it go! Anyway, we finished this thing late at night, well late for me, as I used to knock-off at five, but time didn't matter to me, much. I stayed on I suppose until half-past six in the summer. "You know what it wants?" he [Marquis] said. "What?" said I. "Thyme," he said, "It wants to be planted with thyme, and I know where there's some." And I said "Where?" and he said "Newmarket Heath. Will you pump up the tyres on my bike?" So he went in and changed, and he cycled all the way to the Heath, and in the morning he got a haversack full of thyme. These are the sort of things that I admire. It's a long stretch from there to Newmarket Heath.

John Hunter (1932–2005), the son of Alec Hunter of Thaxted, was thirteen when he first met Marquis. Precisely what occasioned this meeting Hunter does not say, though it would seem likely that they met in Thaxted church in the summer of 1944 when Marquis was decorating the wooden eagle lectern for the Rev'd Jack Putterill, who had succeeded his father-on-law, Conrad Noel, as vicar in 1942. Hunter paid his first visit to Pledgdon Green Cottage in 1945 and would subsequently cycle from Thaxted to Pledgdon Green when he was home from school to visit Marquis to chat with him about medieval buildings and gardens; at the time of his 1945 visit the Herb Garden with its vine trellises and scented

[8] Accession number HO/2/6/1. Inscribed in Imogen's hand: "The garden in the cottage belonging to the Marquis d'Oisy."

[9] He later moved, after Marquis' death, to Cook's Hill, Takeley.

[10] Waterfield had purchased a five-acre meadow at Broxted in 1935 which he converted into a spectacular garden, Hill Pasture, subsequently commissioning Gerald Flower, a pupil of the architect Erno Goldfinger, to design Ashgrove House to complete the project.

[11] Mortimer of Dunmow.

plants was in its element. The interior of the Cottage made a great impression on the young Hunter:

> Inside was huge open fire [then unusual] with spit, wooden trenchers, pewter mugs and horn-handled knives and forks.[12]

Hunter, who had a profound interest in all aspects of architecture and genealogy at the time, recalls how Marquis once showed him a family tree in which his cadet branch of the d'Oisy family inherited the old title when those in line perished on the crossing to Brazil, fleeing the Revolution and the guillotine[13].

Jack Haigh (b. 1927) and his brother Ronald first got to know Marquis towards the end of the war when they delivered firewood to Pledgdon Green Cottage. However picturesque Pledgdon Green Cottage might have appeared to the young John Hunter it was, by 1947, in a somewhat dishevelled condition, having received hardly any attention since Gordon Barker's father had repaired the roof in the 1920s. Consequently a decision had to be taken to either restore the building – which Marquis could not afford – or to provide alternative accommodation. In the end it was suggested by Ronald Haigh that he might be able to get hold of a redundant army hut and re-erect it in the Cottage garden to serve as both living accommodation and a studio workshop. Marquis agreed to this and it was delivered by four Italian prisoners of war, who were working for the Haighs' father at that time, and erected by Ernie Jaggard, Reg Payne and John Rattee on the site of a small barn that had burnt down some years before.[14] Marquis was so strapped for cash that he paid for the hut by giving the Haigh brothers various items of painted furniture. When John Hunter revisited Marquis in the 1950s, he recalled him as being "still kindly and courteous", but "now lived in a large shed with his manservant Bernard [Keel] and his dogs." To Hunter, Marquis had the better qualities of the *Ancien Regime*: old fashioned good manners, culture and optimism. Two years prior to this visit the government returned to Marquis the land commandeered in 1939. Jack Haigh recalls how he had then entered into an agreement with Marquis to farm the eight acres and was surprised to find out after Marquis' death in 1959 that he did not, in fact, own the land.

It was in 1945 that the architect, Stephen Dykes-Bower (1903–1994), was working on the small church of St Mary the Virgin at Tilty, Essex, generally

[12] After the demolition of the Cottage these items went to Bob Smith and are still [2013] at Pledgdon Hall Farm.

[13] It was my privilege to have know John Hunter between 1974 and 2004 and we often spoke of Marquis.

[14] Due to an incident with a Tilley-lamp. This was the barn where the furniture was stored and painted.

restoring its fabric, re-assembing the fragments of the medieval font and installing a new pulpit in the seventeenth-century style. Dykes-Bower, who lived at Quendon Place in the small village of Quendon, adjacent to Saffron Walden, may have known of Marquis through John Barclay, who ran the village pub.[15] Thus it was that Dykes-Bower asked d'Oisy to paint the faux Jacobean font-cover and the underside of the pulpit's tester. It is interesting to see that the palette selected by d'Oisy for the font-cover is exactly that as used in the previous year for the lectern at Thaxted.

It was also in 1945 that Marquis came to the attention of Captain H. Neville Lake DSO RN (1893–1979)[16] of Furneux Pelham, the managing director of Rayment's Brewery.[17] This meeting was brought about by George Langham-Service, one of the area managers of the brewery,[18] who had been introduced to Marquis by Imogen Holst. By then business was bad for Marquis and he had been reduced to making fruit boxes and tarring barns to eke out a living. Fortunately, Capt Lake was at that time looking for an artist to paint some inn signs for some of the thirty-five public houses owned by the brewery. Suffice to say, Capt Lake and Marquis got on well and Marquis was given the job, painting most of the signs in a small barn opposite the parish church at Furneux Pelham and at George Felton's cooperage at Rayment's Brewery. John Langham-Service, George's son, recalls how as a child he watched Felton and Marquis "outside a barn, opposite the parish church, working on a pub sign in the style of a mid-nineteenth century German painting."[19]

Meanwhile, at Thaxted, the condition of the bells in the church tower was vexing the vicar, the Rev'd Jack Putterill. A report solicited from Michael Howard of the bell-founders Gillett & Johnstone in 1948 revealed that three of the bells were cracked and would have to be recast with the remainder requiring new steel headstocks, ball-bearings and clappers.[20] The cost was to be about

[15] I knew Dykes Bower for the last twenty-eight years of his life and regret not having discussed Marquis with him.

[16] Capt Neville Lake DSO RN and Mrs Florence Lake. Capt Lake was a distinguished naval officer in WWI and WWII. He came from one of the original Suffolk families that founded Greene King Brewery, and became managing director of Rayments Brewery, Furneux Pelham. His wife, Florence (née Hawkins), was the daughter of the Head of Customs in China.

[17] Rayment's Brewery was established at Furneux Pelham in 1860. The business was sold to Greene King in 1928 and closed in 1987 when the brewery buildings were converted to private dwellings.

[18] George Langham-Service met Capt Lake whilst serving in the Royal Navy. They both left the service in 1934 and Mr Langham-Service joined Capt Lake as Rayment's free-trade representative.

[19] Letter, John Langham-Service to Julian Litten, 17th January 2011.

[20] J. Putterill, *Thaxted Quest for Social Justice* (Marlow: Precision Press, 1977), 86–9.

£1,000 and so a grand Town Procession was organised to raise the funds. A colourful Maypole was made and the children of the Catechism were taught the Maypole Dance. Putterill's wife, Barbara, led off the procession by carrying the Maypole, on top of which was a large bunch of flowers. The Morris Men and the Country Dancers joined in the procession, followed by the townsfolk, led by Marquis.

Marquis got on well with George Langham-Service and his wife, Alice, though she was of the opinion that whilst d'Oisy was a kind man, "he was probably not that which it seemed".[21] It also appears that Marquis once told Mrs Langham-Service that he had once briefly appeared on stage under the name of Louis d'Oisy.[22] Over the next two or three years Marquis painted a number of items for Mr and Mrs Langham-Service, including a dressing table and stool, a triptych icon of the Sacred Heart and, as their gift to Furneux Pelham Roman Catholic Chapel, a painted statue of the Virgin & Child and a pair of wooden candlesticks for it was in about 1947 that George Langham-Service had converted to Roman Catholicism, followed by Mrs Lake in 1949 and Capt Lake in 1950.

The Roman Catholic parish covering Furneux Pelham was Old Hall Green with a church at Puckeridge, thus travel to Mass on Sundays was a difficult cross-country journey. The parish priest, Fr Lynam, would not countenance a mass centre so allegiances were transferred to the Redemptorists at St Joseph's, Bishops Stortford. Unfortunately, the people from Furneux Pelham were not made welcome and an *impasse* was reached. Capt Lake appealed to Westminster, but they upheld Fr Lynham's objections. Eventually Cardinal Bernard Griffin was persuaded by the Papal Nuncio to allow a chapel to be constructed if priest coverage was available from Allen Hall at St Edmund's College, Old Hall Green, Ware, Hertfordshire.

Fortunately there was no need to build a new chapel for in 1950 Capt Lake donated a sixteenth-century Grade II listed barn at Furneux Pelham for the purpose, being part of Tinkers Hill Farm and farmyard complex owned by Rayment's Brewery. The farm itself was sold at the same time to Iris Hughes of Pelham Hall, who was sympathetic to the cause, thus the farmhouse with its stables and barn were ceded to the Lakes. For many years a priest was ferried by Mr Langham-Service to and from the rustic chapel at Furneux Pelham until transport was eventually provided by Allen Hall itself. All that was now needed was an artist and designer to convert the barn into a chapel, and whom better

[21] Comment from Mrs Gillian Drew, daughter of George Langham-Service, 29th November 2010.
[22] Information from John Langham-Service, George Langham-Service's son, 17th December 2010.

for Capt Lake to approach than Marquis? Marquis was now seventy years old, but the little Chapel of the Annunciation at Furneux Pelham, with accommodation for thirty-eight worshippers, was a contract which turned into a labour of love, occupying Marquis' remaining years and becoming his *chef d'œuvre*. Precisely how many of the current d'Oisy fixtures and fittings – the majority of which were financed by Capt Lake – were *in situ* for the blessing of the Chapel in February 1950 is difficult to ascertain, but from the vast amount that survives it would appear that Marquis was adding items almost up to the time of his death in 1959.

The ground floor of the Chapel, entered via a tarred door with appliqué panels of late-seventeenth-century figurative decoration,[23] contains a vestibule and a Lady Chapel. d'Oisy's work abounds. In the vestibule is a reclaimed continental eighteenth-century carved wooden panel crowned by a pair of flamboyant putti and, in a grey-painted chest of drawers [d'Oisy], an elaborate book-cover of red velvet decorated with gilt-headed upholstery pins and a d'Oisy triptych of the Virgin & Child, the latter awaiting conservation.

Immediately beyond the vestibule is the Lady Chapel, illuminated by a two-light arcaded window to the south and borrowing light from the north by the installation of a large late-eighteenth-century continental filigree panel of arabesques. The Lady Chapel, which has star-spangled plaster lierne vaulting, is entered via a two-bay western arcade with decorative soffits and contains a painted plaster statue of the Virgin & Child within a painted niche, flanked by a pair of wooden candlesticks painted blue and silver.[24] On the floor in front of the niche are four mid-nineteenth-century wooden continental candlesticks, decorated by d'Oisy in red and gold, and a missal stand which probably once lived on the altar in the main Chapel above. Steps lead up from the west end of the Lady Chapel to the Chapel of the Annunciation.

The Chapel of the Annunciation has the appearance of a Bedouin tent, a feat achieved by a huge hanging in red on a cream ground, said to have been found by Mrs Lake in a junk shop in Elsenham, at which time it was sold as having been part of an Egyptian market stall. The pair of gilt-brass candle-sconces on the north wall are fabricated from two grip-plates of marquisate coffin furniture incorporating candle-brackets from an old chandelier, a typical product of d'Oisy's fertile creativity.

Everywhere one looks can be seen Marquis' work, from the small statue brackets to the large icon of Our Lady with its elaborate decorative casing, the painted statue of the Virgin & Child and the rood beam behind the altar. But by far the star of the show, *a la* the Leiston triptych of the 1930s, is a beautiful little

[23] Presumably provided by Marquis.
[24] Presumably the ensemble commissioned by Mrs Langham-Service.

painting of Our Lady of the Annunciation with, at her feet, miniature depictions of the three medieval churches in the immediate vicinity of Furneux Pelham.

Leading off from the Chapel is a small vestry, with simple furniture painted by d'Oisy. The vestment chest contains five complete sets of silk Low Mass vestments[25] in the Latin style. They are beautifully made, with matching woven braids, and though now more than sixty years old are as pristine as when first made, fully illustrating the quality of workmanship that Marquis learnt during his time with Louis Grossé. Indeed, these vestments mark the culmination of Marquis' career and one can imagine the love that went into their making, for here was a departure from the world of pageants, creating real vestments for actual use in the Mass, and one wonders if, as he was making them, his mind ever wandered back to his early years at Erdington and Caldey and the hopes that he once had for the religious life.[26]

[25] Each comprising chasuble, stole, maniple, burse and chalice veil.
[26] Its congregation having dwindled, the Chapel of the Annunciation, Ferneux Pelham, closed on 31st July 2013.

PART 6

DECLINE AND DEATH: 1951–1959

The Festival of Britain planned for 1951, being the centenary of the Great Exhibition of 1851, was celebrated throughout England. Thaxted had taken the decision in 1950 that their contribution would be a pageant and a dance display in front of the Guildhall. John Hunter recalled how Marquis had visions of planning an illuminated flotilla for the River Thames, but with the financial straits of the post-war years there would have been no reception for an event of that magnitude. Instead Marquis had to content himself with the role of Castleton King, dressed in velvet and with a tricorne hat, leading the procession in the Thaxted festivities. The event was recalled by G. I. Ginn:[1]

> Thaxted village made its contribution to Festival Year with a dance display in the Market Square ... While these were being danced the dancers and band slipped away to form up for the Winster Procession. This was led by the Marquis d'Oisy in colourful eighteenth-century costume. The procession was followed by the Winster Morris Dancers and Reel, and the party ended with Circassian Circle.

At least one photograph survives of Marquis at the festivities, showing him with a young Stanley Moss[2] on his arm, dressed in female attire and holding a lace-fringed parasol. This image – probably the last photograph to be taken of d'Oisy – was published in the local newspaper. Marquis looks at his happiest, though Stanley Moss is somewhat more apprehensive.

Marquis was seventy in 1951 and still living in his second-hand army hut in the grounds of Pledgdon Green Cottage, his income limited to his state pension for there was no new work coming in from the major departmental stores, his type of artistry being no longer required. Some of his bills were paid by giving his creditors items of painted furniture; doubtless Captain Lake was aware of Marquis' straits, which probably explains the commissions he gave him for the many artefacts at Furneux Pelham Chapel. On the publications side, there was slight fanning of the flames when, in 1952, Marquis re-wrote his 1927 *Ideal Home* article on Little Easton Manor, though this time with the title 'Spirit of the Past' and with some additional illustrations.[3]

[1] G. I. Ginn, 'Dancing in Thaxted', in *English Dance and Song*, December 1951 / January 1952, 83–4.

[2] Stanley Moss had been born and bred in Thaxted, Baptised by Conrad Noel, and subsequently a server at Thaxted church, he was one of the six coffin-bearers at Noel's funeral in 1942.

[3] Marquis d'Oisy, 'Spirit of the Past' in *Ideal Home*, 1952.

Marquis was also beginning to suffer from ill health. There was an occasion when he required treatment for his varicose veins, which had burst one day whilst he was at home. Unfortunately, he had no bathing facilities in the army hut and so had to be taken to the cottage next door to be cleaned up. According to Reg Payne, Marquis later had the varicose veins removed privately in a London clinic.[4] Gordon Barker also recalls how he would take him to hospital at Chelmsford in association with surgery he required for a double hernia and, later, for cataract treatment, but it was in 1956 that Marquis was diagnosed with cancer of the prostate. The end was near.

On 14th June 1958 the silent screen star Irene Rooke died at the age of eighty. The majority of her property, including Pledgdon Green Cottage, was left to her husband, Milton Rosmer, and it was presumably he who, aware of the ruinous state of the place and the dire financial straits that Marquis was in, gave the freehold to Marquis. Needing money badly, Marquis decided to sell Pledgdon Green Cottage and its associated acres and move in with Bernard Keel at his cottage in Smith's Green. As it was, he was desperately ill and could not be expected to continue living such a Spartan life in the old army hut. The cottage was sold for £200 to a spurious property developer from London called Geoff Allen, who had a reputation for buying-up derelict properties, re-insuring them and then setting them on fire to claim the insurance.[5] This came to the notice of Marquis who asked Robert Smith, who was at that time living at Pledgdon Green, if he would be so kind as to keep an eye on the place, saying

> Please, if the phone rings in the middle of the night, will you come out and have a look to see if I'm being burnt out?

Rather than set fire to Pledgdon Green Cottage, Geoff Allen repaired it and installed his mother there.

It was either at the end of 1958 or at the beginning of 1959 that Marquis moved to Smith's Cottage, Smith Green, Takeley. His sight was badly affected by the cataracts, he was almost blind and was dying of the prostate cancer. Had not Keel taken him in there is every possibility that Marquis would have ended his days in Chelmsford hospital. Various items from the derelict cottage were put into store, with Robert Smith providing space in one of the outhouses of his father's farm at Pledgdon Green Hall for most of the kitchen utensils. Capt Lake continued to show his concern, giving him money now and again, but it was Bernard Keel who looked after and nursed him.

[4] This was probably paid for by Capt Lake.

[5] Geoff Allen was to go to prison in 1976, serving seven years concurrently for having set fire to Shortgrove Hall, Newport, Essex in 1968 and Briggate Mill, Worsted, Norfolk in 1975.

On Thursday 10th December 1959, the night before Marquis died, Keel asked Jack Haigh if he could help in the nursing as he felt that he could not cope on his own. However, the smell from Marquis' wounds was so overpowering that Jack made his excuses, saying that he couldn't stay long as he had a young family waiting at home. Haigh was not to see Marquis again for he died in the early hours of Friday 11th December 1959 with Bernard Keel at his bedside. Later that morning Marquis' GP, Dr J. L. Tasker, issued the death certificate, giving the cause of death as "carcinomatosis and carcinoma of the prostate". Bernard Keel registered the death on the same day, giving Marquis' age as 79[6] and his occupation as "Artist (Painter)".

Marquis' body lay upstairs in the cottage, a rosary entwined around his fingers, until the morning of the funeral on Monday 14th December when the undertaker's men carried the body down the winder-staircase to coffin him on the ground floor. Reg Payne called in at the cottage at 08.00 on the day of the funeral to ask after Marquis' health only to be told by Keel that he was dead and that the funeral was to take place in two hours time, so Reg hastily cycled home and changed into his funeral attire.

Marquis used to say that he would like to be buried at Furneux Pelham, taken there on a brewer's dray. But that was not to be. The funeral mass, celebrated by Fr Kelly, was held at the Roman Catholic church of Our Lady and the Blessed Anne Line[7] at Great Dunmow, with Bernard Keel as chief mourner and about a dozen others present, including Capt and Mrs Lake, Mr and Mrs Langham-Service and Reg Payne. This was followed by interment in the churchyard at Great Dunmow, where the burial register has him erroneously recorded as "Louis Loysey". After the required time had elapsed a modest stone with kerbs was erected above the grave; the kerbs remain *in situ*, but the stone no longer survives. It was Reg Payne's opinion that the funeral, the fees and the monument were all paid for by Capt Lake.

As the *Herts & Essex Observer* only came out on Fridays the death announcement did not appear until 18th December:

> OISY – Amand Amboise Louis Marquis d'Oisy, of Pledgdon Green, Henham, passed away at the age of 79 years, at the home of Mr. B. Keel, of Henham Green, Takeley. R.I.P.[8]

[6] This is true. In fact, Marquis was 79 years, five months and twenty-one days old, based on his given birth date of 21st June 1880.

[7] When d'Oisy first knew the church in 1917 it was dedicated to Our Lady; Anne Line was added following her beatification in 1929. On her canonisation in 1970 it became "Our Lady and St Anne Line."

[8] *Herts & Essex Observer*, 18th December 1959, 10.

This was accompanied by a short obituary, presumably penned by Bernard Keel, on the front page of the same issue:

Death of Marquis d'Oisy

A well known figure in local art circles, Amand Amboise Louis, Marquis d'Oisy, of Pledgdon Green, Henham, died at the home of a friend at Smith's Green, Takeley, on Friday. The Marquis, who was 79 years of age, came to England from the French town of Oisy, with which his family had been closely associated since 1665, when he was 12 years of age. He moved to Henham during the First World War. Marquis d'Oisy, who was a batchelor [*sic*], assumed the title on the death of his grandmother in 1888. Father Kelly conducted the funeral which took place at Dunmow Roman Catholic Church on Monday.[9]

d'Oisy had little to leave, dying with but 30*s*. (£1·50p.) in his pocket. Gordon Barker acquired from Bernard Keel a pair of ormolu-mounted blue porcelain Sevres candlesticks, a horn beaker, three pewter plates as well as Marquis' copy of Gertrude Jekyll's book *Old English Household Life*. Robert Smith also acquired a few items, but it was Bernard Keel who kept what little there was to keep, though later on he sold Marquis' relic finger-ring and, on 14th June 1965, some items at Sotheby's in New Bond Street in their sale of *Objects of Vertue*:

The Property of the late Marquis d'Oisy
132 DESSERT KNIVES AND FORKS. Two pairs of Dessert Knives and Forks with prongs and blades, the handles enamelled in cloisonné techniques with scrolls in pink and white against a green ground and set with garnets, 6¾in, *possibly Hungarian*.

They sold for 30 guineas to a Mr G. Lawrence, a well-known dealer in such items and who had purchased 55 of the day's 173 lots. Subtracting the commission due to Messrs Sotheby's, and adding the 30/- in Marquis' pocket at the time of his death, his estate would have worked out at about 25 guineas (£26.25p.). This was to be the entire residue of the d'Oisy inheritance.

1 (opposite). Marquis d'Oisy at the age of 25, c.1905–06, looking quite the French aristocrat in patterned silk waistcoat and an evening suit with velvet reveres. The only item of jewellery is a ring on the second finger of his right hand, the traditional finger in France for displaying a wedding ring. He seems to have taken great pains to wear his beard and moustaches in the style of Napoleon III (1808–1873); furthermore, the posture he has adopted is based on the 1865 portrait of Napoleon III by Alexandre Cabanel in the Musée du Second Empire at Compiègne. This is the earliest known photograph of Marquis.

[9] *Herts & Essex Observer*, 18th December 1959, 1.

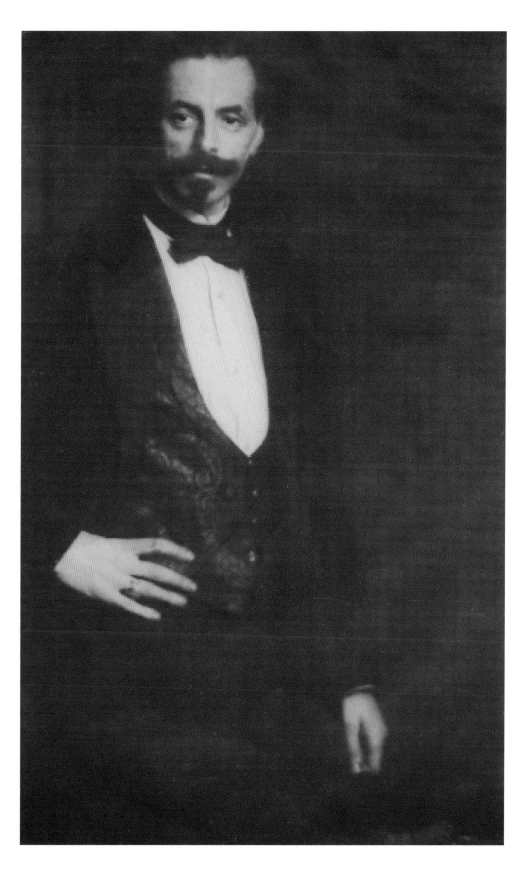

2. Irene Rooke (1878–1958). 1913. Studio portrait by Bassano. Silent screen and stage actress, Irene Rooke left school in 1896 and went directly on to the stage. Between c.1915–39 Marquis designed many of her stage outfits and it was she who offered him, rent free for life, the cottage at Pledgdon Green, Essex in 1917.

3. The Rev'd Conrad Le Despenser Roden Noel (1869–1942), at the south-west door of the Lady Chapel of the church of St John the Baptist, Our Lady and St Lawrence, Thaxted, Essex, c.1916. Marquis had met Noel in the autumn of 1906 at St Mary's, Charing Cross Road and renewed is acquaintance when he took residence at Pledgdon Green, occasionally attending services at Thaxted church and sometimes acting as an altar-server. However, as a Roman Catholic, his rightful place of worship would have been the Roman Catholic church at Great Dunmow. Noel was probably one of a handful of individuals who knew Marquis' true identity.

4. The Litany Procession. Church of St John the Baptist, Our Lady and St Lawrence, Thaxted, Essex. c.1916. Frances Noel, Conrad Noel's sister, was a talented amateur photographer and took a number of images for post-card purposes in the 1920s. Mike Goatcher has identified the figures as follows (left to right): Harold Mason, Walter White, Harry Skellern, Cliff Yeldham, *Fred Fitch*, *Billy Fitch*, George Harvey, Dick Bassett, *Arthur Caton*, Guy Hollingsworth, George Rolph and Russell Wright. This one is of particular interest, for those in italics took part, at one time or another, in Marquis' pageants.

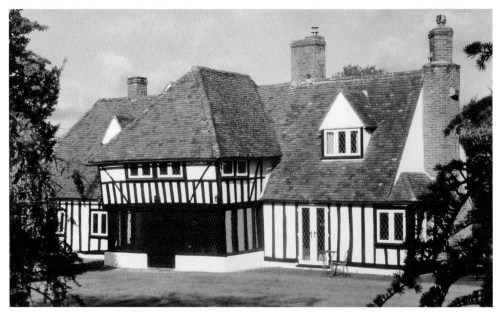

5. Marquis' cottage at Pledgdon Green in 2014. Lent rent-free to Marquis by the silent-screen actress Irene Rooke, he lived here from 1917 to 1947. He did very little with it and, by 1947, it was so derelict that he erected a second-hand army hut in the garden in which he lived until 1958. John Hunter recalls visiting the cottage in the mid-1940s. Following Marquis' sale of the property in 1958, it underwent a restoration.

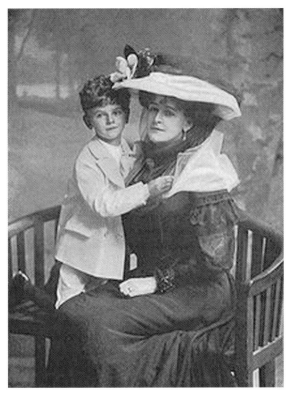

6. Daisy Maynard, Countess of Warwick (1861–1938) with her son, the Hon. Maynard Greville (1898–1960). 1906. Daisy Warwick befriended Marquis in 1917. He was a frequent visitor at Little Easton Lodge, Essex and often stayed there to look after her dogs when she was away. The wife of Lord Guy Greville Brooke (later 6th Earl of Warwick), she was a great gossip, which earned her the soubriquet of 'Babbling Brooke'.

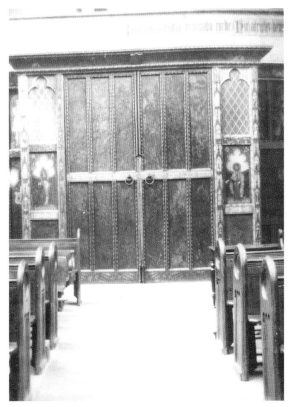

7. The west screen in the church of Our Lady of the Holy Souls, Bosworth Road, Kensal New Town, 1921. Marquis' earliest known commission – 1921 – was to paint the west screen at Our Lady of the Holy Souls, Kensal New Town with a depiction of the Last Judgement and, in the lower panels, arabesques flanked by, on the left, a mitred saint and, on the right, Our Lady of the Holy Souls. At the time of this commission, gained for him by Louis Grossé, Marquis was using the name Marquis de St André de Tournay d'Oisy.

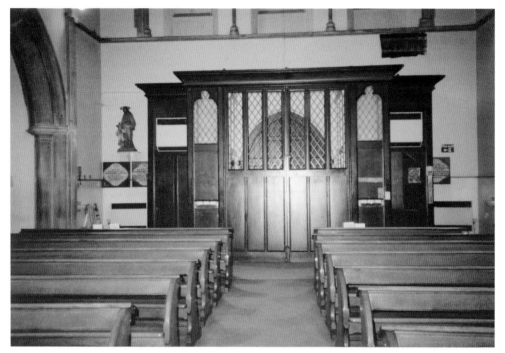

8. The west screen in the church of Our Lady of the Holy Souls, Bosworth Road, Kensal New Town, 2012. In the 1960s the decoration on the screen was painted out, but in 2010 some sample scrapes were made to ascertain how much of the original survived. Sufficient traces were found to justify a comprehensive scheme to expose it all, as and when funds are available.

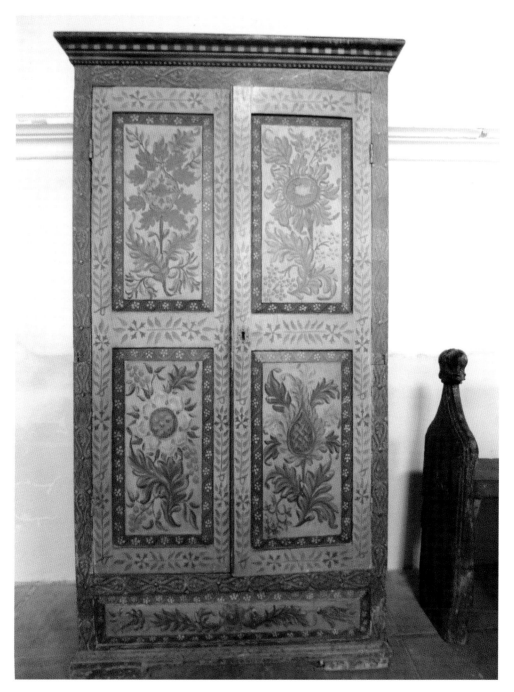

9. The Vestment Press. Church of St John the Baptist, Our Lady and St Lawrence, Thaxted, Essex. 1923–24. This elegant press, its arabesques based on those on the west screen at the church of Our Lady of the Holy Souls, Kensal New Town, was commissioned by Conrad Noel in about 1921–22. Unlike his other pieces, here Marquis was asked to decorate an existing item of furniture rather than to provide something entirely new.

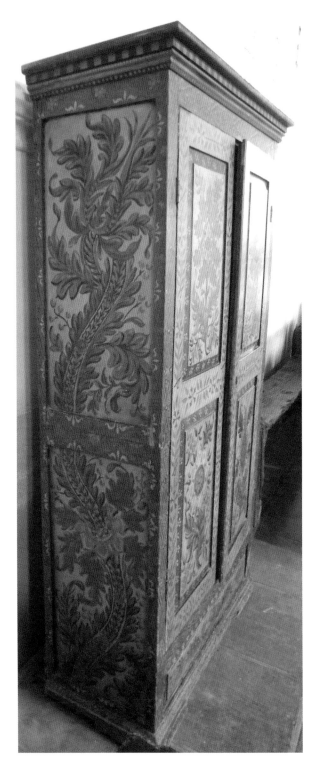
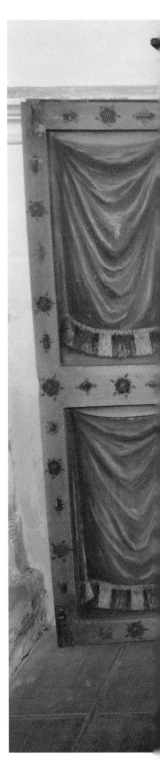

10. The Vestment Press. Church of St John the Baptist, Our Lady and St Lawrence, Thaxted, Essex. 1923–24. The side of the press, showing the arabesques, a design similar to that used by Marquis two years earlier for the lower panels of the Kensal New Town screen.

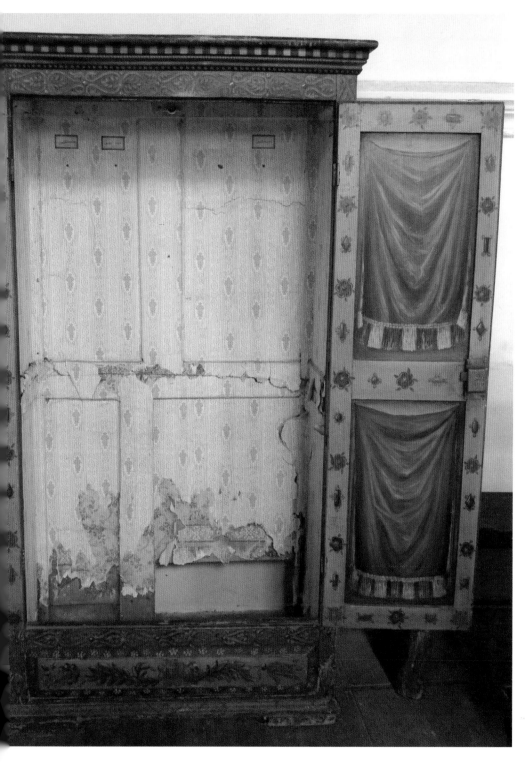

11. The Vestment Press. Church of St John the Baptist, Our Lady and St Lawrence, Thaxted, Essex. 1923–24. When the press had been decorated, Noel had the interior wallpapered. The labels for the various coat-hooks remain in situ and are written in Noel's distinctive hand.

12. The Vestment Press. Church of St John the Baptist, Our Lady and St Lawrence, Thaxted, Essex. 1923–24. Two of Conrad Noel's distinctive coat-hook labels. In pencil, beneath the label 'Candlebearers', has been written 'H Rolph', presumably a relative of the George Rolph who appears in the Litany Procession photograph of c.1916.

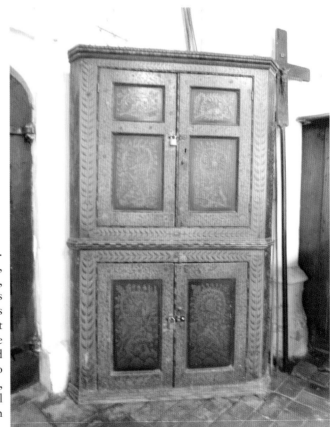

13. The Sacristy Cupboard. Church of St John the Baptist, Our Lady and St Lawrence, Thaxted, Essex. 1923–24. As with the Vestment Press, this was also commissioned in about 1921–22. Destined for the storage of candles, thurible and incense, Marquis decorated it to compliment, rather than twin, the Vestment Press. It is still used for the purpose which Noel intended.

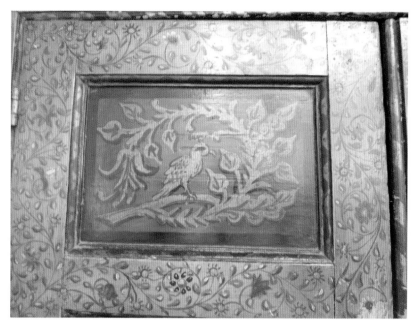

14. The Sacristy Cupboard. Church of St John the Baptist, Our Lady and St Lawrence, Thaxted, Essex. 1923-24. Detail of one of the panels. Green and gold, red and gold, and blue and gold were Marquis' favourite combinations.

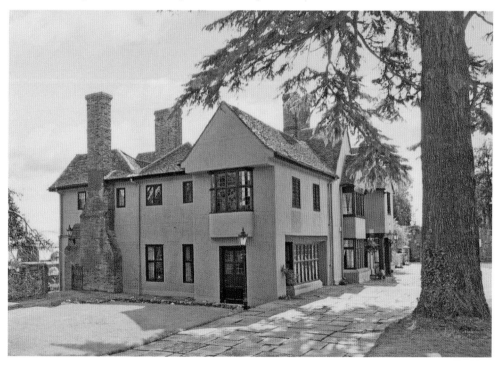

15. Little Easton Manor, Essex. 2014. It was in 1925 that Marquis was asked by Basil Dean, the Countess of Warwick's son-in-law, to advise on the restoration of Little Easton Hall. Marquis' contribution was little more than advisory, but he did supply Dean with a number of items of painted furniture over the next decade, much in the same way as he had provided Lady Warwick with pieces of decorated furniture for Little Easton Lodge.

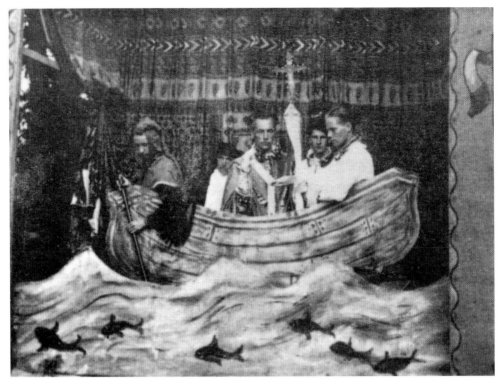

16. Marquis as St Thomas à Becket returning from France on 1st December 1170 in the Pledgdon Green Pageant, *The Passion of Master St Thomas*, Saturday 10th July 1926. Peformed in the Marquis' garden at Pledgdon, with sets devised and painted by him and costumes made by himself and John Barclay, with R. A. Glazenbrook as stage manager, the tableaux were presented on a small stage with doors, representing a cathedral, while the lawn front was used for other portions of the play. The review in the *Herts & Essex Observer* noted that "the Marquis d'Oisy sustained the part of Becket with grace and dignity." Having worked for Grossé, Marquis would have been conversant with episcopal vestments. This photograph, and the next, was taken by Arthur Caton, who was at the time a member of the Thaxted choir.

17. Marquis as the martyred St Thomas à Becket in the Pledgdon Green Pageant, *The Passion of Master St Thomas*, Saturday 10th July 1926.

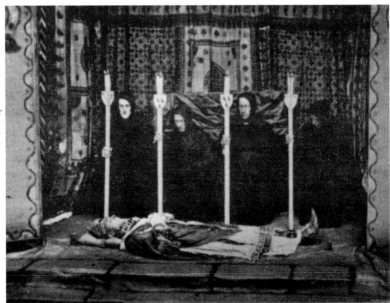

18. The garden in the cottage belonging to the Marquis' d'Oisy, Pledgdon Green, Essex. Photograph by Imogen Holst, whom Marquis had coerced to conduct the orchestra for his first Pledgdon Green Pageant, *The Passion of Master St Thomas*. The pageant took place at Pledgdon Green on Saturday 10th July 1926, the day on which Imogen Holst took this photograph.

19. Bed-head. c.1927. When Conrad and Miriam Noel moved into Thaxted vicarage in 1910 they commissioned a pair of single beds from Ernest Beckwith of Coggleshall, Essex. One was subsequently sold but the other was painted by Marquis, though in more delicate tones than he traditionally employed.

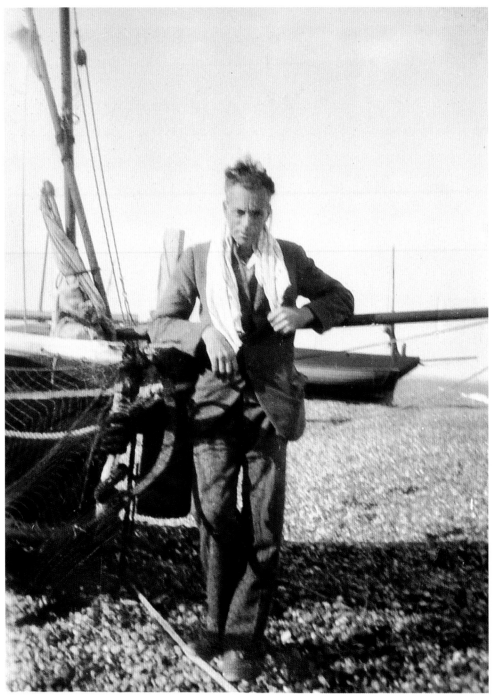

20. Marquis at Dungeness, Kent, Sunday 30th September 1928. Three of the Thaxtedians who took part in Marquis' 1928 springtime pageant at the Parry Theatre, London were Fred and Nellie Livings and their son Edward [Ted]. In the autumn of that year the Livings' rented a cottage at Dymchurch, Kent between Sunday September 30 and Saturday October 6 and invited Marquis to stay with them. On the day of their arrival they went to Dungeness and photographed Marquis on the beach, lolling against a fishing-boat with a towel around his neck, as though he had just come back from paddling in the sea.

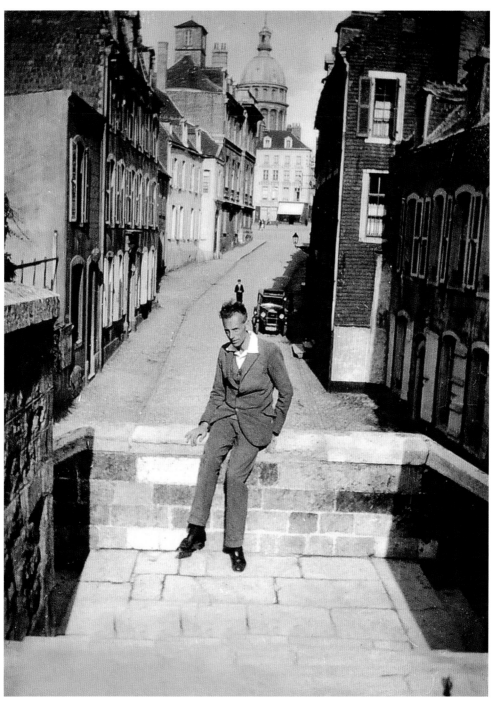

21. It was on Monday 1st October 1928 that Marquis and the Livings' took a day-trip to Boulogne, which was probably his only trip to France, though he would have liked some to have thought otherwise. It was a bright, sunny day and Mr Livings had Marquis pose for a photograph, with the dome of the Basilica of Our Lady in the background. He looks rather apprehensive, as if hoping that Mr Livings would hurry up and take the photograph before he topples over the wall. Marquis would have needed a passport to get him into France, but he would have no qualms in applying for one in the name of Marquis d'Oisy.

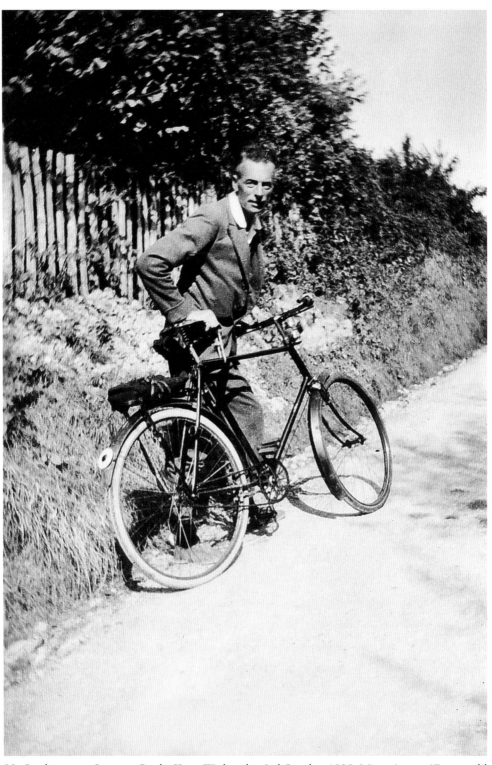

22. On the way to Lympne Castle, Kent. Wednesday 3rd October 1928. Marquis was 47 years old when this photograph was taken, but looks much younger.

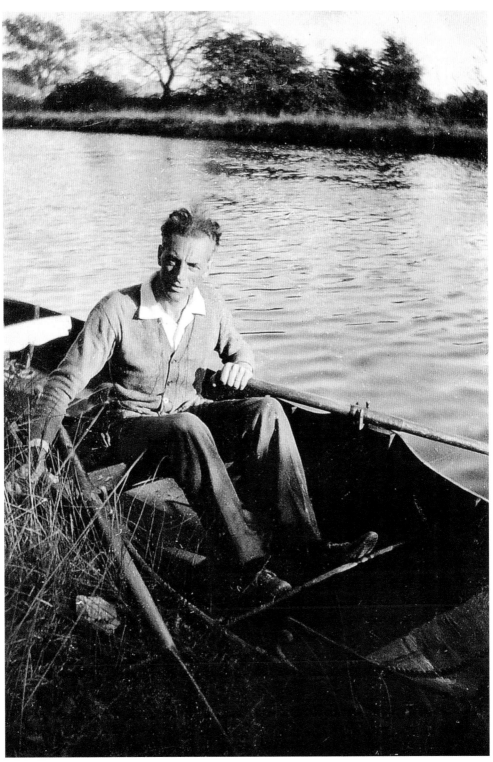

23. On the Royal Military Canal at West Hythe, Kent, Wednesday 3rd October 1928. There is no record of Marquis ever being a rower; on balance one would say not, bearing in mind that his steadying the boat by holding on to a tuft of grass on the bank.

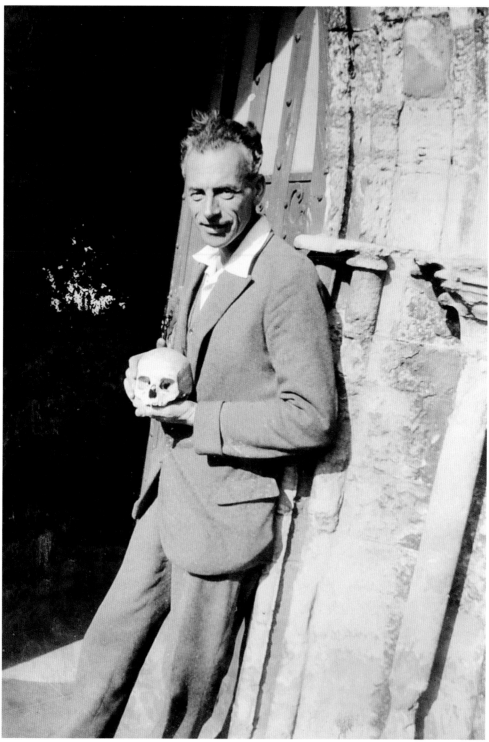

24. Marquis outside the crypt of St Leonard's, Hythe, Kent. Wednesday 3rd October 1928, adopting his "Hamlet" pose for the camera. His suit may have seen better days and could have benefitted from a close encounter with a steam-press, but it is elegantly cut; note the cuffs to the sleeves. Marquis took this one suit with him and wore it for the duration of his autumn holiday.

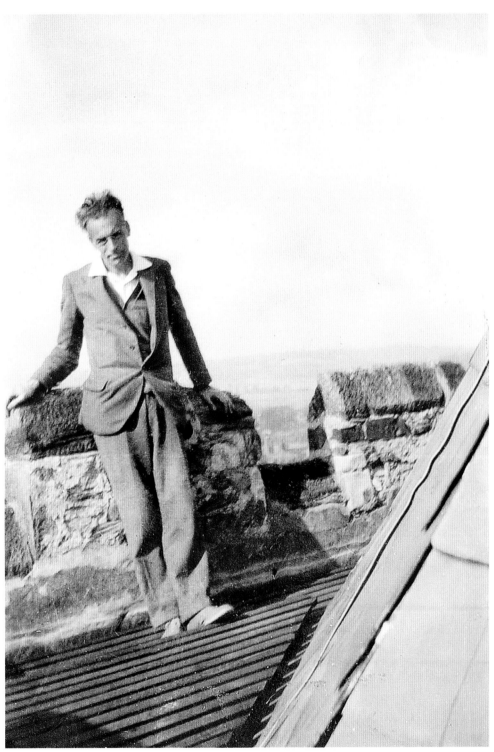

25. Marquis had no head heights and here, on the tower of St Mary's, Rye, Sussex on Thursday 4th October 1928, he looks a little uneasy. The pose is relaxed but, at the same time, somewhat tense, as he poses for Mr Livings, the Sussex Downs in the background. The structure in the right foreground is the lead-covered pyramid "spire".

26. On the White Rock Pier at Hastings, Sussex, Friday 5th October 1928. The autumn holiday at its end, Marquis snoozes in a deck-chair before both he and the Livings return to Essex. The pier was built between 1869 and 1872, to the designs of the great pier-engineer Eugenius Birch, but it had been severely burnt in 1917 and was not rebuilt until 1924. The shadow in the foreground is that of Frank Livings, bending over his Box Brownie to get a snap of the snoozing d'Oisy. From the angle of the shadow, Marquis is occupying a deck-chair on the west side of the pier.

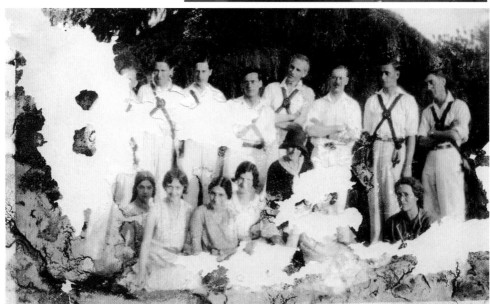

27. Marquis as a member of the Thaxted Morris Men, 1930–32. This image is the only known photograph of Marquis as a member of the Thaxted Morris Men, but the picture has been heavily water-damaged. He is in the back row, fourth from the right. It was taken in the vicarage garden at Thaxted, together with members of town's Country Dancing team. It is recorded that Marquis danced at Earls Colne, Essex as one of the Thaxted Morris Men in 1932.

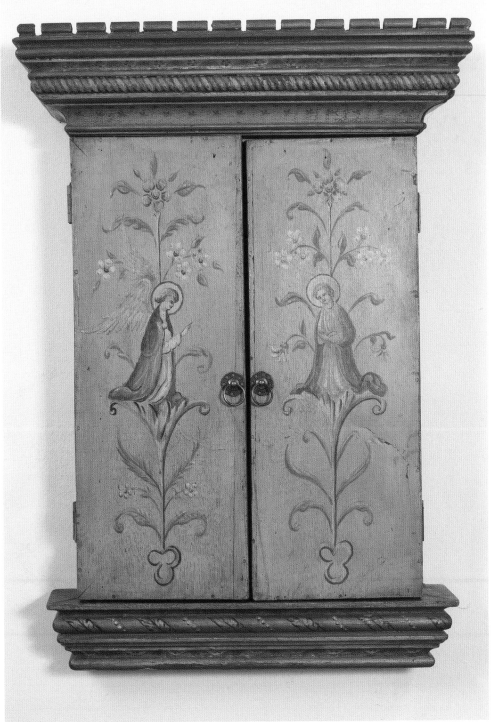

28. The Leiston Tripytch, 1933–34. Commissioned by a lady – Irene Rooke, according to Gordon Barker – this fine item is now in the church of St Margaret's, Leiston, Suffolk. Marquis painted at least three such items during his lifetime, one being in private hands and the third at Ferneux Pelham, Hertfordshire. The closed wings depict the Annunciation.

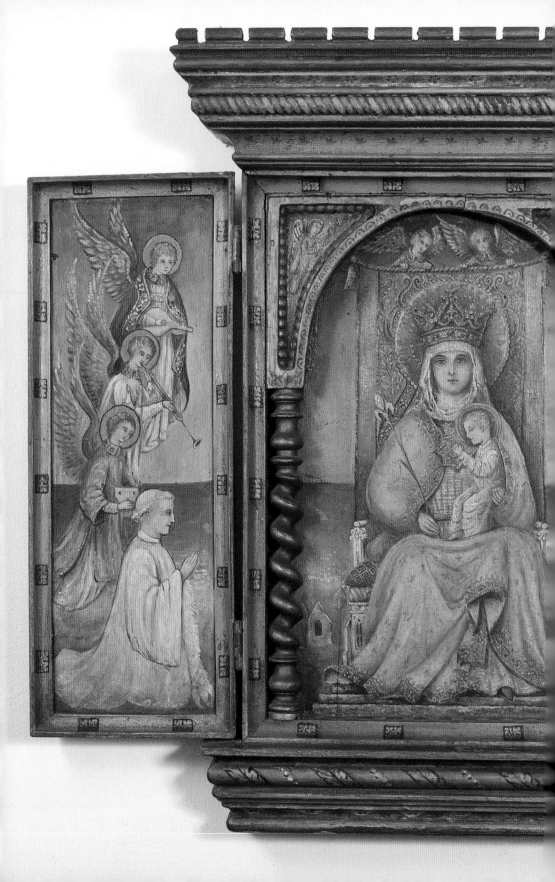

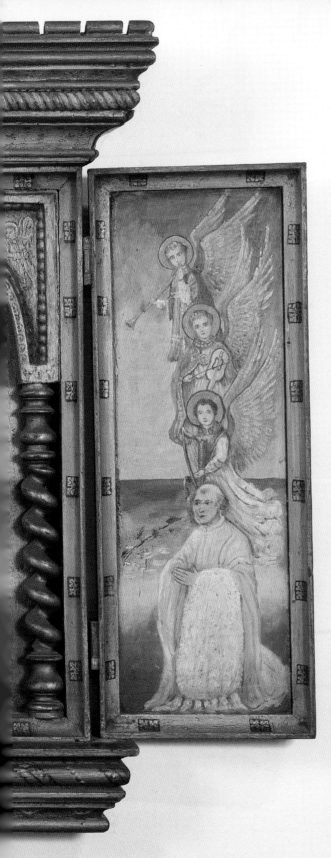

29. The Leiston Triptych. 1933–34. Church of St Margaret, Leiston, Suffolk. The left and right wings depict kneeling Premonsratensian canons, each attended by three angels with musical instruments, whilst in the central panel is a depiction of Our Lady of Leiston against a view of Leiston Abbey (as according to Marquis) and the sea, with a sailing ship and a steamer.

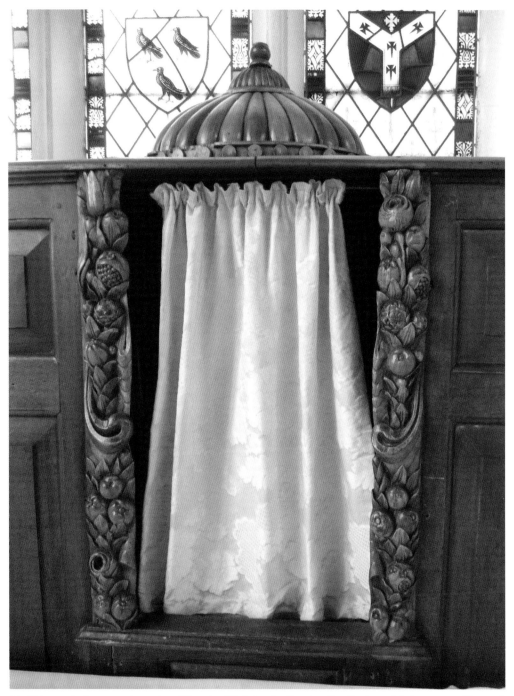

31. Tabernacle frame and cresting. Church of St John the Baptist, Our Lady and St Lawrence, Thatxed, Essex. Becket Chapel. Tabernacle cresting, 1934–35. The carving flanking the tabernacle is Jacobean and its colouring is by Marquis. The flat 'dome' above the tabernacle is a Marquis confection.

30 (opposite). Painted statue niche. Church of St John the Baptist, Our Lady and St Lawrence, Thaxted, Essex. Becket Chapel. Statue niche, 1934–35. Ten years had elapsed since Marquis last worked in Thaxted church, but in 1934 Conrad Noel asked him to undertake some embellishments for the chancel chapels. For the Becket Chapel, to the north of the altar, he was asked to decorate a statue niche, which he did in his standard "draped fabric" technique.

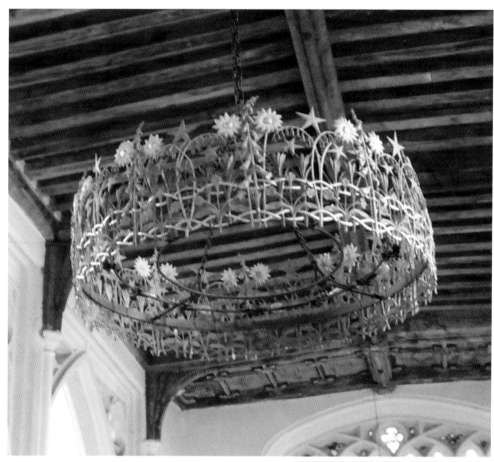

32 (above). Corona. Church of St John the Baptist, Our Lady and St Lawrence, Thatxed, Essex. 1934–35. Noel ordered a matching pair of coronas for the Lady Chapel in the chancel south aisle. Of pewter, in the form of stars with spring flowers (daisies, saffron crocus, harebells, forget-me-not, lilies) painted in natural colours, Marquis was particularly proud of their appearance.

33 (right). Corona. Church of St John the Baptist, Our Lady and St Lawrence, Thaxted, Essex. This sepia photograph of one of the Lady Chapel coronas was taken by John Gay in 1948. John Hunter (b. 1932) remembers being in the church when Gay was doing the photography.

34 (opposite). Corona adorning the Statue of Our Lady. Church of St John the Baptist, Our Lady and St Lawrence, Thaxted, 1934–35. Marquis' corona for the statue of Our Lady was made from the same material and to the same pattern as his coronas in the Lady Chapel.

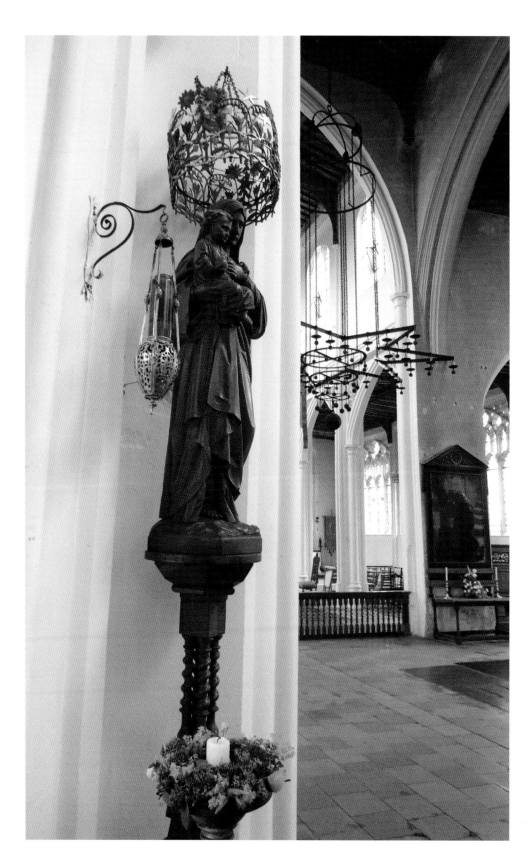

35. High Altar cresting. Church of St John the Baptist, Our Lady and St Lawrence, Thaxted, Essex.1934-35. Marquis completed his 1930's scheme at Thaxted with cresting for the High Altar and riddle-curtains, identical in material, design and colour to the Lady Chapel coronas. Removed during the vicarate of the Rev'd Jack Putterill (Conrad Noel's son-in-law), the cresting was for many years stored in a chest in the church, but went missing in the mid-1990s.

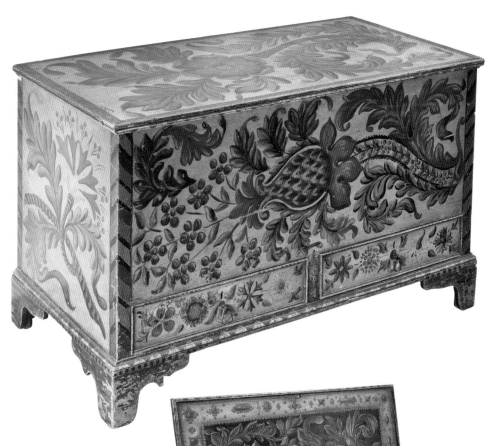

36 (above). The Arabesque Chest. c.1935–40. The work at Thaxted church was the influence behind Kate Butters' purchase of three items from Marquis over a period of five to six years. The Arabesque Chest was the most sumptuous and shows Marquis at his best.

37 (right). The Arabesque Chest. c.1935–40. The interior, showing Marquis' predilection for embellishing the inner parts with "drapes".

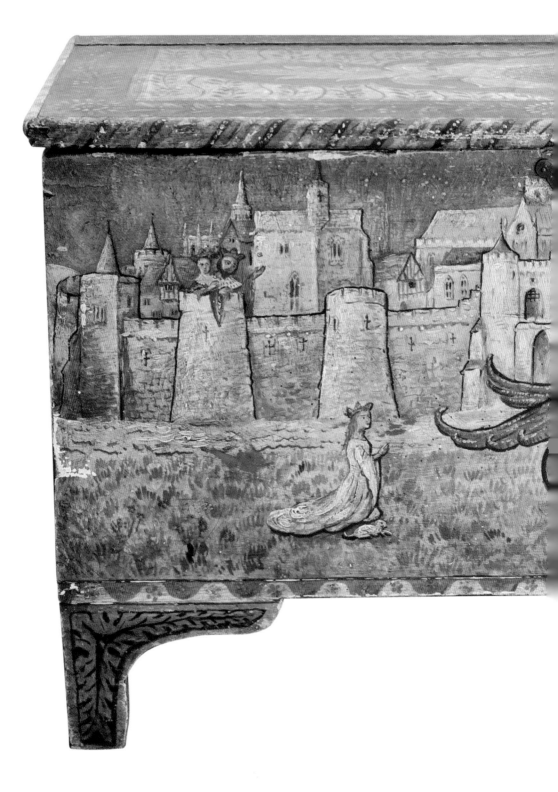

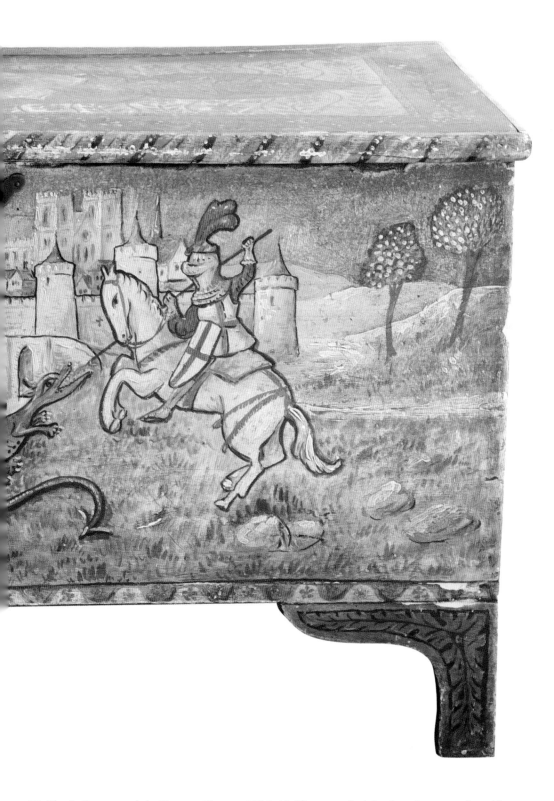

38. The St George and the Dragon Chest. c.1935–40. The second of the three items purchased by Kate Butters. There is a pleasant whimsy in the naïve nature of its execution.

39. The Lutterell Armoire, c.1935–40. The third of the three items purchased by Kate Butters. The Lutterell Psalter, a Lincolnshire manuscript of 1320–40, was acquired by the British Museum in 1929 and was published in facsimile format in 1932, which helps to date the armoire. The twelve images on the doors are taken from the manuscript's marginal illustrations.

Marquis considered the Lutterell Armoire to be one of his more important works.

40 (opposite). The Lutterell Armoire, c.1935–40. The top panel of the left-hand door, showing laymen drinking, a monk sampling wine and a lady bellowing a fire, all images based on the famous manuscript.

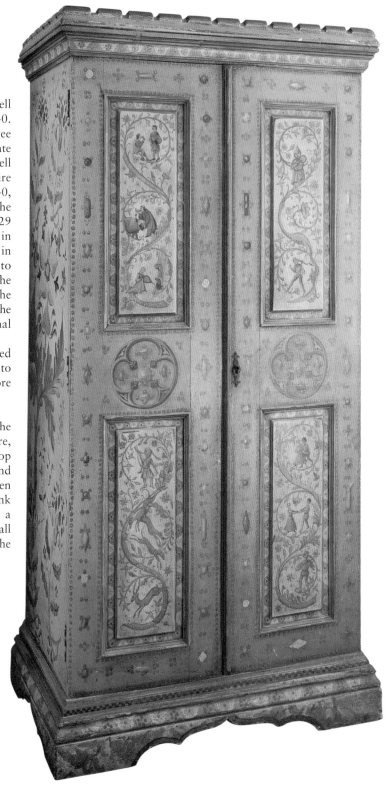

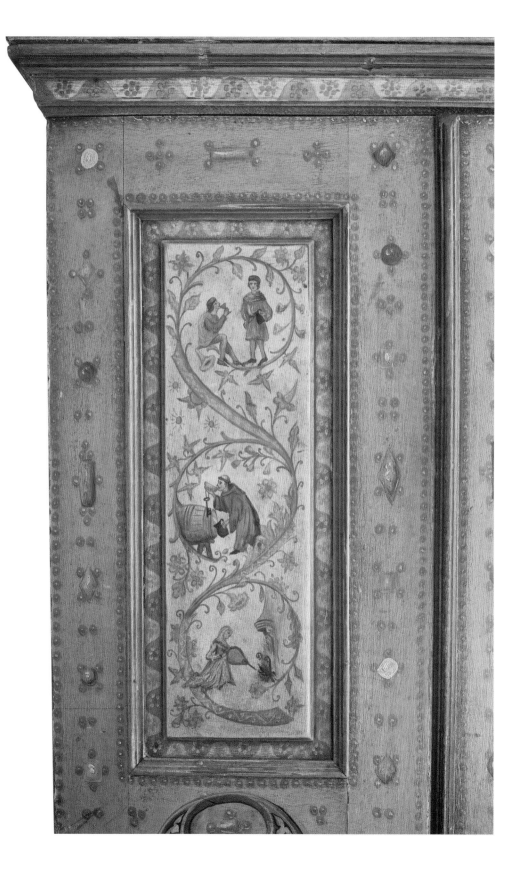

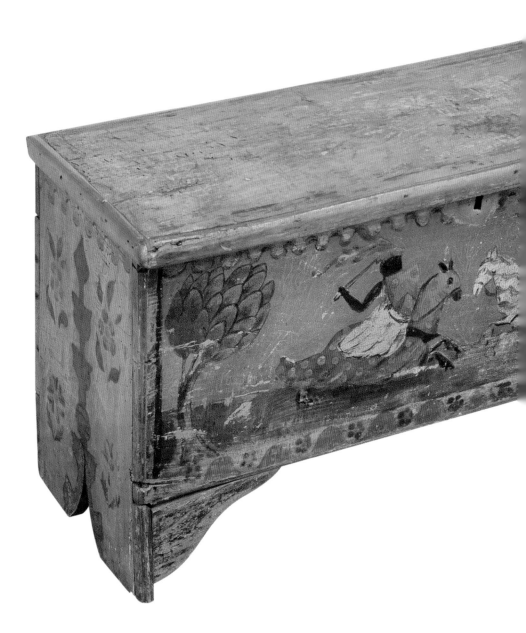

41. The Knights' Chest. c.1935–40. Purchased from Marquis by a Thaxted resident, the front panel depicts a sword fight between two mounted knights.

42 (opposite). The Knights' Chest. c.1935–40. The interior, showing a romantic castle on the underside of the lid and d'Oisy's embellishment of the inner parts with "drapes".

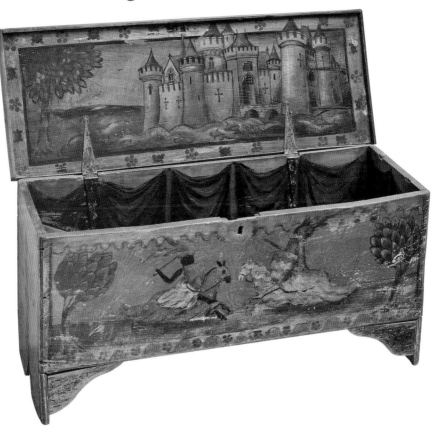

43. Letter from Marquis d'Oisy. Undated, but presumably written on Friday 5th July 1936. d'Oisy used as his letter-heading the armorial bearings of the de Tournays. Here he is writing to his then chauffeur, George Hoy. "Dear George, I can't get you on telephone. Leslie wants to take his mother & Father to the show tomorrow in my car. He wants to leave his motor bike with you and pick it up when he brings the car back tomorrow. He has some petrol. What do you think about it? I think that you might let him have it tonight and he will bring it back tomorrow afternoon. All the best. Louis."

Scenes Of The Centuries Recreated A Hatfield Pageant.

Scenes that have taken place at Hatfield, Hertfordshire, since the d of Queen Elizabeth were re-enacted in Hatfield Park when the He fordshire Folk Dancers produced a pageant entitled "Seven Centur of Dancing." The grounds of Hatfield House, which was the home Queen Elizabeth during her childhood and retirement, were lent by Marquess and Marchioness of Salisbury. Between five and six hund dancers took part in the pageant. Photo shows Miss C. James a court lady of the 18th century being carried in a sedan chair.

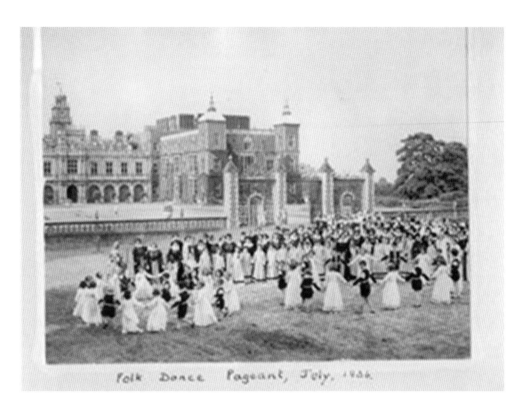

Folk Dance Pageant, July, 1936.

45. Pageant at Hatfield House, Hertfordshire. Saturday 6th July 1936. Schoolchildren dancing Skellenger's Round in the Elizabethan interlude of the pageant.

44 (opposite). Pageant at Hatfield House, Hertfordshire. Saturday 6th July 1936. Marquis' largest, and last, pageant, *Seven Centuries of Dancing*, required some six hundred performers. The orchestra was conducted by Imogen Holst and Ralph Vaughan Williams was in the audience. The Herts & Essex Observer published a photograph of the event showing a Miss C. James being carried in a sedan chair as a court lady of the 18th century. Marquis also made an appearance, in the guise of King Charles II.

46. Painted Dining Chair. c.1939–45. Commissions were few during the war years; the simple decoration of this late Regency chair reflects the sombreness of the time.

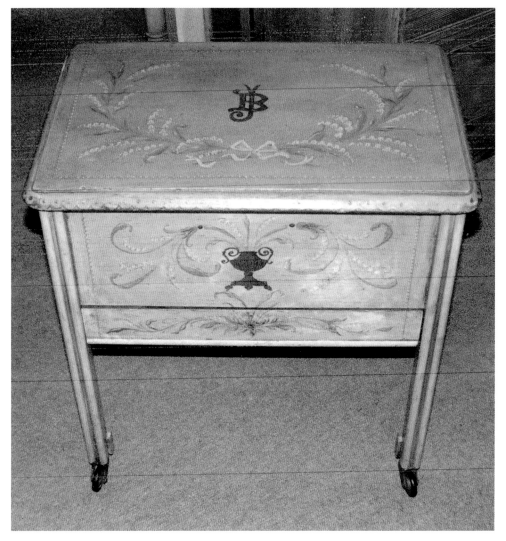

47. Bed-side Table. c.1939–45. A specially-commissioned bed-side table, the owner's initials within a cartouche of spring flowers and grasses.

48 (opposite). Lectern. Church of St John the Baptist, Our Lady and St Lawrence, Thaxted, Essex, 1944. Aware that he was on hard times the Rev'd Jack Putterill asked Marquis if he would care to decorate the church's late-nineteenth-century wooden lectern. The colour scheme is more restrained than his earlier work at Thaxted, leading more towards the sensitive than the garish. It was painted *in situ*, for John Hunter recalls that he first met Marquis when he was working in the church on the lectern.

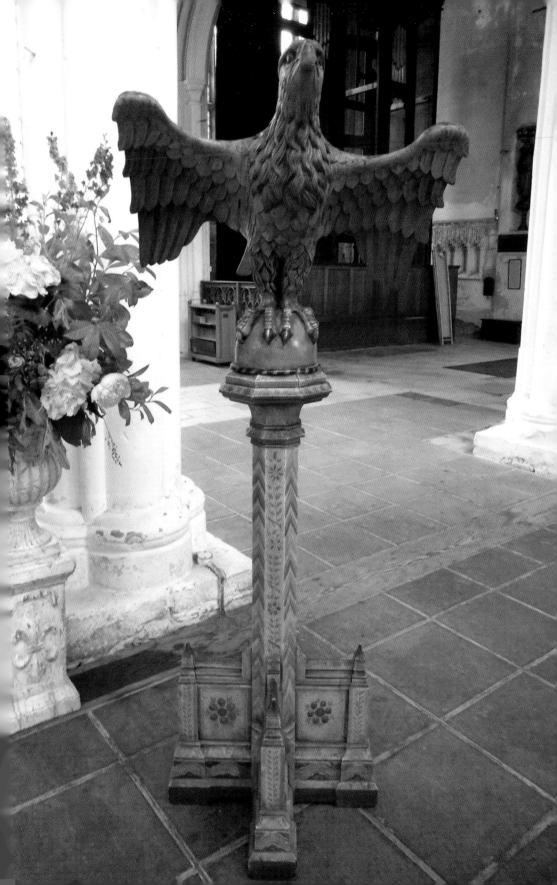

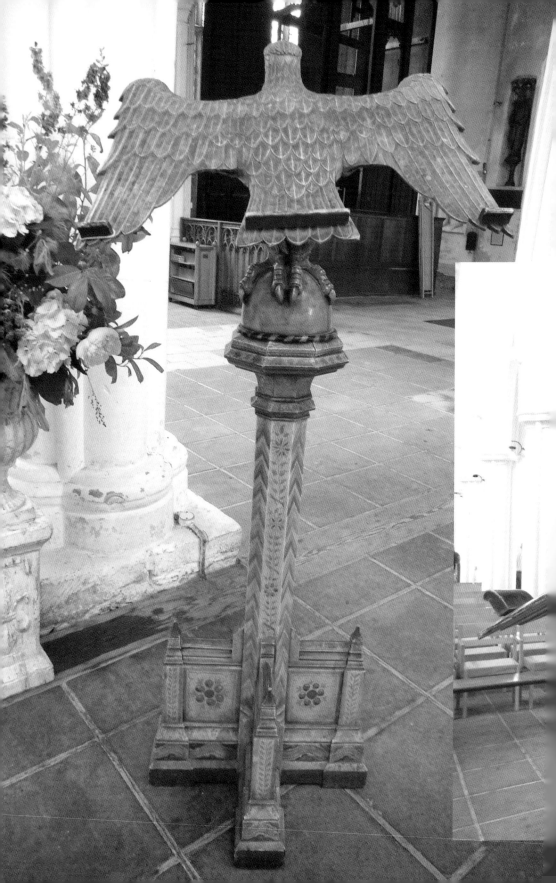

49 (opposite). Lectern. Church of St John the Baptist, Our Lady and St Lawrence, Thaxted, Essex, 1944. The back of the lectern shows Marquis' delicate treatment of the eagle's wings.

50. Lectern. Church of St John the Baptist, Our Lady and St Lawrence, Thaxted, Essex, 1944. A close-up of the eagle book-rest of the lectern.

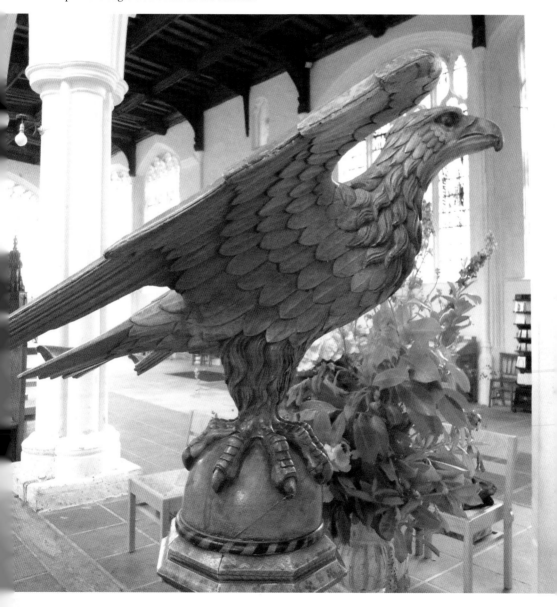

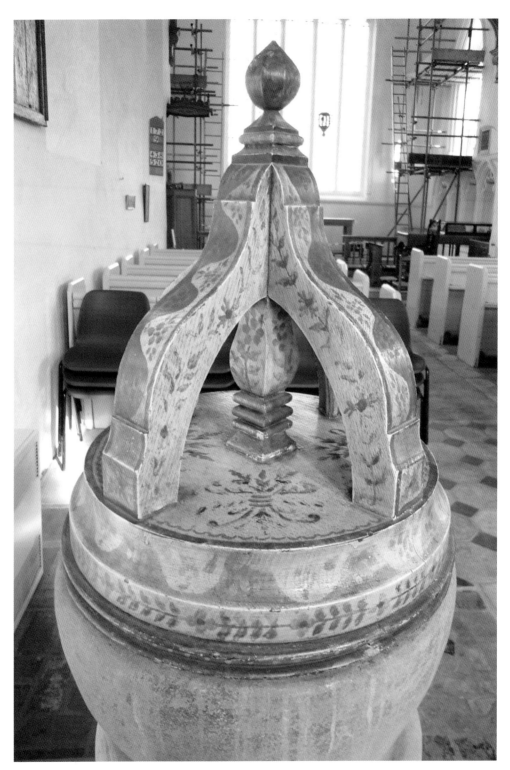

51. Font cover. Church of St Mary the Virgin, Tilty, Essex. 1945. The architect Stephen Dykes Bower, who knew Marquis, asked him to decorate the font cover at Tilty as part of a comprehensive restoration of the building. Marquis obliged.

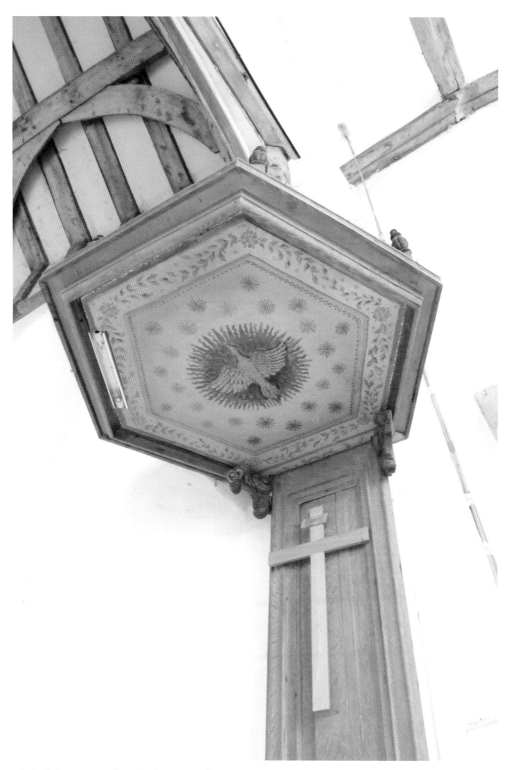

52. Pulpit canopy. Church of St Mary the Virgin, Tilty, Essex. 1945. The pulpit canopy, depicting the Holy Spirit amongst stars, was the second of the two items commissioned by Dykes Bower for Tilty from Marquis.

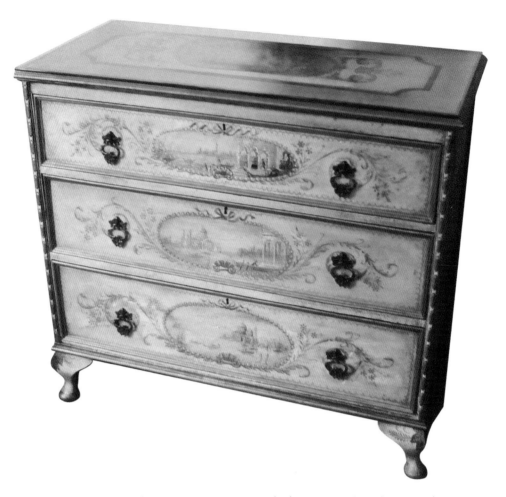

53. The Venice Chest of Drawers. c.1945–50. In the late 1940s Marquis was paying some of his bills by barter. This fine chest of drawers, painted with scenes of Venice, was one such piece, sold to his chauffer at a reduced price in respect of monies owed to him. It is accompanied by a matching two-door cupboard, which now belongs to the same collector who owns tis piece.

54 (opposite, above). Jewellery Casket. c.1950. In the form of a miniature Italian marriage chest, this exquisite item was d'Oisy's wedding present to the son of one of his war-time patrons.

55 (opposite, below). Jewellery Casket. c.1950. The underside of the lid, depicting d'Oisy's impression of the Lagoon at Venice, the interior with his traditional "drapes".

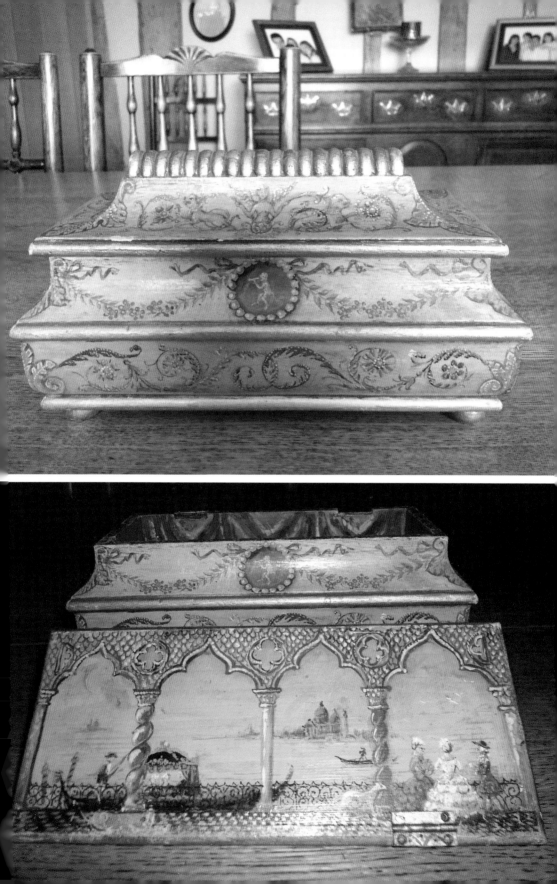

56. Triptych of the Sacred Heart, c.1950–51. Incorporating a commercially-printed illustration of the Sacred Heart of Jesus, the triptych box for this little item was made and decorated by Marquis for his Hertfordshire friends, George and Alice Langham Service.

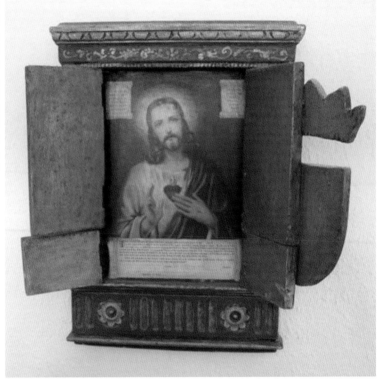

57. Chapel of the Annunciation, Furneux Pelham, Hertfordshire. 1950–58. In 1950 Captain Lake donated a sixteenth-century Grade II barn at Furneux Pelham for the purposes of a Roman Catholic chapel, the Lady Chapel being on the ground floor and the main congregational area on the first floor. The interior was designed by Marquis, who made almost all of its fixtures and fittings, a labour of love which was to take him well into the 1950s.

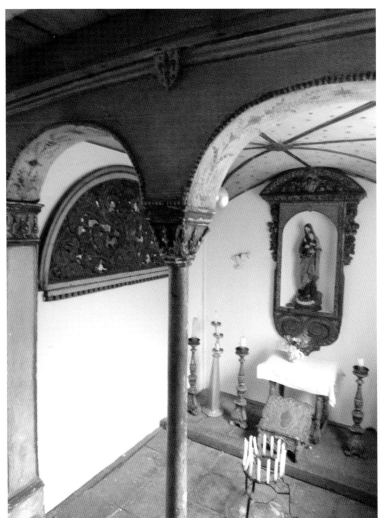

58. Chapel of the Annunciation, Furneux Pelham, Hertfordshire. Lady Chapel, 1950–58. An assemblage of fixtures and fittings, old and modern, acquired by d'Oisy from a multitude of sources and decorated by him, gave the Lady Chapel a particularly Spanish baroque flavour, akin to the works of Martin Travers.

59. Chapel of the Annunciation, Furneux Pelham, Hertfordshire, 1950–58. Detail of the painted soffit of one of the Lady Chapel's arches.

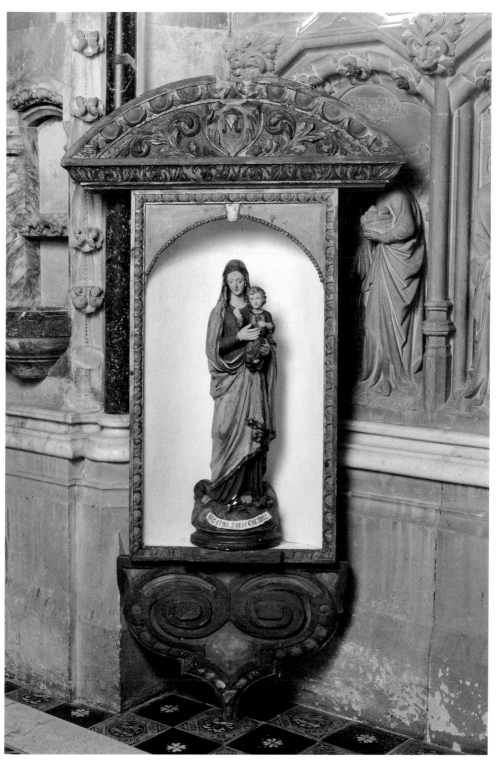

60. Chapel of the Annunciation, Furneux Pelham, Hertfordshire, 1950–58. Statue of Our Lady, painted by d'Oisy and presented to the Lady Chapel by Mr and Mrs Langham-Service. This item is now at St Edmund's College, Ware, Hertfordshire.

61. Chapel of the Annunciation, Furneux Pelham, Hertfordshire, 1950–58. The first floor chapel, with its fabric ceiling, was found by Mrs Florence Lake in a junkyard at Elsenham and is said to have been part of an Egyptian market stall.

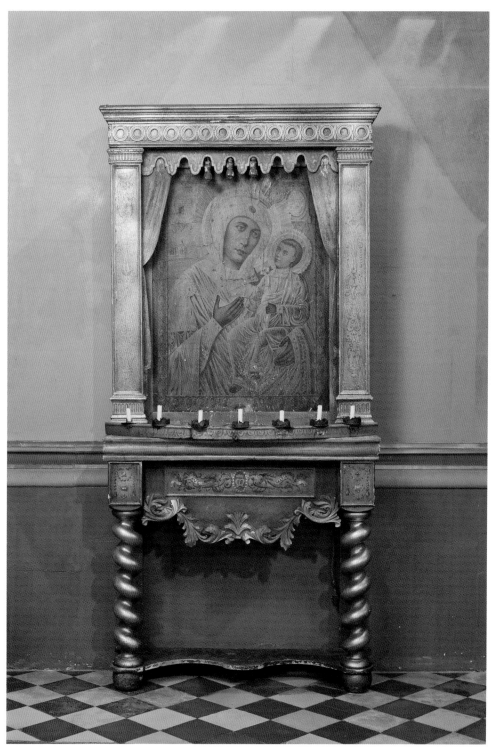

62. Chapel of the Annunciation, Furneux Pelham, Hertfordshire, 1950–58. Icon of the Virgin and Child. A cut down Victorian side table with a canopy of salvaged fragments, exquisitely decorated by d'Oisy, makes and impressive frame for the chapel's main shrine. This item is now at St Edmund's College, Ware, Hertfordshire.

63. Chapel of the Annunciation, Furneux Pelham, Hertfordshire, 1950–58. Our Lady of the Pelhams. Our Lady holds a model of the Chapel whilst, at her feet, are depicted the towers of the three churches of the Pelhams, viz. Brent Pelham, Ferneux Pelham and Stocking Pelham.

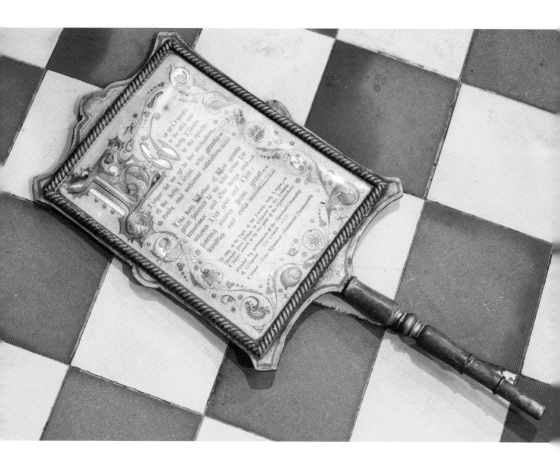

64. Chapel of the Annunciation, Furneux Pelham, Hertfordshire, 1950–58. Prayer-card holder. The illuminated prayer-card was printed in 1901, but the holderm resembling a Spanish fan, was made and decorated by Marquis. This item is now at St Edmund's College, Ware, Hertfordshire.

65 (opposite). Chapel of the Annunciation, Furneux Pelham, Hertfordshire, 1950–58. Painted cross. This small image, 10 inches (25 cm) high, was used in a stave as a processional cross and in a block as an altar cross. This item is now at St Edmund's College, Ware, Hertfordshire.

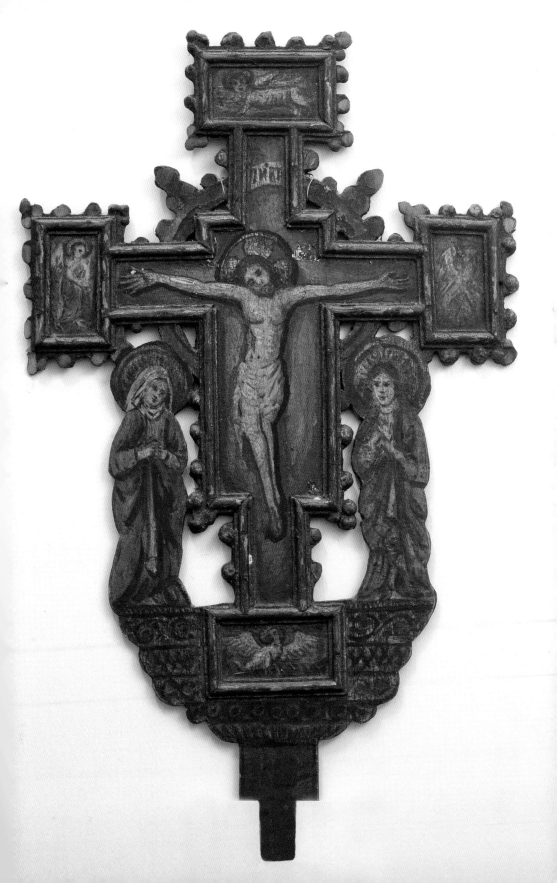

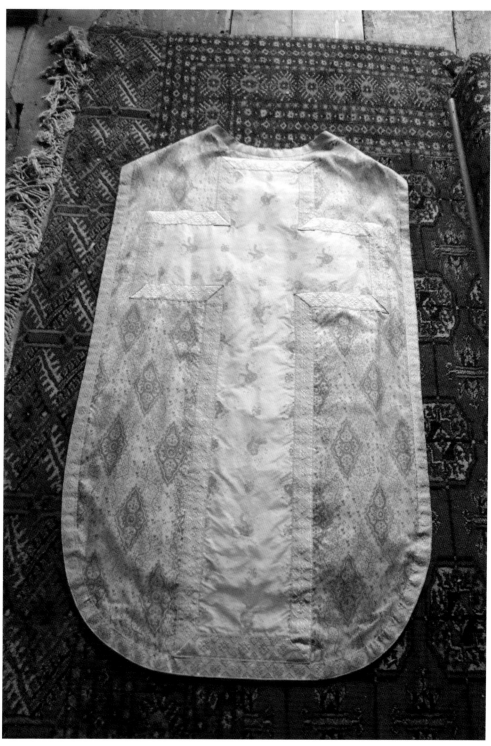

66. Chapel of the Annunciation, Furneux Pelham, Hertfordshire, 1950–58. Best White chasuable. Marquis made six sets of Low Mass vestments for the Chapel, each set comprising of a chasuble, stole, maniple, burse and chalice veil. Each set is of the finest silk, albeit domestic rather than ecclesiastical, with quality braids presumably purchased from Grossè's.

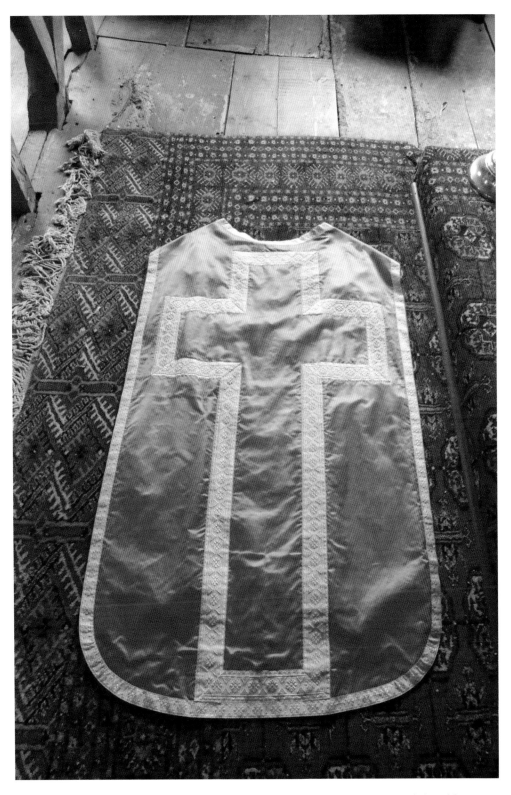

67. Chapel of the Annunciation, Furneux Pelham, Hertfordshire. 1950–58. Red chasuble.

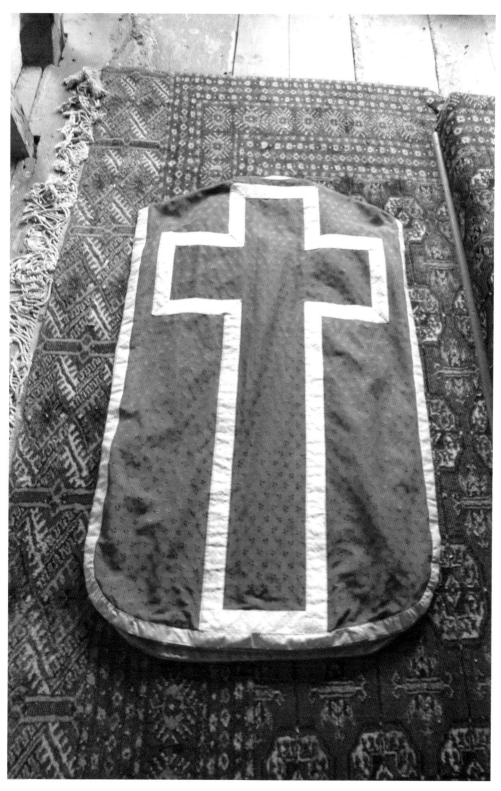

68. Chapel of the Annunciation, Furneux Pelham, Hertfordshire, 1950–58. Green chasuble.

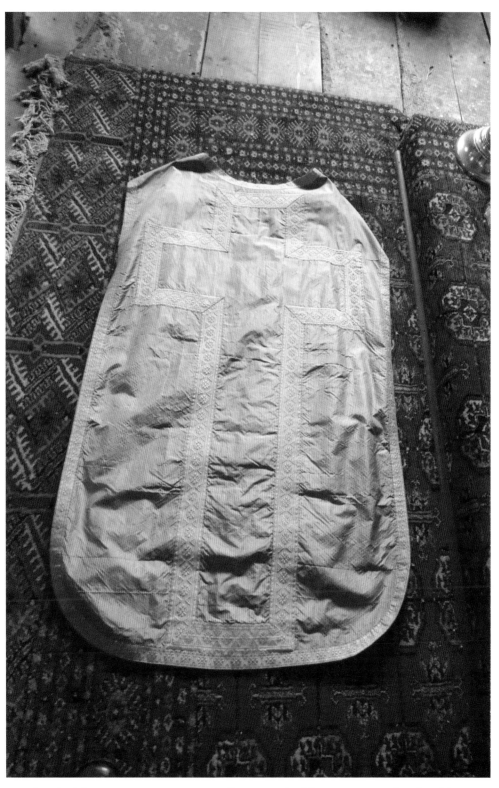

69. Chapel of the Annunciation, Furneux Pelham, Hertfordshire, 1950–58. Blue chasuble.

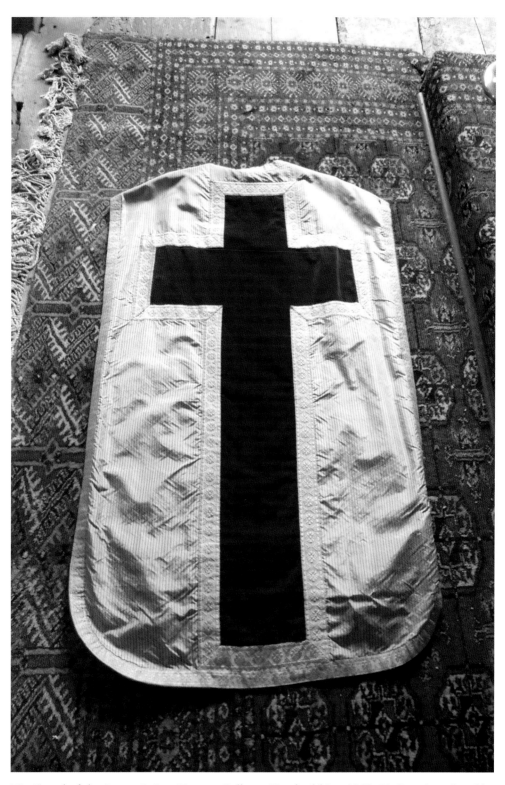

70. Chapel of the Annunciation, Furneux Pelham, Hertfordshire, 1950–58. Requiem chasuble, set 1.

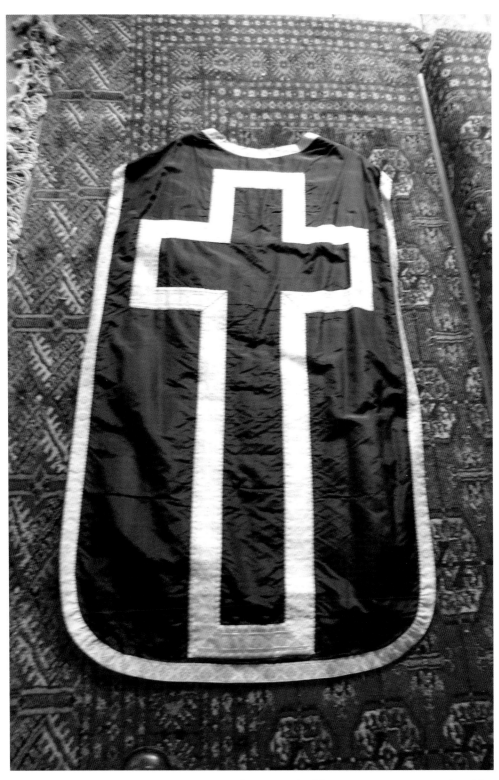

71. Chapel of the Annunciation, Furneaux Pelham, Hertfordshire, 1950–58. Requiem chasuble, set 2.

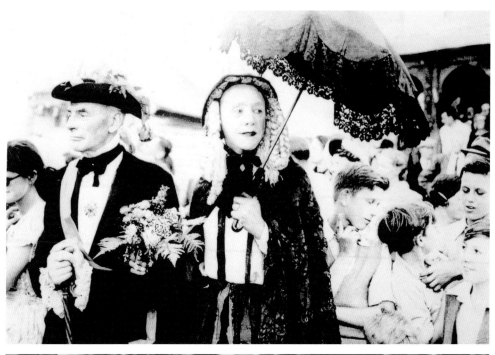

72 (opposite, above). Marquis, as Castleton King, and his "lady", played by Stanley Moss, at Thaxted's Festival of Britain festivities in 1951, organised by Alec Hunter. The black umbrella later passed to Arthur Caton, who subsequently used it whenever he took part in the town's Horn Dance. Marquis looks quite at ease, though the same cannot be said for Stanley Moss, whose performance is providing much amusement for the small boy on the right. This is the last known photograph to have been taken of Marquis.

73 (opposite, below). Planter, c.1955. A decorative item in d'Oisy's later style, created from a salt-pot.

74. Coffee-grinder. When Marquis moved out of his army hut at Pledgdon Green in 1958 he disposed of most of its contents. This French coffee grinder, probably painted by d'Oisy in the 1920s or 1930s, was acquired by the son of one of his war-time patrons who continues to own it.

75. The Roman Catholic church of Our Lady, Great Dunmow, Essex, c.1910–15. It was here in this small chapel that Marquis worshipped between 1917 and 1959, and it was also here that his funeral Mass – a small affair, celebrated by Father Kelly and attended by a dozen or so faithful friends – took place on Monday 14th December 1959.

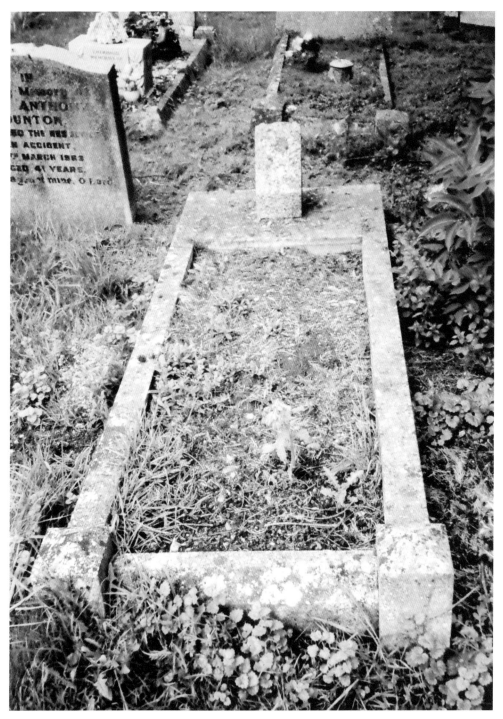

76. Marquis' grave in the churchyard of St Mary the Virgin, Great Dunmow, Essex, photographed in 2013. Marquis' funeral expenses, including the cost of the kerbing and stone, were met by Captain H. Neville Lake DSO RN (1893–1979), Managing Director of Rayment's Brewery, who had befriended him in the late 1940s. The tablet with the details of his name and death-date was stolen many years ago, whether by souvenir hunters or a devotee of Marquis' work, one cannot say.

WHO WAS THE MARQUIS D'OISY?

Marquis told Gordon Barker's father that he had inherited his title from his grandmother in 1888 when he was eight years old and that he had inherited £100,000 and made a further £100,000 in his lifetime. It seems likely only five individuals knew the true identity of Marquis; these would have been Dom Bede Camm, Rev'd Henry Bernard Ventham, the Rev'd George Chambers, Rev'd Conrad Noel and Marquis himself. There were, of course, a number of individuals who did not consider him to be an aristocrat at all. Les Carr (b. 1927) of Pledgdon Green, who used to drive the Marquis to and from London, once told Gordon Barker that "he never was a marquis". Frances, Countess of Warwick was of the same opinion, as was her son-in-law Basil Dean, and also Ernie Drane, the Parish Clerk at Thaxted in the between-the-wars years[1]. Similarly, Mrs Zeta Hill[2] (b. 1918) of Bolford Street, Thaxted was of the firm opinion that "he was never a marquis. Some thought he was an Italian waiter who had come over to England. I met him once or twice, at Broxted, but never had dinner with him. There were certain cliques in Thaxted during those days, and some people knew him and others did not. A lot of people invented these titles between the wars."[3] Sylvia Heath, Conrad Noel's grand-daughter, observed that "all the people in Thaxted realised there was something very 'phoney' about him."[4]

The definitive comment on the d'Oisy line was provided on 27th August 2012 by Grègoire Delforge, President of the Oisy le Verger Historical Society, France who wrote to John Langham-Service:

> The mayor has passed on your letter of 19th July to me and so I will try to help you in your research.
>
> Your questions are not straight forward to answer – you tell me of a Marquis Ambroise Thomas de Saint Tournay d'Assigny; so please find below a summary of the Tournai d'Assigny family.
>
> In 1605 Henry IV, King of France and Lord of Oisy, sold some of his land to finance his war to Antoine de Tournay, a knight; his ancestor being Charles de Tournay. Antoine's son, Philippe de Tournay, leaving no descendants, left his nephew Julien Eustache d'Assignies to inherit and to

[1] Information on Ernie Drane from Peter King, 23rd September 2010.

[2] The daughter of the Rev'd Percy Elborough Tinling Widdrington [b.1873; d.1955]. Widdrington, a friend of Noel's since the foundation of the Church Socialist League in 1906, became vicar of Great Easton in 1918. Great Easton was another of Lady Warwick's livings.

[3] Telephone conversation between Julian Litten and Mrs Zita Hill, 8th January 2011.

take the title Tournay d'Assignies, making him Julien Eustache de Tournay d'Assignies

Eustache Joseph Eugene de Tournay d'Assignies died without a descendant in 1792, he left his enormous fortune to his nephew Charles Louis Marie Ghislain de Potho. This succession took place during the French Revolution; the inheritant, living outside of France, was put on the list of immigrants, and the succession was overthrown and sold by the state.

Therefore the line of succession for the Tournay d'Assignies stops at the Revolution; if it were the Kingdom of France, it would be the Montblanc family (a Belgian noble family) who would have succeeded Charles de Potho, who also died without a successor.

Your character still remains a true enigma and I ask myself several questions. For example, the number of forenames that he has just simply does not exist in France, also you state that he was imprisoned for a night in Cambrai in 1909-1910 when he asked too many questions about his ancestors, but during this time the Revolution was over; was this character an imposter or a compulsive liar? The name Louis d'Oisy is unknown to me.

It all seems a real mystery to me, however it does attract my curiosity and I see that in your letter you have several accounts of conversations from your character that could provide some elements to shed light on this enigma.

Of course, it could well be that Marquis was indeed born in Rio de Janeiro on 21st June 1880 and that he was brought to England by his mother in 1888, the year that his grandmother died[5] and from whom Marquis said that he inherited the title. For that to be the case d'Oisy's grandmother would need to have been a direct descendant of Eustache Joseph Eugene de Tournay d'Assignes' nephew and heir, Charles Louis Marie Guislain de Potho, the rightful inheritor of the d'Oisy title and estates in 1792. Indeed, to cut it even finer, d'Oisy's grandmother would need to have been Charles Louis Marie Guislain de Potho's daughter. Similarly, it could also well be that Marquis' father was indeed a viscount and his mother a countess in her own right, and it is to be regretted that Marquis never mentioned the precise titles his parents held.

In 1889 the Emperor Pedro II of Brazil went into exile and the Portuguese, Spanish and French aristocracy, landowners, hangers-on and sycophants whose families had drifted to Brazil since the French Revolution left with him, though some had already left in 1885 sensing that the end was nigh. Marquis could have landed in England in 1885/6 or 1888, which would mean that any earlier language would have soon been replaced by English, albeit with a slight accent.

[4] Correspondence, Sylvia Heath to Julian Litten, 25th February 2013.

[5] Marquis did not say if this was his paternal or maternal grandmother; one assumes the former.

There is also a possibility, until proven otherwise, that his father perished at sea in 1896 on the crossing from Brazil to England and that Marquis inherited £600 as a result of that death. What begs the question is why Marquis and not his father inherited the d'Oisy title in 1888? In the natural course of things one would have expected Marquis' father to have acquired the title with Marquis inheriting it in 1896 on his father's death. John Hunter recalled how, in 1945, Marquis had shown him a family tree in which his cadet branch of the family had inherited the title when those in line perished on the crossing to Brazil, fleeing the Revolution and the guillotine.

Further questions arise regarding Marquis' identity. When he was at Caldey the 1901 census records him as "living on own means" which could, of course, have come from the alleged £600 inherited by him five years earlier with the death of his father in 1896. Had that sum been invested on his behalf until he reached his majority in 1901 then it would have grown by at least 3% per annum to £700. Again, we have no idea when his mother died and whether or not this brought in any more capital. A calculated guess leads one to consider 1915 as the date of her death[6] for it was in that year he claimed he set himself up in business as Marquis d'Oisy, subsequently taking on Palegates Farm, Broxted, Essex in 1917[7] and renting premises in St John's Wood in 1920. That he was not of British nationality may explain his absence from service in the Great War and Reg Payne records how his father was registered to sign Marquis' alien papers during the Second World War.[8] Again, when Marquis appeared before the bankruptcy courts in 1921 and 1931 he gave his name as Amand Edouard Ambroise Marie Louis Ettienene Phillippe de Sant Andre de Tournay d'Oisy, Marquis d'Oisy. During the hearing he stated that he was a Brazilian subject, held a French title of nobility but had no territorial possessions. Surely he would not have lied to the court regarding his true name? Would he? There is a possibility that he was indeed a Brazilian citizen, but his claim to the French title is highly suspect.

[6] If, as Marquis inferred, she was living at Regent's Park at the time of her death then her place of burial would have been St Mary's Roman Catholic Cemetery, Kensal Green. A search of the burial registers of the period 1st January 1914 to 31st December 1915 identifies one female with the surname Thomas, a Louisa Thomas, aged 73, who died in St Joseph's House for the Aged Poor, Portobello Road and buried in Public Grave 151F on 2nd January 1914. I am grateful to Anna Humphrey, Superintendent of St Mary's Roman Catholic Cemetery, Kensal Green for this information.

[7] He relinquished the farm for Pledgdon Green Cottage in the same year.

[8] Marquis would have been fifty-nine years of age in 1939 when the Second World War started.

When at Caldey he also told the census officer that he had born at Bath, but there is no Ambrose Thomas recorded in the censuses of 1881 and 1891 for that city. But if he really was Ambrose Thomas why did he subsequently select Marquis d'Oisy as a name? It is worth noting that 1903–05 saw the phenomenon of Orczy's *The Scarlet Pimpernel* both as a book and a play with one leading character, Count de Tournay of the Oise, and another, Amand St Just. This had followed on from a 1900 Revolution saga, *Robert de Tournay*, by William Sharpe.

In March 2013 John Langham-Service observed:

> I think that from the outset the most important facts are his year of birth 1880/81, his noviciate at Erdington, his sojourn at Caldey, his church furnishing years and his pageant costumes and furniture enterprises. Out of all this, his bankruptcy and the personal reminiscences of those who knew him, there comes a picture of an extremely talented man who was incapable of running his affairs. It would seem that he had neither anyone to turn to, nor anyone to trust from an early age, hence post-Erdington he became associated with and was taken in by the wrong sort of people such as Columba Mary Ventham and, perhaps, O'Halloran. It would seem that he was seduced by their lifestyle and companionship for the family he needed. If this was so, he must have been alone from a very young age. He could indeed have had a small inheritance and perhaps had been guided by a schoolmaster or a priest, possibly in north-west London. His life after Caldey would seem to indicate he had continued a 'working oblate' type of existence before reverting to his original name and then assuming the name of Louis de Tournay d'Oisy, either for theatrical or artistic reasons.

The missing years – 1902 to 1915 – leads one to speculate that after his short sojourn working as a navvy he may have been involved as a scenic painter or perhaps a theatrical costumier[9] which would explain his subsequent artistic flair and how he came to know so many in the theatrical profession. He did, after all, say to Mrs Langham-Service that he once briefly appeared on the stage as Louis d'Oisy.[10] It was in 1905 that the French-born pageant master Louis Napoleon Parker (1852–1944) started the vogue for such spectacles, with the Sherbourne Pageant in 1905. What is interesting for us is that in 1906 Parker was invited by Frances, Lady Warwick to mount a celebratory pageant at Warwick Castle over a five day period with 15,000 performers and tens of thousands of spectators. Could it be that Marquis was one of the many people in Parker's employ at that

9 The Mander & Mitchenson Theatre Collection has one item relating to an Ambrose Thomas in an album (GB2649-MM-PD-AZ) of items in the category 'Designer and Artist' though the on-line catalogue does not divulge what the item is. They have nothing listed under the name of d'Oisy.

10 No record of him appearing on the professional stage during the period 1900–1929 has been traced.

time making the scenery, props and costumes? Indeed, what better training for his subsequent association with Louis Grossé.

Michael Yelton, the historian of between-the-wars Anglo-Catholicism, commented in June 2011:

> The d'Oisy problem is fascinating and I have spent some considerable number of leisure hours on it without much result. The problem is that since Thomas/d'Oisy used different names, it is impossible to be clear as to what he was originally called: I suspect he was incapable of telling the truth about his origin. In 1901, while Thomas was on Caldy, Ventham was in Barry, South Wales, at the Priory of St Paul: he is entered in the census as a priest, which he clearly was not, and I bet that he did not tell them that in 1895 he had married a woman old enough to be his mother![11]

In January 2013 I wrote to Sylvia Heath, Conrad Noel's grand-daughter, to ask if she could shed any light on Marquis and of his work. She replied on 5th February:

> I have a <u>very</u> vague memory of him when he was around at Thaxted – probably in the thirties – as a small wiry man - very intense - & obviously a very talented artist. My grandmother Miriam was obviously very impressed with his furniture painting & had many articles of furniture painted including of course The Bed.
>
> The bed was beautifully done – painted with an ivory base – and all the mouldings & carvings picked out with gold – I think also that it was lightly scumbled with gold – but this has now worn off. There were vases of lilies & leaves in The Italian style painted on the head & foot of the bed. Around the canopy was a frieze with embroidered birds & flowers – with flag-like hangings – it seems oriental, but we don't know where it came from.
>
> Originally there were two such beds – (so my Mother said) – & they were made for Conrad & Miriam when they first went to Thaxted. They were made by Ernest Beckwith – the wonderful wood craftsman who restored Paycocks – (The wool merchant's house where they lived before arriving at Thaxted.) The beds were commissioned to be copied in detail from the painting of *The Dream of St Ursula* by Carpaccio. When they first had the beds they were painted an orangey-red colour (so my Mum says) - & were in the large bedroom overlooking the garden. Placed on a black & white felt floor covering & red scattered rugs – the effect must have been amazing. Later one bed was sold & the other one painted by the "Marquis".[12]

Marquis took as his grant of arms three demi-lions rampant, surmounted by a French ducal coronet. He used it as a heading on his personal note-paper, raised and embossed in blue ink. This was the heraldic device of the de Tournay's: or, three demi-lions rampant, gules.

[11] E-mail to the author.
[12] Correspondence, Sylvia Heath to Julian Litten, 5th February 2013.

Whether or not he was happy with his lot, who can say? He was perhaps happiest between 1925 and 1936 when he was working on restoring Easton Manor and busy with his pageants, though the overshadowing bankruptcy years of 1921–1931 would have tarnished that rapture. That he never lost his fascination with the allure of the religious life is witnessed by his attempt in 1923 to persuade Conrad Noel to convert the almshouses and Chantry in Thaxted churchyard into a College of Priests. And though, according to Peter King, he occasionally served as sub-deacon at Thaxted church, particularly during Harvest Festival, it was not until 1950, when he was in his seventieth year, that he was reconciled to Roman Catholicism. His only subsequent interlude of joy was in 1951 when he appeared as Castleton King in Thaxted's Festival of Britain celebrations.

But in the dark winter nights of the 1940s and 1950s, alone at his second-hand army hut at Peldgdon Green, dozing on its veranda and surrounded by his dogs, did his thoughts ever return to his happier boyhood days in Brazil or, indeed, to wherever it might have been that he spent his childhood? Whatever the truth of his origins, nothing can detract from his craftsmanship. He was neither an eccentric nor a rogue. Rather he was an exquisite exotic, a bird of elegant plumage of which the world now has too few. On balance, one cannot but like him, a rare creature who created for himself a life of fabulous tell-tale and for the world in general a multitude of outstanding works.

APPENDIX I: REMINISCENSES

1. *Reminiscences of Gordon Barker: 2010*

Conversation between Gordon Barker, Heather Barker, Julian Litten and the Rev. Anthony Couchman, Thursday 22nd July 2010 at Elsenham, Essex.

GB: A couple of years ago I wrote to Caldey Island asking about d'Oisy, but they wrote back and said that their records had been passed over to another abbey. But I wrote to them a couple of weeks ago, asking now for information on Ambrose Thomas.

JL: Yes, as that was his real name; we assume.

GB: It might not be Ambrose Thomas any way!

JL: That's the risk, isn't it?

GB: It could have been Charlie Brown!

AC: Ideally, you want his parents' name, don't you?

JL: That would be on the birth certificate.

AC: Do you think, then, that he was using someone else's name?

JL: Well, no. If he had invented this name for himself specifically, so that he could not be traced, and then to live in the middle of nowhere where nobody knew where he came from was a clever ploy.

GB: Do you know how I believe he came to this area? Well, apparently he came over to this country, I believe, in your writing to Peter [King of Thaxted], in a ketch. We don't know when he came here, but apparently he turned up in Essex probably in the parish of Henham, which is Pledgdon Green, in 1917. Well, I'm wondering if he deliberately planted himself close to the Countess of Warwick.

JL: How interesting that you say that, because we do know that he was acquainted with Conrad Noel, though we are not sure how close the friendship was.

GB: So you think that my assumption is right?

JL: I certainly do. And he would have liked the idea of being close to Little Easton and Lady Warwick.

GB: To my mind, he was a most extraordinarily clever man, and not only in whatever he did. Did you see the photo of him? [This is the photograph of Marquis in evening dress]. I did not know him like that. I knew him as a grey haired man, clean shaven. I can hear his voice in my head now. He didn't appear to have any accent; no brogue. Having said that though, you could tell by him he seemed to be a very well-educated man.

JL: Yes, I think that he would have been.

GB: He was well educated.

JL: We'll probably never know where he came from.

GB: Well, I was hoping we could find out.

JL: Well, if we're correct with the name Ambrose Thomas, and I'd like to think that we are, the one name that I'm dubious of is 'Ambrose', as it sounds rather ecclesiastical. He was for a time involved – when he was about 19 – with the *episcopi vagantes* which, I suppose, to an impressionable young man seemed quite a romantic group to *be* associated with.

GB: But on there [pointing to the long list of d'Oisy's names] he's not 'Ambrose' but 'Ambroise'.

JL: And I would not be at all surprised if we find out that his real name was something like Eric Thomas, or Jack Thomas, and that he might well have come from London. Aelred Carlyle said that his head was too much in the clouds and that it would be better for him to spend more time in the real world before he considered a cloistered life.

GB: Where on earth did you find that out?

JL: This is from the book by Anson, its all about the history of the *episcopi vagantes;* people who believed they were bishops.

AC: Some were quite legitimate.

JL: Yes, some were, but even they were somewhat tenuous.

GB: I wonder why – or maybe I shouldn't ask – why did he get kicked out of Caldey?

JL: Because they, too, were of the same opinion as Father Carlyle.

GB: Well I wondered if it was for another reason.

HB: Had he done anything wrong?

JL: I don't think that he had. Remember that you've got this person who is 19 going on 20, probably gone straight from a small private school and been quite captivated by this type of recreated medieval life of ecclesiology, liturgy and incense. He was quite an impressionable young man; it's a sadness that he had not gone straight from school to university, as that might have knocked the romance out of him. Whilst he might have considered those at Caldey exotic, they took themselves very seriously and did not have any room for a romantic. It would have been better, as he was told by Aelred Carlyle, to enjoy some real life and then apply to them again.

GB: I've already written to Caldey again for Ambrose Thomas. I might have to write again and ask for a Fred Thomas!

JL: I think that you'll be all right with Ambrose. There is a monastery in

Scotland[1] which has all of Peter Anson's papers and there might be something among them which he chose not to publish about Thomas simply because his book was getting too long.

GB: Being this end, I might be able to find out more. As there are things I can find out. He was a gifted man.

JL: Anson also tells us that when he came to Thaxted he was designing ladies couture before he painted furniture. Yet again this theatrical output ...

GB: Well, he made all of his costumes for his pageants which he held in his garden.

GB: This is mentioned in Lady Warwick's book, *Life's Ebb and Flow*.

JL: The sadness about *Life's Ebb and Flow* is that she does not mention Conrad Noel at all, even though she was patron of Thaxted parish. My interest in the Marquis is with his association with Conrad Noel.

GB: I started a postcard collection of Elsenham where I was born, then Henham where my mother was born and then Thaxted where my father was born. I've got three grandparents buried in the old churchyard and something like 400 postcards of Thaxted, including two or three of Conrad Noel.

JL: So, back to this file of d'Oisy material. But better than the file, of course, are your personal memories for paper has a coldness that does not bring a vitality to the story.

GB: Did you want me to tell you the time when I took Marquis out in the car?

JL: Yes, please.

GB: Well, there was a telephone call in the garage and my father called across to me and said "The Marquis wants to go to Takeley."[2] It was a bitterly cold winters' day, so I went to Pledgdon Green and pulled into his driveway. The Marquis all of a sudden appeared through the trees and we bid each other good-morning and he said "I want to go to Boswell's in Takeley to get some timber." So off we go into Takeley – I remember pulling in behind this very large building and it was full of timber. It was mostly pine floorboards; I don't think that it was the Marquis's cup of tea. Anyway, the Marquis hunted about for a little while, couldn't find what he wanted, you see, as he probably didn't have any money as he was always broke – never got any money with him – absolutely skint. Anyway, we went back to Pledgdon Green and then he showed me in the cottage that he actually had lived in but he didn't live in any longer because it was an extremely poorly thatched

[1] Nunraw Abbey, East Lothian. On making enquiries the present Abbot said that the Anson papers were, in fact, in the local library. However, the local library said that they were at Nunraw.

[2] This was after 1947, as GB mentions the army hut.

roof and the water was pouring in, but he did show me inside and I can remember going in and there was an absolutely huge, massive, inglenook fireplace full of old-fashioned stuff and when you walked into this room it was like walking back five hundred years. You probably won't believe this, but the floor was cobblestone, not cobblestone that you'd find in London streets but like you'd find on a cottage path. Anyway, he explained different things and then we went to his living accommodation, which was up in the garden, a very large army hut; it was long, and going in the end door the passageway between the doors had antique furniture piled either side, you see, and this small room at the top, which is something like the size of this room we're sitting in – about fourteen, fifteen foot square – was two tables in there. There was one on the left-hand side from the room we had just come from, and there was one on the other side. Well, there were things on this table I'd never seen before. "Marquis," I said, "what's this one for?" "Oh, that's a coffee grinder; I'll show you how it works." He went over to a cupboard and brought these coffee beans, tipped them in the top and wound the very large handle on top. Round it went and then a little drawer came out; the aroma was absolutely magnificent. So he said, "Would you like a coffee? It's a very cold morning" and I said, "Oh yes please, Marquis". Anyway, he goes over to the cupboard to fetch us two cups, without handles on, they were as black as you could ever imagine and he said "These cups are over a hundred years old." I thought "Why hadn't he thought of washing them up?" He made this coffee and the aroma was absolutely wonderful, then turned and went over to this other table, bordering the other room, and on the way over I saw a hole in the floor about the size of a saucer. Well, he sat with his back to the door and I sat facing him and kept looking at this cup, which was absolutely awful, and he was sipping his; he was going away on it. Mine was going over and over. "Marquis," I said, "I think you've got someone at the door." So off the Marquis trots about fifteen or twenty foot away and whilst he's gone this coffee went down the hole in the floor. As he was coming back in I was just pretending to take the last dregs out, put the cup down, and the Marquis said to me, "It's a very bitterly cold morning, you must have another one." But I couldn't throw that one away, could I? So here I am, fifty-five years later, no worse for wear!

He was so eccentric; you couldn't get anyone more eccentric than him. He was a real oddity. One of the locals told me he went up to the farm in Broxted and said he wanted some potatoes, a sack of potatoes, and so the chap said "I'm going into Bishop's Stortford, I'll deliver them on the way home." Well, he did deliver them on the way home, and this chap sat in the car with his mother and the Marquis came out of his cottage, paid for the

potatoes and they couldn't understand why, when he went back in, he backed all the way into the cottage. He turned round to go into the cottage and then they discovered why: he'd got no seat in his trousers.

JL: I like this bit [reading from Fred Knight's notes in GB's file]: Marquis "would invariable appear from his workshop, which was also his sleeping quarters, in his dressing gown, loosely thrown on, plus an enormous hat. I could only stare with mouth open. I subsequently got to know his manservant Bernard Keel well, as when money got tight with the Marquis, Bernie took a job three days a week as a gardener with Humphrey Waterfield, and I cut the lawns at Hill Pasture once a week during the season. When both the Marquis and Humphrey had died, Bernie moved in retirement to Takeley Street where, presumably, he eventually passed away." I'm fascinated by this photograph of the Marquis in Thaxted Morris gear.[3]

GB: Yes, that was taken at Earls Colne, I believe. You'd know the Marquis, because he's much taller than anyone else. It's a very poor photograph, which is unfortunate. You probably didn't know all this material existed?

JL: No. I didn't think many people knew about him. Ah [looking at a press-cutting], he had a bankruptcy served against him! [Reads from cutting]: "1931. Application for an Order for Discharge from Bankruptcy. The Order was made on 25th January 1921. The applicant, who had assets of £118 and debts of £1,524 is a Brazilian subject, held a French title of nobility without any territorial possessions. He was brought to this country as a child in 1886 and, in 1900, with £600 representing legacies, he began business as an artistic designer of houses and furniture. In 1917 he took Pledgdon Green Cottage for the purpose of demonstrating his works to people who required their properties restored and, in the same year, he took a farm at Broxted, Essex. The failure was attributed to losses in connection with the Essex farm and Pledgdon Green Cottage, to interest on borrowed money, and the slump in the trade which caused a decline in his designing business." The discharge was suspended for two months from 12th December 1931. Fancy telling ... this man was under oath!

AC: He probably thought that it was true.

GB: Ah, but what he said he believed. The Marquis only told you what he wanted you to know.

[3] The men are wearing baldrics. Mike Goatcher relates that the baldrics were worn until 1938, when the rag waistcoats were introduced. This helps date the photograph. Mr Goatcher also mentioned that Arthur Caton told him that the red jackets worn by the Thaxted Horn Dance were made by the Marquis and the mitres/crowns by Alec Hunter.

JL: [Reads another press-cutting.] *Herts & Essex Observer*, 1936, p. 5: "18 January. The Marquis D'Oisy gave a lecture, 'Dress Thorough the Ages', to the Elsenham Women's Institute." Probably showed some of the gowns he had made for his pageants, no doubt.

GB: Do you think he was buried as Louis Lorsey?

JL: Well, if he was then the burial register was filled in by someone who was hard of hearing.

GB: So do I.

JL: [Showing a few sheets of pencil notes to GB] Is this your hand?

GB: No; that's Kate Butters.

AC: He must have been good not only at designing but also at cutting out.[4]

GB: Another thing I've forgotten to tell you, and I must tell you at this point, he rented at one time, right from the beginning in the late '30s right up to 1942, he rented this cottage next door to store his furniture, but he had to come out as the man who owned it found out that the Marquis was paying too much rent, if you know what I mean. Everything the Marquis did he was like a highwayman, he covered his track up behind him.

JL: Now was the chap who was his manservant called Bernard Keel?

GB: Yes, he lived at Smith's Green but later moved to Cooks Hill, Takeley.

JL: [Looking at more papers in GB's file]: Ah, here's something on the pageant at Hatfield House. This is dated 6th July 1936. Then, on 12th October 1922 he did a *Pageant of Fashion* at the Holland Park Rink, Kensington: "The *Temple of Fashion* will be the principal feature, and there will be a pageant showing the *Dawn of Fashion*, with its passage through various countries. There will be scenes designed by the Marquis de Tournai D'Oisy." So, he was calling himself that then. And here's more on his financial position: 17th March 1921 he had to appear at a Public Examination before Mr Registrar Hope in answer to Mr E. Parker, Assistant Official Registrar. Liabilities of £1,575 and assets of £576. Here he is again in his Morris outfit.

GB: I think that I got that photo from Kate [Butters].

2. *Reminiscences of Kate Butters: 1986*

Some of John Hunter's information came from pencil notes compiled by Kate Butters on 26th April 1986, now in the possession of Gordon Barker. It is probable that they were penned for publication in the *Thaxted Bulletin* and subsequently given by Kate to John Hunter for him to use as the basis of his

4 Marquis' cutting out was done by John Barclay.

more comprehensive recollections published in the *Thaxted Bulletin* in 1990. Kate wrote:

He lived in a quaint cottage at Pledgdon Green which he furnished with the right kind of furniture. There was a big open fireplace with a spit and all the medieval cooking utensils, wooden trenchers, pewter mugs and hot plates, and horn-handled knives and forks. I remember his herb garden and the place with all kinds of beautiful scented plants to use in his cooking. He was extremely interested in the middle ages; customs, dress, food, and history and spent a great deal of time and energy planning and directing pageants and getting friends and neighbours to perform historical plays of the period, for example, *The Murder of Thomas à Becket*. I recall a play based on the story of *Robert of Sicily*, which was performed in his garden. A few of us played in Father P's[5] orchestra, played various little sketches of music of the period, i.e. the Earl of Salisbury's Pavan. He made use of the Thaxted Morris Men and the girls who danced country dancing when he planned elaborate pageants. One such was in Hatfield House[6] when the men, in red tights and tunics, and girls in medieval costume. Mine had a wonderful head-dress, difficult to keep on. He was an amazing figure, very tall and thin, and often to be seen cycling in an old cloak. During WWI he was suspected of being a spy or, at any rate, a peculiar one. He was very artistic and would paint a plain wooden chest with truly delightful designs and colours. I have one of these chests with a lovely picture on the front showing St George and the Dragon. I also bought his favourite wardrobe and pictures depicting the Treasures of Life (Fire, Wine, Dancing, etc). He painted the eagle lectern in Thaxted church, made all the costumes for his productions, using an old treadle sewing machine."

According to Peter King, Kate's partner, Arthur Caton, always referred to Marquis as "*à la* Marquis".[7]

3. Reminiscences of Jack Haigh: 2009

From a letter written by Jack Haigh [b.1929] to Gordon Barker, January 2009:

I first met the Marquis at the latter part of the Second World War when my brother and I delivered firewood to him. He was a very different person; much an aristocrat, a tall man with a loud voice which made him stand out from the rest. Soon after meeting with the Marquis, my brother Ron sold him an army hut, and the hut was erected with the help of four Italian prisoners who at that time worked for my father.[8] The hut was a replacement for the Marquis's cottage

5 Father Jack Putterill.
6 July 1936.
7 Information from Peter King to the author, 19th August 2014.
8 In fact it was erected by Reg Payne, Ernie Jaggard and John Rattee. The Italian

which had almost fallen down and was uninhabitable. It was very evident from this time the Marquis's money had run out and, unfortunately, most of his friends had disappeared. In 1939, due to the food shortage, the Marquis lost valuable arable land which was given to the local farmer by the government. In 1948 the land was returned to him, and then he offered eight acres of his land to me. I farmed this land until his death in 1958 [*sic*] and I subsequently found out that it was in fact not his but belonged to a great friend of his who allowed him to live there for life.[9] In his hey-day, 1920 to 1930, his cottage and garden were kept in immaculate condition and he hosted some wonderful parties for many fashionable friends. His parties were also famous for traditional Morris dancing. In the early days of Pledgdon Green one of his greatest friends was Lady Warwick who lived at Easton Lodge Manor. Quite often he was seen cycling to have lunch or dinner with her. They had a lot in common, and both had political leftish views. It was said that after one of these dinners they went around the grounds of the manor viewing the deer. Lady Warwick turned to the Marquis to say, 'Oh, Louis. Isn't life just *wonderful*!' After relaying the story he turned to me and said with a chuckle 'I don't know what she expected of *me*!' They remained friends until she died. In the early years the Marquis did very well selling his paintings, which could command a very good price. Most of his work was completed at a large house in London.[10] With the onset of war, his London trips subsided and then came to an end and he relied on the selling of his furniture that he painted in the typical Marquis D'Oisy style. After the war he returned to London to sell his work and sometimes only being paid his expenses. He often used to call me to borrow a quid or two, and would give me an IOU. Sometimes he was able to pay me in cash. Other times he would repay me with a piece of painted furniture which I had to sell to get my money back. I enclose two photographs of pieces I was given by the Marquis; unfortunately, I only have one piece in my care, which is a beautiful writing bureau he gave me just a few hours before he died.[11] Many times he would telephone me and beg me to fix his old car which was a Morris 14 so he could make a trip up to London. He never drove himself. He would ask his old friend Bernie Keel or others to drive him. But, in the end, the car was no longer repairable and was towed back to my farm where it stayed for a very long time until a dealer collected it for a few pounds. As time went on the Marquis suffered a lot with bad health. Once he was haemorrhaging quite badly and was told to get into a very hot bath to stop the bleeding. But he did not own a bath, and he did not have any method of heating that amount of water and a neighbour came to the rescue, by lighting

prisoners of war probably merely delivered it.
[9] This was the actress and silent screen star, Irene Rooke.
[10] One assumes that this was house at St John's Wood mentioned in 1921.
[11] This would have been on the night of Friday 10th December 1959.

their copper and finding a very old bath for him to bathe in. In the early days he had many different types of jobs. One of these was digging the Underground tunnels of London. Towards the end of life he became very ill and spent his last weeks with his old friend, Bernard, who he had known for many years. His personal things, some quite unique, were left with Bernie Keel. At the passing of Bernie, the Marquis's belongings were left for me in Bernie's will. Unfortunately, the will was unsigned and was deemed null and void. Needless to say, I was never able to take possession of these items. Bernard Thomas Keel, was buried at Takeley, 5th October 1973 aged 65.

4. *Reminiscences of John Hunter: 1990*

As a teenager, John Hunter (1932–2005), the architect son of the textile designer Alec Hunter, who lived at Market Cross, 25 Town Street, Thaxted, Essex, knew Marquis. In 1990 he provided an article[12] for the *Thaxted Bulletin*, pp. 10–12:

People slip swiftly from view and it is important for those who remember those who should be remembered, to put their recollections in writing. The Marquis is certainly someone to record, an individualist (perhaps eccentric) survival of the *Ancien Regime* who remained a French citizen and Roman Catholic. He is something of a mystery. He showed me his family tree in which his cadet branch of the family inherited the title when those in line perished on the crossing to Brazil, fleeing the Revolution and the guillotine.

Certainly the lands in France had gone (where is Oisy – or indeed which Oisy?), and he lived in a house at Pledgdon Green with a few acres of land. The house was medieval and this was his style of life. He slept on an open balcony guarded by two greyhounds. Inside was a huge open fire (then unusual) with spit, wooden trenchers, pewter mugs and horn-handled knives and forks. Behind was his formal herb garden with vine trellises and scented plants. It was all still magical when I saw it in 1945. There was something of the January scenes in Flemish breviaries, where the lord feasts, and the marquis would have known them well.

He was a medievalist and lived in that time and a talented decorative artist, running a workshop decorating furniture for Liberty and elsewhere. In the midst of these activities he put on pageants and historical plays, notably *The Murder of Thomas à Becket* in 1927. Kate Butters and Arthur Caton have fortunately kept photographs so we can see something of the style and talent of these productions, which were good and memorable to those who saw them. *Becket* was performed in his garden and Kate Butters played in Fr Jack's[13] orchestra for the occasion with snatches of early music. A. A. Thompson of Henham wrote the

12 Based on pencil notes compiled by Kate Butters and now (2014) with Gordon Barker.
13 Fr Jack Putterill, Vicar of Thaxted 1942–74.

scripts, and friends and neighbours took part. There was a pageant at Hatfield House[14] with the Thaxted Morris and girls in medieval attire. The Marquis made all the costumes on an old treadle sewing machine.

He contributed to our church:[15] two decorative cupboards, the painting of the eagle lectern, and figure and niche of St Thomas Becket. He respected Conrad Noel but disapproved of Anglicanism as heretical.

I was told that the Marquis was a terrifying driver. Years after his death my mother[16] would slow down on the Elsenham road, at the Pledgdon turning. Eventually the Marquis came to grief descending the long hill into Little Hadham; the car ascended the bank and [the Marquis] pirouetted on his elbow, nonchalantly extended from the driver's door.[17] After that he drove no more. But I was also told a story that he once set off on his car for a holiday in Cornwall and early in the trip saw some beautiful doors for sale, bought them with his holiday money and returned home.

I met the Marquis first in 1945 when he still had hopes of re-living his style of the 1930s. Subsequently I used to cycle over to chat with him about medieval buildings and gardens and he was always kindly and courteous although the house and herb garden had become ruinous and he now lived in a large shed with his manservant Bernard and his dogs. He had schemes – a huge illuminated flotilla on the Thames for the Festival of Britain – but these are dreams. He emerged in style magnificently in 1951 in velvet attire and tricorne to dignify our dancing festivities as Castleton King. Subsequently he lived on a reduced state and died attended by the faithful Bernard in about 1959/60. Sadly the house passed into other hands and suffered one of the nastiest 'restorations' I have seen. But then no-one would probably have wished to live in the Middle Ages as he had – central heating and other conveniences of the rich had become freely available. One can shudder at the idea of a D'Oisy theme park and a Marquis legend which would be the contribution of our own sad tourist times.

The Marquis seemed to me to have the better qualities of the *Ancien Regime*: old fashioned good manners, culture and optimism. Kate and Arthur have helped with these notes and I hope that others will add to them. He enriched the lives and cultural horizons of many people.

5. *Reminiscences of Reginald ('Reg') Payne: 2010*

Conversation between Julian Litten, Anthony Couchman, Gordon Barker, Heather Barker and Reginald ('Reg') Payne (b. 1927) at Elsenham, Essex on

14 July 1936.
15 The church of St John the Baptist, Our Lady and St Lawrence, Thaxted, Essex.
16 Margaret Hunter.
17 Reg Payne records that the Marquis broke his arm so badly that its had to be plated and pinned, after which he was only able to use his left arm for writing and painting.

Monday 6th September 2010.

RP: So there's a blank spot [in Marquis's life] between 1902 and 1917. Well I'm just trying to think He told me he was 21 when he worked on the tube at Kentish Town or Camden Town as a navvy. Now if he was 21 that would have been 1901, wouldn't it?

JL: So that was after Aelred Carlyle had advised him to get some experience of life.

RP: It was, mmm ... I think he told me he came to Pledgdon Green or somewhere at the beginning of the First World War and he tried to get involved in something locally like you would have the ARP here but they didn't want to know you see because he was an alien.

JL: Or they believed he was an alien.

RP: Yeah. My father used to fill his forms in for him actually, sign them, his alien forms. So he was still a foreigner.

AC: He still could have been a spy!

RP: I think it's what they thought!

GB: Well, they thought he was a spy when he was renting the cottage next door because they said he was flashing a torch about.

JL: But it's a bit of a cheek when he says he is [a foreigner] but isn't and is content for people to sign alien forms for him.

RP: Then he told me that later on in life, when he was still a young man, he went to France, to Combre,[18] where he is supposed to have originated from, and they put him prison as they thought he was an imposter.

JL: Well, they didn't wear it lightly, did they?

RP: The next day they simply released him, waved him goodbye and that was it. So it's all mysterious, isn't it?

JL: Do you know roughly what year that would have been when he went to France?

RP: No. I can't think of any way I can get round that one.

JL: He's given a number of dates to various people as to when he came to England. We can pick that up from various documents.

RP: Well perhaps there's one way you could track him down. His cousin was King Alfonso of Spain[19] and King Alfonso raced cars, and in those days they

[18] Cambrai, pronounced "Combre".

[19] Actually Prince Alfonso (b. 10 May 1907), father of King Alfonso XIII, crashed into a telephone booth in America in September 1938 and appeared to have minor injuries but his haemophilia led to fatal internal bleeding and he died on 6 September 1938. He was initially entombed at Woodlawn Park Cemetery and Mausoleum, Miami,

had exposed wheel things – no fairings or anything – and he had a dread of being decapitated and he wore a long scarf and it wrapped around the wheels and ...

JL: ... killed him.

RP: Now that would be documented, wouldn't it? And if that's his cousin ...

JL: There's a book that came out in 2007 on Princess Beatrice,[20] who was the last child of Victoria and Albert, and her daughter married the King of Spain. Alfonso was her grandson. But there's nothing whatsoever in that book about d'Oisy or the d'Oisy family and they don't appear anywhere on the extended genealogical tree in the book.

RP: Now that is strange. Everything's strange about him [Marquis].

[Reg produced a copy of *Life's Ebb and Flow*, the autobiography of Frances, Countess of Warwick.[21]]

JL: Ah! *Life's Ebb and Flow*!! [Reading from page 339] "At my home farm Gustav and Isobel Holst have made a cottage in an abode of delight with an old barn for their music room. Here their only child, Imogen, sends out the wonderful music that has gained her scholarship at an early age that men might envy. No more than a stone's throw from the lodge the Horrabins rest in from their editing of *Plebs* and their political canvassing in Peterborough.[22] Nearby, the tall Marquis d'Oisy, image of a remote ancestor, the great Cardinal Richelieu, paints and decorates his furniture and composes pageants." Well, just a teeny, tiny mention, but there he is.

RP: All those other names ring a bell – Cranmer-Byng ...

JL: Yes, they do; don't they?

RP: ... and Basil Dean. Of course, he [Marquis] spoke of the family – Lady Warwick, Guy, and Mercy and Maynard – in general conversation, as though *I* knew of these people! "Of course, Guy ...". Well, who was Guy?

JL: When did you first come across Marquis?

RP: Well, we knew him years ago when I was a boy. He was always referred to

Florida and in 1985 was re-entombed in the Pantheon of the Princes in El Escorial. The Marquis appears to have confused the mode of death of the Prince with that of Isadora Duncan who died in the way RP related at Nice, France on 14 September 1927.

20 M. Dennison, *The Last Princess: The Devoted Life of Queen Victoria's Youngest Daughter* (London: Weidenfeld & Nicolson, 2007).

21 Frances, Countess of Warwick, *Life's Ebb and Flow* (New York: William Morrow & Co., 1929), 339.

22 James Francis Horrabin (1884–1962) was a Labour MP for Peterborough 1929–31 and edited a magazine of this name.

as "the Frenchman" or "the old Frenchman". I suppose in the mid '30s.

JL: And what did he look like?

RP: What did he look like? He was six foot five; the most fairest man I've ever met in my life. He drove a car erratically and had no sense of cornering in a car, so consequently he was hurtling along and simply turned the wheel and ... urgh! Consequently, early one morning going to Hadham he cut his arm clean off, except for a string. And he told me, he said, "That I had a good mind to pull it off and throw it away", he said, "I was so fed up with all this." But he put it together and walked into Hadham, rung the bell of the surgery and the doctor came, it was two o'clock in the morning it was. He said he [the doctor] nearly fainted and wanted to know what the horse manure was. Of course, in those days horses were on the road and he must have rolled over on the road or something. Anyway, three years this was plated-up in Charing Cross Hospital, in a sling, and then he wrote all his correspondence with his left hand and did his painting with his left hand, 'cause it was his living. Extraordinary man. He gardened one day and jammed the fork and it went through the instep, through the bottom of his gardening boot so he couldn't get the boot off. But he'd got to go London to the theatre with his friends; cycling! So he said, "I couldn't get that boot of so I took the other one off. I looked a bit incongruous going up there." But, I mean, he cycled to London; and the next day, of course, his leg was swollen. Near at hand there was a doctor who was having a house built and he said, "My god!". And he cut this boot off and treated him anyway and he [Marquis] was the most fearless man he'd [the doctor] ever known. These plates [in his arm] were quite big plates, countersunk plates, lying around the place. He was all screwed-up, but he managed to push a wheelbarrow full of stones. Extraordinary man.

GB: Reg, he had his coffin made, didn't he?

RP: He had it once, and he used to get in when his friends were coming. He'd make a noise inside, you know. It was bit old hat after a time. Of course, he used to look after Easton Lodge when Daisy Warwick went away. She used to give him the keys, bring the dogs over, so he used to go over there in a horse and trap, drove a carriage and four. So he knew them all, intimately.

GB: Marquis had two greyhounds, didn't he?

RP: He had loads of dogs, yes. She [Daisy Warwick] wanted him to live in Stone Hall, separated from the Lodge, about half a mile from the main house, but he declined.

JL: Can you recall what any of those dogs were called?

RP: They were all female. Sally, Jenny, a little whippet Alice, and he had a rogue – supposed to be a pedigree – Alsatian – I can't remember the name of that damn thing. But I had a glass of milk sat with him [Marquis] one night, and he [the dog] simply came into the house and bit the whole thing, glass and everything. He used to eat single Ever-Ready razor blades and things like that. He [Marquis] was most annoyed as it was said to be a pedigree dog.

JL: Did he have any other animals?

RP: Yes. He was self-sufficient. He had a Jersey cow, used to be tethered on the green, and he had a goat. There was plenty of milk.

JL: Did either of them have names or not?

RP: I can't remember now their names, but I didn't have anything to do with the animals, to tell you the truth.

JL: Can't say that I blame you.

GB: Tell them about the gypsies.

RP: Oh my god! Then again he was fearless. In those days they looked like a lot of cut-throats, you know. They used to have these sort of Captain Cook's scarves on their heads and the women used to smoke clay pipes. And of course they brought their vans into his garden entrance, which was the kitchen garden, and of course they set up camp, lit a fire, oh my god, and put the pot up on the iron and put this stew in and they all sat round and down he [Marquis] went. He said "I was so enraged. I went amongst them and I picked that pot up and I tipped everything on to the fire. I let all the horses go and half of them went up to Thaxted. And his nostrils flared – he had big nostrils – when he was angry.

JL: Do you know who owned that cottage? It was lent to him for life by a friend.

RP: Yes, I do. It was an old actress named Irene Rooke.[23]

GB: But, Reg, before he lived there I believed he lived at Palegates.[24]

RP: Yes, he did live at Palegate Farm.

GB: My great-uncle lived at Palegates and my great-uncle moved in after the

[23] Irene Rooke (1878–1958), died at Chesham, Bucks 14 June 1958, appeared in stage plays and made about nineteen films during her career. Amongst these were: *Lady Windermere's Fan* [Ideal Films, released 28 August 1916], *Pillars of Society* [produced by Harry Lorraine, released 1920] and *Hindle* Wakes [released January 1929]. In 1927 she bought 'Spindles', a cottage hideaway at Dungeness. She was married to Milton Rosmer. She retired from the profession about twenty years before her death. An oil portrait, *Irene Rook at Home*, painted 1938 by Robert John Swann is in the Victoria and Albert Museum, London [S.433–1980].

[24] It was, in fact, Palegates Farm, Broxted, Essex.

Marquis came out. It's quite true. This is where he [Marquis] went broke, in Palegates, I believe.

RP: Well, I thought he was constantly broke, to be perfectly honest.

GB: Well, he was. But didn't Captain Lake ... he kept bailing him out?

RP: He bailed him out a lot, I think. Of course, he [Marquis] wanted to be buried at Furneux Pelham where the Lake's lived. And he said, "I don't want any hearses, you know. I just want, when the beer wagon comes along, just pop the coffin on there," he said.

JL:　And I believe that he also used to paint some of the pub signs?[25]

RP: And also some of the furnishings. Linen-fold doors on the White Horse pub at Hatfield Heath. And one or two things he did. Yes.

JL: And would those doors still be there?

RP: I think the doors are still on the Hatfield Heath one.

GB: Reg, do you know where any of his painted furniture is today?

RP: I haven't got a clue, Gordon. I've never come across anything to tell you the truth.

GB: I know where some of it is.

JL: And he also provided a fair amount on a reasonably regular basis for Liberty's in London.

RP: I think he did some work for Robert Sayle & Co.[26] But then he did a lot of private work, obviously to the sort of Bohemian type – actors and that sort of thing, you know. But I went down to Drayton Beauchamp,[27] near Tring, and he laid a patio. That was during the war [WWII] because I had to bribe the Yanks to get some tins of food.

JL: And can you remember who he was doing that work for?

RP: Yes, she was an ex-actress. Ann Trevor[28] her name was, and she married a man called Garland. It was a long time, I'm going back to '42 or '43.

JL: So he was really in to this fraternity. And I am wondering if this is where the

[25]　The signs were made by the brewery cooper, George Felton. d'Oisy painted them "in the style of a mid-nineteenth-century German painting". Information from John Langham-Service, 17 Jan 2011.

[26]　A department store in St Andrew's Street, Cambridge. It opened in 1840, sold to Gordon Selfridge in 1934 and thence to John Lewis in 1940, retaining the name Robert Sayle & Co. until redeveloped between 2004 and 2007, then re-opening as John Lewis.

[27]　Buckinghamshire.

[28]　Ann Trevor (1899–1970). Her real surname was Trilnick. She appeared in nine films between 1920 and 1939.

secret is going to be for us as to what happened to him between 1902 and 1917. Because later on his life – well, in his early middle age –

RP: ... and what about this tube business at Camden Town?

GB: He worked on the banjo.

RP: That was a frame covered in wire netting and they angled the debris through and that separated the soil from the stones.

GB: He said he was not musical,[29] didn't he?

RP: Well, he played the banjo!

JL: Did he play any instrument?

RP: Oh, he could play the piano.

JL: Oh, could he?

RP: There was a piano, a baby grand, brought up there. He used to play that, oh yes.

GB: Did he play that piano you rubbed down in London?

RP: Oh I don't know about that, because I was only there that one day. This was a brand-new baby grand, got the corrugated cardboard all round the legs. And of course, it was like glass; made for Maples or somewhere. And he said to me, "Come on then, come on." So I said, "For what?" He got this sandpaper out, like an attaché case full of sandpaper, and I had to rub it down, get all the gloss off. And then, just before I left, he put a coat of white paint on. And someone told me, "That table,[30] you should have seen it afterwards. It was all acanthus leaves. Beautifully done."

JL: He certainly had a talent.

RP: Oh he did, he did. Yes. And he was shrewd.

GB: Reg, do you think he did anything other in life other than painting?

RP: Nothing springs to mind, Gordon.

GB: That was his only job?

RP: As far as I know. I'll tell you what he used to do to supplement his income. He used to go and make fruit boxes out at Barnston. The fruit boxes were all in sections, you know, and he nailed them up. I'd forgotten all about that.

GB: What year would that been?

RP: That would have been about the beginning of the War.

[29] A Freudian slip on GB's part! In the 1920s and 1930s, "are you musical?" was a way of enquiring of a person if he was homosexual.

[30] RP probably meant piano.

AD: I suppose, possibly, that doing the piano stuff was beginning to fall off.

RP: Possibly.

GB: During the War when money was short he tarred Smith's barns at Pledgdon Farm.

RP: Well, there you are. He was a man of all trades, you see.

JL: And what were his eating habits?

RP: Every morning he had a loaf delivered to my father's pub which I used to take to work. It was a long loaf, specially made for him. He used to say, "It's all the sweepings of the floor, you know." It was just a long loaf, with three or four cuts in the top, you know.[31] Break that in large lumps, and he had this – I believe it was Roman to look at it – it was a massive cup. I don't know if you've ever saw it. It was a big, thick, yellow terracotta cup and he'd have that full of – well, he used to grind his own Algerian coffee-beans. The old-fashioned grinder with the drawer underneath. And then he got the percolator – the French percolator – where you put the container in the ... well, like a teapot with the handle on the side. And then he'd have this lovely strong ... I could smell that a quarter of a mile from when I was going to work. I used to think, "Hello. He's up. He's got going." Yes, and so he'd eat just this plain bread. Always on time. Always started on time. He'd had a wash and shave before I got there and he was always ready for work. Always.

AD: Did he work for your dad, then?

RP: No, my dad just had the village shop and said, when he [Marquis] died, "Of course, you know, I used to send him food. He never paid me."

JL: I can understand that. I assume he was a vegetarian?

RP: No, no; because I've seen him eating chicken. No, that's not true. He ate most things, because he would do everything in the Victorian manner. He had this hair sieve; he'd cook the beetroot and then you'd have to mash this through the hair sieve. You don't see them now, do you? Made of wood, layers of wood, like a skip, got together and then this horse hair. And it came out beautiful, and it was so fresh, wasn't it?

GB: Was he a non-smoker?

RP: I only saw him smoke once, at your [GBs] father's garage. He sat in the car, and away I went to pay your father, and when I came out he'd got a cigarette. Just for me he'd done it! He held a cigarette like that [holding his hand away from his face] and just blew it out. "I can smoke", he said!

GB: Tee-total?

[31] A 'French stick'.

79

RP: Oh yes, he ... oh he wouldn't touch anything – oh, no. Only if you went to a cocktail party he would have tomato juice. Never seen him with anything alcoholic.

GB: Can you remember, Reg, the actors and actresses that used to come to his house. I know Ellen Terry ...

RP: I can. I can remember one or two. Florence Deswood was one that came there. And he [Marquis] did work for Dodie Smith of *101 Dalmatians*.[32] She came over there. But when we went to Drayton Beauchamp we went down to see an old actor, and I did see him on the television once, Milton Rosmer.[33] So he was still involved with them all. Lived at Iver Heath, apparently.

GB: The most famous one was Ellen Terry, wasn't it?

RP: Of course, that was before my time. But he has a Visitors' Book with all the names in. Ellen Terry and the whole shebang. Don't know what became of it, though.

GB: That would have told us and enormous amount ...

RP: A lot of things, yes.

JL: I'm beginning to get the impression now that when he says farewell to Buckfast Abbey, in those missing fifteen years before he turns up at Pledgdon Green, there is every possibility that he might have had a life in the theatre itself.

RP: Could have been scenery. He could have been a scenery painter. It's a possibility, isn't it?

JL: Otherwise, how would have been able to gather around him these various actors and actresses?

GB: He made costumes, didn't he?

JL: Yes, he did make costumes

RP: He used to get angry about that. He used to get angry about those costumes. "All that time making this lovely costume," he said, "for this beautiful girl, mannequin, and then these fat Jewesses thinking they could get into them." Still, they ordered them .

JL: Did he have a 'short fuse' then?

RP: Never with me. Not ever with me. But he did [with] some people who

32 Dorothy Gladys 'Dodie' Smith (1896–1990), wrote *101 Dalmatians* in 1956. Marquis was probably introduced to her by Basil Dean, who had directed her in a number of plays. She was Furnishings and Furniture Buyer at Heal's in 1929.

33 Milton Rosmer (1881–1971). Actor, film director and screenwriter. His real name was Henry Arthur Lunt and he was married to Irene Rooke.

crossed his path. He could be a terror. He used to tell me that when he first came to Pledgdon Green – you remember the Foster family?

GB: Yes.

RP: The Foster girls told me – 'course he used to wear one of these big-brimmed hats like Tennyson wore – had a cape, cycling along, 'course he looked like a monster coming along on this bike ...

GB: ... that all the children ran into the hedge!

RP: ... went behind the hedge and waited until he had gone by. "Bolshevik" they said! He was a laugh and a half, as they say today.

GB: But, Reg, there's not many people like us two who can remember him.

RP: I learnt so much for him. When I'd been working he had a gate-leg table about this size [points to a table 3ft in diameter], oak, deeply grained with age, and we put two or three layers of these dust sheets over the top and there's me sawing, and hammering and banging on the top, and he's painting under the window. And then he'd start to tell me. He'd tell me every one of the theatres he'd seen in London. *Fanny by Gaslight*, *Admirable Crichton*; the list was endless. So I knew all about that. They even came on the telly one night, you know. It was so interesting, and if you were working away time flies, doesn't it? He didn't like anything haughty, you know. I can remember him one day, I thought "What's his nostrils flaring?" He snorted a bit, and it was a cockerel, an old cockerel walking, strutting about, "Go away, you haughty thing! Go on!" shouting his head off, "Ooh, ostentatious thing!"

GB: Did he ever get cross or use bad language?

RP: I never heard him swear at all.

GB: What would you say his accent was?

RP: Oh, it was definitely French because it was never "September" but "Septemberer". And words that came out like that, all the time.

GB: He had a French accent?

RP: He had a cultured accent. These words came through every now and again. Privately educated, he told me. He said he was run in by the beadles at Cambridge. He went there to see a friend and they mistook him, of course, for a college student. They apologised to him, and off he went. But he seemed to be a ubiquitous person, didn't he? Here, there and everywhere.

GB: Reg, what about the time he was racing the steam train?

RP: Oh my god. And that's where he had another accident. A piece of straight road going from Littlebury – where does that go to, Chesterford?

GB: Chesterford.

RP: And up high on the bank in the field he could see a train, from Cambridge to Liverpool Street hammering along. So every time he saw that – the chap on the train would go "Peep Peep" – the whistle – obviously knew, and they'd fly along, you know. One day he went base over apex and landed in the field. He got up and all he was worried about he'd lost a shoe. We searched, and searched and searched but never found the shoe. Size 13; you couldn't miss 'em. He reckons that it might have gone through the sunshine roof, you know. But the funny thing was, you know, he said, "When I woke up in that field, the wheels were still revolving on the car."

GB: He went back a few times to try to find that shoe, didn't he?

RP: He was so angry about that shoe.

JL: Did he ever have the car righted and sent back home?

RP: Of course, they wouldn't insure him in the finish.

JL: I'm surprised that they insured him at the start!

RP: But he did win £50 through John Bull. John Bull advertised and said that anyone who could prove they had broken three bones in a year: £50. He wrote in and got it. The other thing was he said he went down Sussex because he knew all these flowers by their Latin names, you see. Went into this bog and got all these wild flowers. Forgot the bag on the station at Elsenham – I suppose someone thought it was a load of old tat and threw it away – but then the station master came up, apologetic, and said, "I'll see what I can do for you, sir." I mean, a £ was a lot of money in those days. "The company think £50 might be a good offer for you?" £50. For a load of what? For flowers he had picked! Well, his title was worth a couple of quid. That's where the shrewdness came in, wasn't it?

JL: How did people address him? Sir or Marquis?

RP: Just "sir". But to the ordinary people that came round just "Hello!" That's all he'd say. He never pulled any rank with anybody.

GB: I always addressed him as "Marquis".

RP: I called him "Marq", usually. I was 16. "Morning, Marq". I got away with it.

JL: And at that time when you knew him did he still have John as his man-servant?

RP: Now that was John Barclay. I never knew him. He was a Scotsman and he managed a shop. He had a shop in Quendon. The White House. Later on after that, or maybe before, that was a sort of private night club. He said Lady Mercy ... Someone was looking through the window and the policeman – this is what he told the policeman – Lady Mercy was

underneath the sink. He was a character.

GB: Reg, do you think that he ever went in for a prison sentence?

RP: I don't think so. He told me that he went into court once on one of these motoring offences. Down in Sudbury somewhere and the AA chap represented him – lawyer. Course he said, "Would you give your full name, please." He said, "I hesitated, I didn't want to." "Would you give your full name please?" Of course, he reads it all out and, during this, said, "I must apologise to the court." And then this little man – he was a chap from the east end of London – and he explained the situation and his wife came in and contradicted it all. So he came out and, OK, as he was coming down the steps this man was giving him a card and shook his hand and said, "Would you come round to lunch with us?" he said. " ... and, do you know," he said, "I hadn't planned it all. I was going through London" – he had a chauffeur then, I think his name was John – "and said, you'll have to pull up at the newsagent as I want a paper." He walked in and there was this same man behind the counter, bobbing up and down and calling him "My Lord"!

JL: Did he ever tell you about his parents?

RP: Yes. His father was a viscount and his mother was a countess who couldn't speak English. It was French. Lived in Rio – born in Rio, he told me – and he could see a little house with shutters across. He said, "I always remember that little house", and he used to have tears in his eyes. He said his mother had left, I suppose in the wind-jammers or something in those days, I don't know, and they got settled in at Bath. And then waiting for his father, and he got lost at sea. So he inherited his money, I think, when he was about 16. And, as you say, he gave most of it away.

GB: He inherited from his mother or his grandmother?

RP: From his father.

JL: The title he got he said came by his grandmother.

RP: Possibly. He had a family tree. But, of course, I wasn't interested in that then. If I'd had one of those digital cameras, I could have snapped him! But it's gone. It's history gone. There's still a shroud of mystery about him, isn't there? All the time. The whole time.

JL: He's a fascinating enigma. But you've provided another avenue that we could traverse, and that is all of these individuals in the theatrical world subsequently came to see him and, of course, that one of them was the freehold owner of the cottage that was given to him for life. So there is a time when he must have become involved with the London theatrical fraternity.

RP: I would ... just before he died, late '50s, he told me that she'd died. Irene Rooke.[34] They were very old people. They'd been on the scene since 1880 and he was 70-something.

GB: I remember you telling me, Reg, you was driving to work at Stanstead airport, you called in on Smith's Green to see him and you was told that he had died, and that he was upstairs but not in a coffin and was to be buried that afternoon.

RP: No. That morning! That morning. So I must have seen him perhaps an hour before he was boxed. So I went home, dressed and went to the funeral.

GB: They couldn't get the coffin up the stairs. They man-handled him down the stairs and put him in the coffin down the bottom.

RP: It was very narrow in there; the stairs. Twisty, narrow stairs.

GB: They didn't bury him without a coffin. So if you saw him upstairs, and he'd died, and he was on the bed, they'd have man-handled him down the stairs and put him in the coffin and then took him off.

RP: I knocked on the door and said - Bernard Keel came then, he used to live there, didn't he? – "Where is he?". He said, "He's gone". I said, "Where's he gone now?" – as he'd been in hospital, hadn't he? – and he said, "He's upstairs, dead." He'd got a rosary around his hands. I said, "When's the funeral?", he said "'Bout ten o'clock." This was about 8 o'clock in the morning. So I had to go home to change and went to the funeral. It was all done so quickly.

JL: And do you know who performed the funeral?

RP: I couldn't say who it was.[35] I didn't know the man was ill, you see? It was strange to me when he said "He's gone".

GB: Yes, but Reg, he had been ill for some time, because I'd taken him into hospital.

RP: Yes, I went to see him in Chelmsford Hospital. Yes. And then he had a double hernia done, and cataracts on the eye.

GB: I've got a copy of the death certificate, and he died of prostate cancer.

RP: He said, "I have a fear of ... like my cousin, with my neck and that." Blow me, he ended up with a pumped-up collar.

[34] Irene Rooke died at Chesham, Buckinghamshire on 14th June 1958. She was 80 years of age. Rooke bequeathed the Pledgdon Green cottage to her husband, Milton Rosmer. Was it he who gave it to the Marquis after his wife's will was proved on 13th August 1958?

[35] GB subsequently told me that it would have been T. Harris & Son, Funeral Directors and Monumental Masons of Great Dunmow.

GB: Yes, he had a collar. You know who told me had had a collar? Morag Joy, her who lives across the Green.[36] She said he had a collar.

RP: Michelin Man. Bibendium. Like three layers of tubing, you know. It was terrible.

JL: What a rotten end.

RP: And the man that he lived with told me that he left thirty shillings.

JL: Reg, do we know who paid for the funeral?

RP: Well, I've got no doubt in my mind that it was Captain Lake who had the brewery. Because he [Marquis] used to spend a lot of time there.

GB: But Captain Lake. There's no family about there now.

RP: It was a long time ago, Gordon.

GB: But you told me that Captain Lake was an old man in the 1940s so could he have been there in '59 at the funeral?

RP: Well, he was at the funeral. I can see him now: in a trilby hat and raglan overcoat. He lived at Ferneux Pelham, up past the church, on the left. Had a private chapel.

JL: And the funeral took place at the RC church at Great Dunmow?

RP: Yes. Yes. It was a weirdo, this place. It had – well, probably went back to the 1600s by the look of it.[37] Had little, tiny leaded-pane windows – antique when you looked at it – know what I mean? Historic. I was surprised when I went round there one day because it was gone; bulldozed away. It was very small.

GB: Have you got a photograph of it?

RP: No. I known someone had a photograph of that for *Dunmow Broadcast*.

GB: Ah, I think I know who might have one.

JL: And were there many people at the funeral, or not?

RP: Very few. Very few. I suppose, what, about a dozen of us.

JL: How sad.

GP: Yes, it was.

JL: And then off to Dunmow for the burial.

GB: It's a mystery where that piece of headstone went to.

RP: I went down there one day and it was just a blank stone, which I thought was rather odd.

GB: But how come there's no sloping stone.

[36] This would be Pledgdon Green.
[37] This is wrong: it was actually a small nineteenth-century Gothic Revival building.

RP: No, it was a straight headstone.

GB: Fr Anthony and me we looked in the hedge because we thought someone might have taken it and just slung it. Had a good look round. I can understand anyone stealing it if it had got "Marquis d'Oisy" on it, wanting to have it as a keepsake, but apparently it was blank.

RP: Of course, if he was a plain "Mr" he would have been "Mr Tournay". Of course, provided you don't defraud anybody you can call yourself anything.

JL: Unfortunately, he was arraigned twice in the bankruptcy courts and gave his name as d'Oisy.

RP: He was so upset. He said, "I had a lovely place somewhere in London, and the butler I had, one morning I'd finished breakfast and I put the keys to the flat beside the plate and said 'It's all yours', and I walked out and never went back again." He said, "I went back about a couple of years later to see how they were getting on, and the butler peeped around the corner of the curtain ..." Well, he didn't want to know, in case he'd come back to claim it. Sad, isn't it? All of it's sad.

JL: At that time he had debts of about £1,500 and assets of about £500.

GB: And he ended up with thirty bob!

RP: Well, what could he do? All of those years he was in hospital and we didn't have a National Health.

GB: What do you think he'd done with his money? He didn't smoke, he must have frittered ...

RP: He didn't. I told you; that was one of the cases: when he gave away the flat that he'd bought. That was one thing that had gone. There's a blank bit before that as you [JL] say. It's strange this, when he was about twenty-one, navvying, 'cause if that was twenty-one it would be 1901, wouldn't it?

JL: It fits in so well with the timings. Found by this person when he was 19 to become a novice, which is 1899, and by 1901 he's in Caldey and was advised to get some experience of the world. The next thing we hear he is twenty-one, it's 1901 and he's in London working as a labourer.

GB: Yes, but you'd think he'd show up on a census.

JL: But we don't know what he was called then. We have no idea if he was calling himself Ambrose Thomas. As we said the last time, "Ambrose" is the sort of religious name that an aspiring young romantic might have taken on. He is an enigma at the moment. It could be difficult for us to find out, but think that we are beginning to get there. Fortunately, we know about the 1901 navvying in London and we can roughly piece together what was happening to him in his early life. This born in Rio de Janeiro; he gives

different dates to various people as to when he comes to England. He doesn't seem to know himself what the details of this invented story happen to be.

HB: Did he ever talk of siblings?

RP: No, no.

AC: Perhaps he was a spy.

RP: He told me that when he was a young lad ... is it Regents Park that these houses have columns? I've got a feeling that it was Regents Park. He was there with his mother and a tweeny and his said they had a carriage and two horses, as one would have a chauffeur ... He said "One day I came home, the carriage pulled up, and I went up to my door and I thought, 'It's a different coloured door' and I rang the bell and this man came and I said 'What are you doing in our house? Why have you changed everything?' The man said 'I think that the young gentleman lives next door.'" He'd made a mistake with the house. That was vivid. He told me that several times. And how he was in Bath and this house " ... with the river running outside," he said, "and they were so cruel to me. Forbade me to go with them. And I can hear them laughing and happy in the boat as they sailed by. It's stuck with me all those years."

JL: There was his mother, and whomever else, but his father was already dead by then. His grandmother was already dead. So one assumes that when they came over from Rio de Janeiro the first place they settled at was Bath.

RP: Would they have come in at Bristol?

JL: Almost all of these boats at that time will have surviving passenger lists and so one could see which boats were coming over from Buenos Aires to New York and thence on to Southampton, Liverpool or Glasgow in 1888. There would not have been that many.

RP: There's no point following up on that business of the decapitation of the king, is it?

JL: I don't think that he was related to him at all. It's very easy to say one is related to a person if others can't prove it.

GB: What about that cardinal fellow?

JL: Cardinal Richelieu? Well, *he* wouldn't have had any children! The person who was most dubious was the Countess of Warwick. As for Basil Dean, he said that Marquis could not speak French, he couldn't even understand French. Now that's terribly unusual for a person who claimed to be French.

RP: We went to a French restaurant – the Baginaux it was called – and he went [read] through the menu like hot cakes, you know. And that was all in

French. We don't know. The plot thickens all the time, doesn't it?

JL: But there again, restaurant menu French ...

RP: Yes, you could memorize it.

GB: So what we're looking for is what happened 1902 to 1917.

RP: He told me that he came there during the First World War. '14 to '18, wasn't it?

GB: So why is it ... what's your opinion, Reg, as to why he did not participate in the First World War?

RP: Because they would not allow him to. Because he was a foreigner.

GB: Not because he had TB?

RP: He was a very strong man, Never knew him to have a cold, even.

JL: But then he was thirty-four when the war broke out. So he wasn't a spring chicken. And it wasn't until 1916 that conscription was brought in. What did you find was the most endearing part of his character?

RP: To me, he was always very charming. Very helpful. He was like a dad to me. My father was gassed in the First World War and he didn't seem interested in me a lot until the (Second World) war came and he then sprang to life. He was 2nd Lieutenant in the Home Guard – ran that – village pub, village shop, everybody came to him for advice, except me. There was a distance between us. I didn't like to go to him, in case I got snapped-up. So he (Marquis) would tell me, straight away.

JL: The Marquis was always willing to hear?

RP: A sympathetic ear. The most endearing thing I think.

JL: And what use to annoy him?

RP: I really can't think of anything. I suppose, if anyone tried to take advantage of him. I remember when the war agricultural business came in they cut all his hedges and cleared all the ditches out, and he was fuming. One day, a vehicle drew up – about a couple of hundred yards away – and a chap got out with a saw and started to cut wood. And I had a motorbike then. He said, "Follow that car, and let me know who it is!" It was Dick Tracy all over again. This bloke he came from the Land Army and cut the trees down, you see. Well, he was angry. Desecrated his plantation. Funny how it's all grown up again.

GB: You can't see nothing in there now. It's like a forest. Reg, that army hut that he had. Ron Haigh sold it to him.

RP: Yes.

GB: Did the Italians help put it up?

RP: No. Your wife's uncle, Ernie [Jaggard], and John Rattee. We got it up. As a result I got a double hernia. And that was before the National Health, so it was '47. I went into the Navy in '47. That was a bad winter. Terrible winter, that was.

JL: How did Marquis feel that had to move from his cottage to the army hut?

RP: Well, that's another thing he was so angry about. He'd sold this house to this man who was a fire-raiser. Geoff Allen. He burnt one or two houses; he did finally the one at Quendon.[38] So he said, "What shall I do? I've sold it to a fire-raiser". I said, "Yes, I know him well." That was one of his weaknesses. Something that he'd put a lot into was going to be destroyed.

GB: He was also worried that Geoff Allen was mixed up with the Kray twins.

RP: I know. He was always worried about this Geoff Allen. Terrible; being isolated like that.

JL: So one assumes, then, that if he was selling the cottage, that the actress who let him have it for life had died and left it to him? Otherwise, he could not have sold it.

RP: It only went for about £200, I think. It was in a bad state; wanted re-thatching and that. Derelict, really.

GB: Geoff Allen didn't come some time until the mid '50s;[39] and Marquis died in '59 with thirty bob in his pocket. What happened to that money between him selling and him dying?

RP: Well, that wouldn't have been much if he got rid of it in the state it was in.

GB: My grandfather was the last to patch that roof. In the 1920s. He couldn't get his money, but he got it in the end.

RP: It was an era when people weren't involved ...

GB: Can you remember him having a piece added on the front, Reg?

RP: No, I can't.

BG: That was done before your time?

RP: Oh yes. That must have been shortly after he moved there.

GB: He used to sleep out on that. It was open.

RP: It was all open, yes. Sometimes there was a couple of inches of snow on the foot of bed. The dogs used to sleep on it. He called it the Great Bed of Ware because it – well, I reckon it was a couple of beds put together – it was

[38] Shortgrove House.

[39] This fits in with the death of Irene Rooke on 16th June 1958. However, the cottage was bequeathed to her husband Henry Arthur Lunt [Milton Rosmer]; could he have given it to Marquis?

twelve foot, something like that.

JL: It could have been because he had TB that he slept in the open.

RP: Could have been. Could have been. I didn't know anything about that.

GB: And that big fireplace he had in the room nearest to the road, that was all old-fashioned, wasn't it? Spit, wooden plates; "trenchers" they call them.

RP: He had a bread-oven in one corner. I used to put logs on there four foot long on these and-irons. It used to be roasting in there. So hot, so small; it wasn't very big that room. And it was sweltering.

JL: And did he tend to keep the fire going for much of the year?

RP: Yes, wouldn't let you clean the ashes. "You must never clean the ashes out," he said. He had some bellows; you remember those bellows. Had them everywhere.

GB: Tell us about Willy Kobler. Use to get him to saw the wood up, didn't he? Pay him in pennies.

RP: I used to supplement it. He was, er ... when he died, his brother said they put on the death certificate "Cretin". Bit harsh, wasn't it? Yes. He used to ask my father how my brother was when he was flying over Germany when he went in the shop. When he got killed [brother], he stopped. Don't know how he knew, but he didn't ask any more.

GB: Marquis had a wonderful garden early on, didn't he?

RP: Yes, he did. Nice. Pergola.

GB: Who actually looked after it?

RP: Bernard Keel; myself. The day we did the Herb Garden he had a plinth made to put a sun-dial on. I was working on the hedge and I said "Look out!" The wind came, took this massive structure, which was dovecote, crashed it on the floor. It nearly killed him, it did. The Dunmow blacksmith had made it. Inch an a half by about half-inch thick steel, and about three foot square. The centre pillar, it had all rotted. You should see it go! Anyway, we finished this thing late at night, well late for me, as I used to knock-off at five, but time didn't matter to me, much. I stayed on I suppose until half-past six in the summer. "You know what that wants?" he said. "What?" said I. "Thyme," he said, "It wants to be planted with thyme, and know there's some." And I said "Where?" and he said, "Newmarket Heath. Will you pump up the tyres on my bike?" So he went in and changed, and he cycled all the way to the Heath. And in the morning he got a haversack full of thyme. These are the sort of things that I admire. It's a long stretch from there to Newmarket Heath.

GB: Thirty miles, and that's one way.

RP: And after tea! Probably dark when he got back. He was tough.

JL: That was the hardening he probably got as a labourer on the Tube.

RP: Yes, he was tough. He had a lovely belt that one of the navvies had given him. It was all studded with the First World War cross emblems, you know. Essex regiment, whatever. And he treasured that. That went; somebody stole that. They must have ripped him right, left and centre. Had a lot of nice stuff, some of it very interesting. All went.

GB: Did he have a car all the time that you knew him?

RP: He had an Austin ... he used to have a new car every year.

GB: What!? Brand new?

RP: Yes, he use to buy it and sell it before the end of the year. So he got a good return on it. He had a Standard 12 ...

GB: The last one I can remember serving him petrol on was an old Morris 14.

RP: Morris 14. Lovely car when he had it. Except for the engine which, he was coming down from Salisbury, coming down to see me at the old Solent, and the engine disintegrated and cost him about £120 then, which was a lot of money in '47.

GB: So he had several cars?

RP: Oh yes. He had plenty of people to drive them for him. They wouldn't insure him. Hoy from Widdington. I think that's about all, us three.

JL: And what about getting his painted furniture to London?

RP: Ah, yes. London & Stanstead Furnishing Co. They would pick up a load, because of the petrol ration, pick up a load, from London, and bring it to us. Then we would set about doing whatever was necessary. A couple of weeks later they would pick it up and back to London. It all worked out well for him.

JL: And roughly how many items was he sending back to London at any one time?

RP: It all depended on the size of whatever it was. Put it this way: there as enough there for two of us to work for about three weeks. It was done so ... there was quite a few pieces. Quite a lot of small pieces. These wooden tea-caddies, had the lock on. I painted no end of those. Had to sand them all down. But when they were done, they were lovely.

GB: He used to buy his second-hand furniture from Sid Carr.

RP: Yes. Everybody did when they got married in those days.

JL: I hear that he was a generous man and didn't overcharge.

RP: Oh no, he was nice. I got on well with him. He was a shrewd chap. He had

one of his sheds all done out with tables and put his crockery and all that and laid it out all properly. He left quite a packet.

GB: Marquis's metalwork. Did Fred Halls on Mole Hill Green do some of that?

RP: Never knew him to do any. It was Mortimer at Dunmow. Up by the church.

JL: What sort of metalwork was he making?

RP: Hinges and hand-made nails and all that.

JL: Just to give his works a medieval flavour?

RP: Exactly. He made a medieval chair. I don't know what you call those things – you know what I mean? – two half-circles.[40] And then you put the fabric between the arms. It was all so *heavy*. The blacksmith had made massive iron balls that went on the end, you know. And it was all thick iron. You couldn't lift the thing. He got four of those made, as a trial. They ended up in the ditch at the back of the thatched cottage. A sad ending.

JL: Do you recall any large pieces he made, Reg?

RP: Yes. Not what he *made*, but what he *painted*. There was a gentleman's wardrobe and it was solid mahogany. Very heavy. When you opened it, it had all the drawers and everything. He did that, and it looked gorgeous when he had painted it. And I had to do a lot of gilding on that, that's how I remember. And sometimes we'd have furniture with a lot of ornate ormolu which you had to be careful taking off. When I was in hospital last, be about 1980, there was a man in there and I got talking and I said that I used to work for a chap who got a piece of land at Minsmere in Suffolk, on the coast, near what is now Bradwell Nuclear Power Station. He said, "What was his name?" he said. "The Marquis d'Oisy" I said. "Well, I used to work for him," he said, and we got talking. "Do you know, I've never seen a man like him," he said, "Go to Leydon Warwick's and I'd stand behind him and he'd say "Do you want a box for records? Oh I've got just the thing. So-and-so and so-and-so. Little cabriole legs on ..." He hadn't, but he'd come straight back, draw it up and have it made. He employed a couple of carpenters, I remember them there, before I went there. But he had a fire. A tilly-lamp set fire to the original building there. That was about ... the one that we put up, that was on the same site. It was quite a big workshop he had.

GB: Another person who used to drive for him was Walter Andrews.

RP: That's right. I saw him, and he came up to see him [Marquis] beginning of the RAF.

GB: And then there was another chap. When I was in Rye Street Hospital

40 This would have been a 'Canterbury chair'.

[Bishop's Stortford] – 1960s –

RP: Bargle. Bargle. Gilbert Bargle. Round, red-faced man. He just chauffered and that. He taught me to drive. The old boy; that's right. But ... so much happened during those war years, especially when you couldn't get the timber.

GB: One of the last occasions I remember seeing Marquis catch the bus was when going down Dunmow Road into Bishop's Stortford and about 100 yards up from the traffic lights there was a bus-stop on the right-hand side. He was waiting to catch a bus to come out, and he would have gone to Takely and he would have walked from Takely to Pledgdon Green, wouldn't he?

RP: Very likely. Distance was no problem. No problem. Just get on a bike, and go. He never thought anything about it; he never thought twice. You don't see people like that. Character's have now all gone.

JL: And when the work started petering out, say into the first or second year of the Second World War, how did he then make a living?

RP: I suppose he did anything that come to hand. You would do if you made those boxes up, and things like that you see. He wasn't a lazy man by any stretch of the imagination.

JL: There must have been times when he felt very straightened? Especially in the last years; the '50s.

RP: I had a job when I first started work in Stanstead, Cambridge Road, and I was getting five shillings a week. He offered me a £1. And I was near home, could go home for my lunch, so I was in clover, really.

GB: His cutlery, he had, at the table, did that all have bone handles?

RP: Yes, there was all sorts.

JL: And, as Marquis, did he have any heirlooms? Any family portraits?

RP: No, I never saw anything like that. I saw a portrait of the old man that lived in that house before him. He was an old man, sitting there by the front door, in a chair, with a beard, massive beard. And it was in sepia. Very old photograph. That photograph [of Marquis] I let Gordon copy, it's the only one, as far as I know, in existence. 'Cause he used to supplement his ... whatever he was doing ... by lecturing. Yes, he lectured at Women's Institutes. I used to take him all over the show.

GB: Reg, did he ... they paid him for all that?

RP: They paid him for it.

GB: I've got a copy of one he did in Elsenham and he was lecturing on dress. The medieval dress; it wouldn't be any other.

RP: I went and sat in. I usually sat in the car, but I went in once – can't remember actually where it was – it was *Time*[41] he was talking about. And two or three years later in *Country Life* or one of those periodicals there was a picture of the White Rabbit in *Alice in Wonderland*, big watch in his hand, and that was an article by him. You see, you never knew what he did.

GB: Do you remember him Morris dancing?

RP: No, I can't. No. I saw the pictures of the pageants that he had.

GB: So the Morris dancing would be done before the War?

RP: Oh yes. Yes.

JL: The only such thing he did after the War was to appear with the Thaxted Morris in the Festival of Britain Exhibition year of 1951.

RP: Oh, well he was an exhibitionist, wasn't he!? He was always the king in a pageant. Oh yes. Cock of the North!

JL: How did he dress normally?

RP: Pair of sandals, no socks, pair of rough old shorts, and a heavy, thick linen shirt. Summer, winter, hail, snow, blow, whatever.

GB: He nearly always had sandals on.

RP: I can't recall him, even when it was snowing, any different. I mean, how would you like to sleep with six inches of snow at the bottom of your bed?

GB: Dick Knowles told me that in a very, very bad winter – that must have been 1947 when the snow drifts were ten foot deep – Dick Knowles he couldn't get to school so he helped his father – and the land people from the farms – to dig the road out so the traffic could get through. He said he was looking up the road and all of a sudden he saw this figure coming up there. He had a red shirt on, he wore shorts with plimsolls on. In the snow!

RP: He would do!

GB: And he'd only got a shirt and shorts on. New perspective, all this business, a fictitious name and all that. It was a big come down for him, wasn't it?

JL: Yes.

RP: Mixing with society.

JL: That's exactly what I was thinking. I was saying earlier today to Gordon, "How did he *feel* in the 1950s, in the cold winter nights? He was on his own, and there wasn't the money, poor chap. And nobody wanted his talent any more."

GB: But, did he know any different?

JL: Did he know any different?

[41] Or could this have been *Thyme*?

94

RP: He was virtually blind at the end.

GB: There must have been better days.

JL: I think that his 'better days' were 1925 to 1936, doing the pageants and all the painting.

GB: You see, it appears to me, he only had friends. He got no relations. He didn't appear to have any relations, did he?

JL: And all these amazing connections with the crown of Spain, where were they when needed?

GB: Well, they weren't after his money 'cause he hadn't got any.

RP: I wonder; if it was meant to be his cousin, then it must have been his mother's sister, mustn't it?

JL: But how convenient ...

RP: Exactly.

JL: ... to chose a crown of Europe that immediately becomes annihilated through Franco's demands.

RP: Exactly. Exactly. Yes.

JL: I should think that those who could have rumbled him actually didn't rumble people in those days. Conrad Noel might have known. The Countess of Warwick might have known.

RP: He used to have tea with Conrad Noel, funnily enough. He said he never met Wells at Lady Warwick's. "Beastly man," he said, "they told me that he treated her [his wife] badly, with 'Bring my coat!' and so forth. I couldn't have got on with him," he said. And one day Maynard Greville – Maynard Greville used to ride a racing bike before and during the War – always wore a beret, he looked like a racer – always used to come into our pub and my father would address him as "Mr G." so nobody knew who he was. Down a drink. Two or three pints of bitter, and then go on to the next pub. Same thing. Do a circuit. God knows how he rode a bicycle! He said one day, "Old Wells is coming down." – my father, his name was Duke – "Duke, Old Wells is coming down, catch him in a minute, have a look at him." I can see him now; he had a stoop. The great H.G.! He lived at Glebe House.

GB: That's the Old Rectory, isn't it?

RP: I suppose it is.

GB: It's about two or three hundred yards from the church. Near the lakes.

RP: Well, when my sister use to take me on the hard carrier to my aunts at Little Easton, although it was private, the estate, we knew so many people through the pub that we'd always got an excuse that we were going to see George Kent or whoever. But at mile or so from the house we used to watch Wells'

lot playing tennis. And they wore these long dresses in those days, didn't they? Long, white dresses, below the knee.

It was here, towards the end of the conversation the tape ran out. However, I did have four more questions to ask:-

JL: What did the Marquis do for relaxation?

RP: He didn't. He didn't take a newspaper either. Marquis used to say "Blow Berlin up and replace it with a forest." He worked rather than rested. He taught me to do painting, and how to do shadows. He used to buy oil paints and white lead. He was a good and patient teacher and he paid regularly on the dot. £1 a week I got. On birthdays there was always a little treat and whenever we went to London I always lunched where he lunched. He used to comb his hair with a big Roman-style comb, like a big nit-comb.[42] He always used Ever-Ready razor blades. At the time of his death he was almost bald; well, gone on the top but with an angel-roll. His skull came down at an angle at the back; it was flat, and I remember once swatting a fly with a two-foot rule which was sitting on this part of his head. He wore big, heavy Perspex spectacles for painting. One day, he wafted through his garden in a pageant costume, and Billy Kobler asked "Does he often wear ladies clothing?"

JL: What did he do for amusement?

RP: He'd go to the theatres. Never the cinema. The last play that he saw was Agatha Christie's *Ten Little Nigger Boys*. He was an ardent royalist, but, said Marquis, "Prince Rupert of Bavaria is the real king of England."[43]

GB: Marquis was hardly ever ill.

RP: [With a chuckle] He couldn't afford to be.

GB: Where did he buy his clothes from?

RP: Don't think that he bought any. He did have a large quilt which I helped him make for his four-poster bed; it was a big bed, he called it his "Great Bed of Ware". He wore size 13 shoes.

JL: Were there any facilities in the cottage at Pledgdon?

RP: He had a little boiler in the back room of the cottage and a pump for the well was also in the back room. He had a bath and one of the taps was in the form of a brass fish. His varicose veins were terrible, like bunches of grapes. They burst once and bled through the floor, so he had them all taken out, privately, in London. Today, if he was a young man and came back, he would have made a fortune.

[42] Reg Payne probably meant a comb like the medieval ivory ones.
[43] Prince Rupert (Ruprecht) (1869–1955) was the last crown prince of Bavaria, and had Jacobite descent from the Stuart King Charles I.

JL: And did he have a telephone in the cottage?

RP: He used dad's pub in the late 1940s to phone from. He had a phone in the early '40s but couldn't keep it up. I was 15 when I started working for him and 17 when I stopped working for him.

6. *Reminiscences of Robert ('Bob') Smith: 2012*

On Friday 23rd March 2012, Fr Anthony Couchman and I went to Elsenham again, this time to meet with Gordon Barker and Robert ('Bob') Smith (b. 1925) of Pledgdon Hall Farm. Over a fine lunch at *The Cock* at Henham, Bob Smith was able to tell me:

BS: He [Marquis] lived quite close to us, and during the war [WW2] he used to come down to us, destitute. He used to do tarring the buildings, anything for a job. I wasn't very old so I didn't know him that well.

JL; How did your parents get to know him?

BS: Oh, he was quite a character in the area, of course. He used to put on pageants at Easton Lodge. I think there was a great big cedar tree by the side of the Lodge which they used to hang curtains from. I just remember in 1935 – might have been about ten, I suppose.

JL: Can you remember what he looked like?

BS: Yes; this photograph which you have is quite good. The last gentleman that looked after him was Bernard Keel. He lived in a little tiny thatched cottage right under the A120.

GB: Down the bottom of Cook's Hill.

BS: Yes, that would be it.

GB: I remember taking him into Chelmsford Hospital. It must have been 1958. And he had a glass bottle and I can remember the piece of road where he used it. Of course, I didn't understand in those days what he had wrong. I hadn't got a clue. We'd only got four or five miles up the road. I took him into hospital, but I don't know why I brought him out.

JL: What was he *like* as an individual?

BS: Well, one accepted that he was nobility. He was a tall, aristocratic type of person and very upright, with the air of aristocracy.

GB: Well, he looked the part.

BS: Oh yes; very much. He came down during the war [WWII] and painted some of my mother's bedroom furniture. For our wedding present he gave us a lovely little box painted with Italian ... I'll show you later, if you like.

JL: Yes please.

BS: I've got a small collection of early farming implements, and in the back is his chair, his "bishop's" chair. He had greyhounds and they use to also sleep on this chair; the material is there, completely ruined!

GB: There must be a lot of the furniture he painted still around.

BS: Many people tried to buy the cottage at Pledgdon, but when this rogue came – Geoffrey Allen – and handed him a heap of notes, so I understand; he accepted it. Of course, Allen was an arsonist; Shortgrove, his thirteenth arson, let him down and he went to prison.

GB: I understand that after the Marquis had sold it to Geoff Allen he wished he hadn't.

BS: Oh definitely. He came over to us – we lived on Pledgdon Green – when we first got married, and said, "Please, if the phone rings in the middle of the night will you come out and have a look to see if I'm being burnt out." He lived in a shed, right on the side of Geoffrey Allen's and, of course, it deterred the value of it [the cottage]. He didn't like the Marquis seeing what was going on. Ron Haigh sold him [Marquis] the shed and instead of money [Haigh] got bits of furniture.

GB: After I'd taken him to Takeley I took him back to this hut and he had furniture stacked all the way along until one got to the room at the end.

JL: One thing I find unusual is that with all of these presumed aristocratic forebears the fact that whether or not he mentioned that he had siblings or if siblings were part of his story.

BS: I wouldn't have thought so. He was definitely not of the marrying type.

JL: But even if he had no money, it's odd that he had no possessions, family heirlooms; nothing whatsoever.

GB: Well he told my father that he had inherited a £100,000 and earned £100,000.

BS: Of course the story, as you put it in your letter, is that his parents came out of France following the Revolution and then they emigrated out to Brazil. That's all absolute nonsense.

JL: To some extent he was fortunate moving into the country; no-one would ask too much about him.

BS: He was liked. The people at Ferneux Pelham – the Lakes – they were very good to him. Mind you, he didn't expect to be paid (for his work) and he didn't expect to pay either.

JL: Daisy Warwick was never convinced he was an aristocrat.

BS: Locally he was known as the runner between Daisy Warwick and the Prince of Wales, but of course he was too young.

GB: Bob, that couldn't have been, because when he was born and when the Countess packed up with Lord Teddy was 1894 and Marquis would have been fourteen.

JL: Why he chose to invent this persona; that's what I want to know. I don't think that we are ever going to find out.

BS: No, no.

GB: My grandfather patched his thatched roof up in the 1920s. It took some time for him to get his money, but he got it in the end. I get a little annoyed with myself as I could have asked many questions of the Marquis.

JL: As a bankrupt until at least 1931 he could not have received money into an account nor issued cheques.

BS: Well, in fact there were quite a number of people then who lived on barter and didn't use cash.

GB: I think that Marquis was interesting in several different ways. It wasn't just his painting; he was very good at being wily.

JL: Can you remember how he used to dress?

BS: Very smart. That's where this aristocracy comes in. People can always tell, however rough the clothes are, if they're of good quality. Of course, he was a very great supporter of Thaxted's dancing and he produced these plays.

JL: Most of scripts were written by A. A. Thomson.

BS: Yes, I knew A. A. Thomson. He was – to go back to the First World War – with Kodak originally and in 1935 or '36 the Thomsons lived in Henham. His wife loved doing cottages up and moved quite a lot. He lived at White Cottage, and at Broxted. We used to go on holiday to Rottingdean but it left my oldest brother at home and Miss Margaret Reeve, A. A. Thomson's god-daughter, came down to look after him. She came for a fortnight and stayed for thirty something years! During the War my father was on the County Agricultural Committee and she [Miss Reeve] used to be his secretary and do all his work. A. A. Thomson himself had one daughter, she was adopted; he was a great commentator of cricket matches, I think at Brighton or Lords.

JL: So Thompson would write the scripts and Marquis would design the costumes and the sets.

BS: That was on the lawn at Easton Lodge, and my mother – she was no actress – she just took part in the crowd.

JL: He was pretty wily with the people he managed to bring together.

BS: But he'd got that air. It was difficult to say no to him.

GB: Well, people wanted to be with the Marquis.

BS: Yes, or be known as a *friend* of the Marquis.

JL: Was Marquis more of a stay-at-home?

BS: In my day I would have said yes, but I'm not sure ...

GB: He was only interested in his painting, the pageants, his garden. That was his life.

JL: One gets the impression of that. And certainly once he had decided on what the [subject of the] July pageant would be he had plenty of time in the winter months to have painted the scenery or running-up some of the costumes.

GB: Probably of a winter's evening he was sitting in his chair thinking of his next move.

BS: He had this artistic air, which would give him the ability to do these things. It was always strange to me that he came down to the farm in the War to paint the buildings, a man with his ability. So he went through a very rough time.

GB: But in war-time one had to turn one's hand to anything.

BS: True, but that's about the lowest of that type of abilities he had.

GB: He arrived in this area calling himself the Marquis, and in the end I think that he believed it.

BS: And he was so desperately short of money. He kidded everybody, probably even himself.

GB: The Marquis didn't envisage that in years to come there was going to be such a thing as a computer.

JL: I wonder how long it would have taken Marquis to have painted something like the font-cover at Tilty, as I believe that some of his works he did *in situ*.

GB: Well, somebody told me that when he done a table-leg, he was going down like lightning.

BS: You really do amaze me with the connections. I had *no* idea about A. A. Thomson. The family knew him well – well, both [meaning also Marquis] – he was always known as A. A. Thomson but his wife was French.

JL: It would be interesting to know if he [Marquis] did any work for Thomson. We then talked a little about the circumstances surrounding his residence at Pledgdon.

JL: We don't know what document was drawn up between Irene Rooke and himself. She probably knew whom this man was, that he would never survive in the real world ...

BS: ... and doing these wonderful back-drops probably wanted to encourage him and help him.

JL: Oh I'm sure that it was that.

BS: But I never saw him but smart. Not particularly good clothes some of them – they hadn't been ironed, but you could see …

GB: Can you remember him riding that tall bicycle?

BS: No. I don't remember that.

GB: He came down on it and spoke to the ladies in the W.I.

BS: Oh he did a lot of those.

JL: Did the Marquis ride?

BS: Well, he was really past the horse age, really.

JL: I wonder if he ever hunted?

BS: I don't think so. That's how my wife and I met. We would have known. That was way back in the '50s.

GB: I'm almost sure the Marquis never had anything to do with horses.

JL: He seemed to have managed quite well to have hidden himself away for almost forty years in north-west Essex and yet at the same time to have been accepted by the local nobility. I wonder what Cranmer-Byng thought of him.

APPENDIX 2: KNOWN WORKS

Broxted, Essex, Private Collection
Painted chest. Purchased from Ritchies Antiques, Silver Street, Stanstead.

Cheltenham, Gloucestershire, Holst Birthplace Museum
Painted chest, the gift of Imogen Holst.

Chiswick, London, Private Collection
Bed. Made by Ernest Beckwith for Conrad and Miriam Noel and subsequently painted by Marquis for Miriam Noel. According to the owner, Miriam Noel, had a number of articles of furniture painted by the Marquis.

Esperance, Western Australia, Private Collection
Painted dresser, painted upright piano and piano-stool.
The owner lived at Takely and knew Marquis. He was given these items by Marquis shortly before his death.

Furneux Pelham, Hertfordshire, Roman Catholic Chapel of The Annunciation.
The items were provided by d'Oisy between c.1951 and his death in 1959. The tarred door leading into the Chapel has some late-seventeenth-century carved panels, which were presumably attached thereon by Marquis.

Vestibule

Carved continental 18C wooden panel crowned by two putti.

Triptych of Virgin & Child with decorative doors.

Book-cover in red velvet with pattern in gilt-headed pins.

Chest of drawers, painted grey.

Lady Chapel

Statue of the Virgin & Child, plaster; gift of Mr and Mrs Langham Service.

Decorative painted niche for statue of the Virgin & Child.

Four wooden candlesticks, red and gold.

Two wooden candlesticks, blue and silver.

Two-bay west arcade with decorated soffits.

Star-spangled plaster lierne vaulted ceiling.

Two-light arcaded south window.

Semi-circular decorative eighteenth-century continental filigree panel of arabesques in north wall.

First Floor Chapel

Statue brackets, c.1951

Painted statue of the Virgin & Child.

Small painting of Virgin & Child with, at Our Lady's feet, painted represent-ations of three churches in the Pelham neighbourhood.

Painted decorative frame, with stand, for icon of Our Lady.

Small decorative lamp of filigree iron.

Pair of brass candle-sconces formed from two grip-plates of marquisate coffin furniture with three-branch candle-brackets, probably cobbled from a damaged chandelier.

Decorative rope with tassels on communion rail serving as barrier to sanctuary.

Installation of rood-beam behind altar and rood.

Five low-mass chasubles, each with matching stole, maniple, burse and veil.

When the Chapel was closed in 2013 the majority of the d'Oisy items were transferred to the Roman Catholic church of St Richard of Chichester, Station Road, Buntingford, Hertfordshire.

Hatfield Heath, Hertfordshire, White Hart Inn
Painted linen-fold panels, c.1945.

Kensal New Town, London W10 , RC church of Our Lady of the Holy Souls, Bosworth Road
West porch with figures and arabesques on painted panels. 1921. According to the church's website, "The western façade, in Bosworth Road, has an entrance opening into what was to be only a temporary entrance. The porch was designed by the Marquis de Saint André de Tournay d'Oisy, St John's Wood and was blessed in November 1921 in memory of Fathers J. J. Greene and A. S. Baker.

Over the porch, the wall is pierced by triple lancets set between tall slender buttresses, and in the top stage between the two central buttresses the gable is pierced by three small lancets." The painted panels were obliterated by wood-stain in the 1960s.

Leiston, Suffolk, St Margaret's Church.
Besides the west wall of the south transept. Triptych of Our Lady of Leiston, painted in the 1930s by d'Oisy for an RC lady who lived near the site of the original Leiston Abbey. Each of the wings has a kneeling Premonstratensian Canon and three angels with musical instruments. In the centre is the Blessed Virgin, throned with the original Abbey and the sea beyond, and also modern sailing ships and steam ships. It is mentioned in Roy Tricker's 1990 church guide.

Little Easton, Essex, Manor House
Supervised the rebuilding of the porch, the replacement staircase and the exposing of beams. 1925–27.
Little Easton Manor House was put on the market in August 2014 by the estate agents Carter Jonas with an asking price of £5,000,000.

London, Sotheby & Co.
On 14th June 1965, Sotheby's held a sale of "Objects of Vertue. The property of Miss G. A. Harries, Mrs W. D. Blair and the late Marquis d'Oisy." Presumably sent for auction by Bernard Keel.

Milton Keynes, Bedfordshire, Private Collection
Icon of the Virgin of the Sacred Heart, c.1951. Painted for Mr and Mrs George Langham Service in c.1951. The sister of the owner of this item has a painted bathroom stool by d'Oisy, made to go with a dressing-table (*see* **Thetford, Norfolk**) also painted in c.1951 for Mr and Mrs Langham Service.

Pledgdon Green, Essex, Private Collection 1
Watercolour of Rough Apple Cottage, Pledgdon Street, Henham, Essex 1918. Signed by Louis d'Oisy.

Pledgdon Green, Essex, Private Collection 2
Painted chest
Painted chest of drawers
Trinket box
The painted furniture is a simple cream highlighted in light green.

Pledgdon Green, Essex, Private Collection 3
Painted bathroom table and mirror, green/grey. Painted for the owner's mother.
Painted gentleman's wardrobe, green/grey. Painted for the owner's mother.
Painted trinket box, green/grey. An elaborately-painted trinket box. Marquis'

wedding gift to the owner.

High-backed chair, upholstered in what looks like Grossé's fabric.

Painted coffee-grinder; the grinder Reg Payne made mention of it.

Fire-back, iron griddles, pots and pans from Marquis' cottage.

Stanstead Mountfitchet, Sworder's Auction House

In 1995 (day and month not known), Sworder's sold:

Lot 721. Amand Amboise Louis Marquis d'Oisy. A Low Cabinet With A Single Panelled Door within panelled sides, raised on bracket feet. The door painted with a medieval couple, the remainder painted with flowers on a cream ground. 35in wide × 29in high.

Lot 724. Amand Amboise Louis Marquis d'Oisy. A Pair of Painted Wooden Bellows, the top depicting the scene of a castle. 20.5in high.

On 20 March 2002 Sworders of Stanstead Mountfitchet, Essex had for auction two items of furniture by the Marquis:

Lot 1076. The following two lots were decorated by The Marquis Armand Ambroise Louis d'Oisy. The Marquis was a well known figure in local art circles and supplied many London shops with his distinctive painted furniture. The Marquis assumed the title in 1888 on the death of his grandmother and came to England during World War 1 from the French town of Oisy with which his family had been closely associated since 1665. He died in 1959 aged 79. A 3 drawer dressing chest with an oval mirror back and a chest of 2 short and 2 long drawers. 856cm wide. Est. £200/£400. Not sold.

Thaxted, Essex, Church of St John the Baptist, Our Lady and St Lawrence.

Painted corner-cupboard, 1923–4.

Painted vestment press, 1923–4.

Painted decoration of the tabernacle on altar in Becket Chapel, 1930s.

Painted niche and statue of St Thomas a Becket, 1930s.

Painted pewter *coronae lucis*, two in the Lady Chapel and one above the statue of Our Lady in the nave. D'Oisy also provided strips of the same as cresting for the high altar reredos. 1930s.

Painted decoration of the 1896 lectern; 1944.

Thaxted, Essex, Private Collection 1

St George and the Dragon Chest.

Knights' Chest. Painted in the Italian renaissance style.

Small painted chest, exterior now rubbed, but interior pristine.

The Lutterell Armoire. d'Oisy's favourite piece.

Four paintings of *The Pleasures of Life* [Fire, Wine, Dancing, etc].

All but the small chest formerly the property of Arthur Caton and Kate Butters.

Thaxted, Essex, Private Collection 2
Two painted chests.

Thetford, Norfolk, Private Collection 3
Painted dressing-table; executed in 1951 by d'Oisy for Mr and Mrs George Langham Service.

Tilty, Essex, St Mary the Virgin
Painted decoration of the sounding-board of the pulpit and of the font cover, 1945. Both items having been designed by Stephen Dykes-Bower.

Tye Green, Essex, Private Collection
Triple mirror, free-standing dressing-table type, painted with flowers. Purchased by the owner's mother in c.1970 from an antique shop in Thaxted, presumably The Thaxted Galleries, owned by James ('Jimmy') Shepherd.

Widdington, Essex, Private Collection
The Venice Chest of Drawers.
The Venice Cupboard.
Two painted dressing-table mirrors.
Six painted dining chairs.
A painted bed-head.
Four painted chests.
Two painted lamps.
Painted Vase.

In addition, it is known that d'Oisy provided a number of items of painted furniture for the Countess of Warwick for use at Little Easton, Essex and items of painted furniture for Mrs Miriam Noel.

Finally, the one that got away! On 29th August 2011 Gordon Barker wrote:

> I went to an old people's home last week and saw an old relative of mine aged 97. She remembered the Marquis painting furniture but could not tell me much more. She did say that her daughter had a clock that the Marquis painted. When I got home I gave her a ring but was told that sometime ago she scraped it clean to reveal the natural wood.

LIST OF ILLUSTRATIONS

The majority of the photographs were taken by the Rev. Anthony Couchman and enhanced by Michael Bailie. Michael Bailie also took the photographs of the Leiston Trptych and of the furniture in the private collections. Images from other sources are individually acknowledged below. Any omissions regarding copyright of particular images is the sole responsibility of the author.

Churchwardens of Thaxted, Essex. © Author's collection. *Mike Bailie.*

36. The Arabesque Chest. c.1935–40. Exterior. Private collection, Thaxted. © *Mike Bailie.*

37. The Arabesque Chest. c.1935–40. Interior. Private collection, Thaxted. © *Mike Bailie.*

38. The St George and the Dragon Chest. c.1935–40. Private collection, Thaxted. © *Mike Bailie.*

39. The Lutterell Armoire. c.1935–40. Private collection, Thaxted. © *Mike Bailie.*

40. The Lutterell Armoire. c.1935–40. Detail, decoration on doors. Private collection, Thaxted. © *Mike Bailie.*

41. The Knights' Chest. c.1935–40. Private collection, Thaxted. © *Mike Bailie.*

42. The Knight's Chest. c.1935–40. Interior, showing painting of a romantic castle. Private collection, Thaxted. © *Mike Bailie.*

43. Letter from Marquis d'Oisy. 1936. © Private collection, Widdington. *Mike Bailie.*

44. Pageant at Hatfield House. 1936. Lady in sedan chair. *Mike Bailie.*

45. Pageant at Hatfield House. 1936. Children dancing Skellenger's Round. *Mike Bailie.*

46. Painted dining chair. c.1939–45. Private collection. *Mike Bailie.*

47. Bed-aside table. c.1939–45. Private collection. *Mike Bailie.*

48. Lectern, Thaxted church. 1944. Front. Courtesy of the Vicar and Church-wardens of Thaxted, Essex. © *Rev'd Anthony Couchman.*

49. Lectern, Thaxted church. 1944. Back. Courtesy of the Vicar and Churchwardens of Thaxted, Essex. © *Rev'd Anthony Couchman.*

50. Lectern, Thaxted church. 1944. Detail of eagle. Courtesy of the Vicar and Churchwardens of Thaxted, Essex. © *Rev'd Anthony Couchman.*

51. Font cover, Tilty church. 1945. Courtesy of the Viar and Churchwardens of Tilty, Essex. © *Rev'd Anthony Couchman.*

52. Pulpit canopy, Tilty church. 1945. Courtesy of the Vicar and Churchwardens of Tilty, Essex. © *Rev'd Anthony Couchman.*

53. The Venice Chest of Drawers. c.1945–50. Private collection. *Mike Bailie.*

54. Jewellery Casket. c.1950. Private collection. © *Rev'd Anthony Couchman.*

55. Jewellery Casket. c.1950. Detail of painting on lid. Private collection. © *Rev'd Anthony Couchman.*

56. Triptych of the Sacred Heart. c.1950–51. © Private collection.

57. Chapel of the Annunciation, Furneux Pelham. 1950–58. Exterior. © *Rev'd Anthony Couchman.*

58. Chapel of the Annunciation, Furneux Pelham. Lady Chapel, 1950–58. © *Rev'd Anthony Couchman.*

59. Chapel of the Annunciation, Furneux Pelham. Lady Chapel soffit. 1950–58.

© *Rev'd Anthony Couchman.*

60. Chapel of the Annunciation, Furneux Pelham. Statue of Our Lady. 1950–58. Reproduced by courtesy of Paolo Durán, Headmaster, St Edmund's College, Ware, Hertfordshire. © *Mike Bailie.*

61. Chapel of the Annunciation, Furneux Pelham. 1950–58. Upper chapel. © *Rev'd Anthony Couchman.*

62. Chapel of the Annunciation, Furneux Pelham. Icon of the Virgin and Child. 1950–58. Reproduced by courtesy of Paolo Durán, Headmaster, St Edmund's College, Ware, Hertfordshire. © *Mike Bailie.*

63. Chapel of the Annunciation, Furneux Pelham. Our Lady of the Pelhams. 1950–58. © *Rev'd Anthony Couchman.*

64. Chapel of the Annunciation, Furneux Pelham. Painted prayer-card holder. 1950–58. Courtesy of Mr Paolo Duran, Headmaster St Edmund's College, Ware. © *Mike Bailie.*

65. Chapel of the Annunciation, Furneux Pelham. Painted Cross. 1950–58. Reproduced by courtesy of Paolo Durán, Headmaster, St Edmund's College, Ware, Hertfordshire. © *Mike Bailie.*

66. Chapel of the Annunciation, Furneux Pelham. Best white chasuble. 1950–58. © *Rev'd Anthony Couchman.*

67. Chapel of the Annunciation, Furneux Pelham. Red chasuble. 1950–58. © *Rev'd Anthony Couchman.*

68. Chapel of the Annunciation, Furneux Pelham. Green chasuble. 1950–58. © *Rev'd Anthony Couchman.*

69. Chapel of the Annunciation, Ferneux Pelham. Blue chasuble. 1950–58. © *Rev'd Antony Couchman.*

70. Chapel of the Annunciation, Furneux Pelham. Requiem chasuble, set 1. 1950–58. © *Rev'd Anthony Couchman.*

71. Chapel of the Annunciation, Furneux Pelham. Requiem chasuble, set 2. 1950–58. © *Rev'd Anthony Couchman.*

72. Marquis, as Castleton King, with Stanley Moss as his 'lady', leading the Thaxted Town Procession in the town's celebrations for the Festival of Britain, 1951. Unknown photographer. © Bruce Munro, Thaxted. *Mike Bailie.*

73. Planter. c.1955. Private collection. *Mike Bailie.*

74. Coffee-grinder. Private collection. © *Rev'd Anthony Couchman.*

75. The Roman Catholic church of Our Lady at Great Dunmow, Essex, in c.1910–15. Unknown photographer. © Gordon Barker, Henham. *Mike Bailie.*

76. Marquis' grave in the churchyard of St Mary the Virgin, Great Dunmow, Essex as it appeared in 2013. © *Rev'd Anthony Couchman.*

BIBLIOGRAPHY

Peter Anson, *Bishops at Large* (London: Faber & Faber, 1964).

Dom Bede Camm, *The Voyage of the Pax: An Allegory* (London: Burns & Oates, 1906).

James Bettley and Nikolaus Pevsner, *The Buildings of England; Essex* (London: Yale University Press, 2007), 764–5, 787.

James Bettley and Nikolaus Pevsner, *The Buildings of England; Suffolk: East* (London: Yale University Press, 2015), 390.

Sidney Dark, *Conrad Noel: an Autobiography* (London: J. M. Dent & Sons Ltd., 1945).

Basil Dean, *Seven Ages: an Autobiography. Vol. I: 1888–1927* (London: Hutchinson, 1970).

Basil Dean, *Seven Ages: an Autobiography. Vol. II: 1927–1972* (London: Hutchinson, 1973).

M. Dennison, *The Last Princess: the Devoted Life of Queen Victoria's Youngest Daughter* (London: Wiedenfield & Nicolson, 2007)

Marquis d'Oisy, 'Wall Hangings of Today' in *Ideal Home*, February 1928.

Marquis d'Oisy, 'Spirit of the Past', in *Ideal Home*, 1952.

G. I. Ginn, 'Dancing in Thaxted', in *English Dance and Song*, December 1951/January 1952.

Reg Groves, *Conrad Noel and the Thaxted Movement* (New York: Augustus Kelley, 1968).

J. W. S. Litten, *The Marquis d'Oisy; Aesthetic, Exotic and Enigma* (London: Anglo-Catholic History Society 2014).

J. Putterill, *Thaxted Quest for Social Justice* (Marlow: Precision Press, 1977).

A. J. D. Robinson, 'Ferneaux Pelham: The Chapel of the Annunciation', in *The Edmundian* (Ware: St Edmund's College) 2013–14, 17–19.

W. R. Shepherd, *The Benedictines of Caldey Island* (Caldey: Caldey Abbey, 1907).

Rosamund Strode, 'Part I: 1907–1931' on Christopher Crogan (ed.), *Imogen Holst: a Life in Music*, Aldeburgh Studies in Music 7 (Woodbridge: Boydell Press, 2007).

Frances, Countess of Warwick, *Life's Ebb and Flow*, (New York: William Morrow & Co., 1929.

J. P. Wearing, *The London Stage 1920–1929; a Calendar of Productions, Performers and Personnel,* 2nd edn (Plymouth: Rowman & Littlefield, 2014).

M. Yelton, *Martin Travers 1886–1948* (London: Unicorn Press, 2003).

M. Yelton, *Anglican Papalism: an illustrated history, 1905-1960* (London: Canterbury Press, 2005).

Daily News, Perth (Australia), 23 September 1921.
Herts & Essex Observer, 17th July 1926.
Herts & Essex Observer, Saturday 23rd July 1927.
Herts & Essex Observer, Saturday 26th May 1928.
Herts & Essex Observer, Saturday 5th July 1930.
Herts & Essex Observer, Saturday 18th January 1936.
Herts & Essex Observer, 16th July 1936.
Herts & Essex Observer, 18 December 1959.
London Gazette, 28 January 1921.
Saffron Walden Weekly News, 31st July 1942.
The Times 17th April, 1923.
The Times, 7th October 1923.
The Times, 22nd October 1923.

INDEX

Compiling an Index for an enigma with two names can be a difficult task. Should the subject be referred to as Ambrose Thomas or Marquis d'Oisy? In the end I have settled for both, indexing Ambrose Thomas as he appeared before adopting the name of Marquis d'Oisy, and then d'Oisy, Marquis under subject, such as 'ecclesiastical commissions', 'pageants', 'painted furniture' and 'stage costume designs'.

The rest of the Index is in the standard format, viz: Latin and Arabic numerals in ordinary type refer to page numbers, numerals in *italics* refer to a mention in a footnote and the page quoted, whilst those in **bold** type refer to a plate number. However, entries in *italics* refer either to titles of journals or of plays with which d'Oisy was in some way involved.